Timothy Hyman
is a painter and writer. He has lectured on painting
at many universities, art schools and museums in the UK.
In 1993–94 he received a Leverhulme Award and was
made an Honorary Research Fellow at University College
London. He has contributed regularly on twentieth-
century art to the *Times Literary Supplement, Burlington
Magazine, Artscribe, London Magazine* and *Modern Painters*,
among others. Trained at the Slade School of Fine Art, his
work is in several public collections, including the British
Museum, the Arts Council Collection, the Contemporary
Art Society and the Museum of London.

WORLD OF ART

This famous series
provides the widest available
range of illustrated books on art in all its aspects.
If you would like to receive a complete list
of titles in print please write to:
THAMES AND HUDSON
30 Bloomsbury Street, London WC1B 3QP
In the United States please write to:
THAMES AND HUDSON INC.
500 Fifth Avenue, New York, New York 10110

Printed in Italy

Timothy Hyman

169 illustrations, 50 in color

THAMES AND HUDSON

For Judith Ravenscroft

© 1998 Thames and Hudson Ltd, London

First published in the United States of America in 1998 by
Thames and Hudson Inc., 500 Fifth Avenue, New York,
New York 10110

Library of Congress Catalog Card Number 97-61113
ISBN 0-500-20310-5

Printed and bound in Italy

Contents

Introduction

'ONE DOES NOT ALWAYS SING OUT OF HAPPINESS'

Whether it occurs in a Paris street, or walking along a steep path above the Mediterranean, or in a bathroom, where a loved partner spends most of her days, one experience remains constant throughout Bonnard's art: a sudden, revelatory moment of seeing, opening out of a familiar everyday life. Part of Bonnard's inheritance from late nineteenth-century French painting was a focus on the 'little sensation'; he developed novel procedures that allowed him to register the most fluid and transitory perceptions. Yet what makes his art so original, especially after 1920, is its radical subjectivity – the presence of Bonnard himself as a kind of authorial presence within the image. 'Let it be felt that the painter was there', he wrote in 1937. Sometimes he is present in person; more often, we are led by the construction of the space to experience the world through his own eyes, more explicitly than in any painter ever before.

In my first two chapters, Bonnard is still working within a lively metropolitan culture; I will explore his interaction not only with fellow-painters, but with Symbolist poetry (centred on Mallarmé) and with Montmartre anarchism (mediated chiefly through Fénéon and Jarry). Chapter 3 and 4 cover the difficult transitional years, when, bypassed by Modernism, Bonnard develops his own very individual working procedures, in a complex dialogue with Monet and with Impressionism. Then from 1925 to his death in 1947 – my final three chapters – Bonnard is increasingly isolated, based in a small house far from Paris, living beside a sick wife, yet creating what are now generally agreed to be his culminating pictures.

In making my selection from more than 2,000 paintings, I find the works I most admire are usually around the four- to six-foot scale. (Much larger, and intensity tends to be lost; much smaller, and they often dwindle to a less significant picture-making.) This is not quite a public scale, yet neither is it typically domestic; it is about twice that of the usual Impressionist landscape. The defining pictures in this book, such as *Man and Woman, Dining-Room in the Country, The Bowl of Milk* and the

7

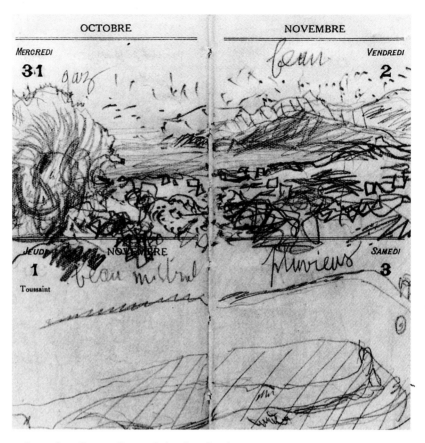

OCTOBRE — NOVEMBRE

MERCREDI
31

VENDREDI
2

JEUDI
1
Toussaint

SAMEDI
3

1 Pages from Bonnard's *agenda* (pocket diary), 1934

Bathroom nudes, are all at this quasi-monumental scale, holding the wall with a kind of intimate majesty. They might be described as Altarpieces, even if their cult is that of Bonnard's private epiphanies.

How should we place Bonnard's work in terms of the traditional genres of painting? In Still-Life and Landscape, Nude and Interior, and in the genre we call 'Genre', surely among the highest of this century; less secure in Portrait, though he stands, with Beckmann, as the most compelling self-portraitist of modern times. He attempts, but does not always succeed in, several large Mythologies. But what is the genre of the many Bonnards — some of the most memorable — that do not fit any of these categories? A term like Figure Composition seems absurdly inadequate when faced with *The French Window*. Here, as in the Bathroom pictures,

8

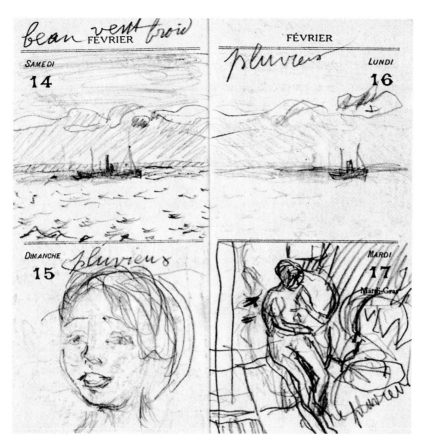

2 Pages from Bonnard's pocket diary, 1931

Bonnard registers a moment, intensely seen and intensely felt; and his subject is precisely that registering, in all its complexity.

From about 1920 onwards, nearly all Bonnard's paintings have their origin in one or more small and very swift drawings. These little sketchbook leaves are extended by his practice of filling in each day his *agenda du mémorial de poche*, or pocket diary – a tiny divided half page, in which he notes the weather (*beau* or *brouillard* or *nuages* – 'fine', 'foggy' or 'cloudy') accompanied by a small pencil image. We have an entry for almost every day from 1927 to 1947; sometimes his resumé of a work in progress, sometimes the earliest imprint of a moment of seeing. This organic daily accumulation of emblematic images is close to the core of Bonnard's activity.

Today we know far more than most of Bonnard's contemporaries about the circumstances of his life; about his frequently tormented relationship with Marthe, and about his involvement in the 1920s with Renée Monchaty, and its tragic consequences. Yet, fifty years after his death, much still remains mysterious. Few letters have been published, and there is no biography. We have some pages of *Notes* from his later years, but no equivalent to the journals of his friends Vuillard and Vallotton. Likenesses of him exist by Redon, Gauguin, Vuillard, Vallotton and others, and there are several memorable photographs; yet the image of the man is surely most vivid in Bonnard's own late self-portraits, where the head is nearly always in darkness.

Anyone who surveys the accumulated mass of writing on Bonnard will realize that there is little general agreement. Even the dating of individual pictures may differ by a decade or more. Critical interpretations are no less divergent. Many Bonnards are at large in the world. There is the perceptual Bonnard of Jean Clair and the topographical Bonnard of Sargy Mann; but also the neo-Rococo, almost frou-frou Bonnard of Annette Vaillant. There is Bonnard the joyous picture-maker, uncomplicated celebrant of the good life, who is the subject of so many monographs; but there is also the distressed, desperate Bonnard conjured by the American painter Eric Fischl, and, more subtly, in Gabriel Josipovici's novel based on the Marthe/Pierre relationship, *Contre-Jour* (1986). From the essays of Patrick Heron, Bonnard emerges as the formal master of patterned structures; and we have Bonnard the creator of Proustian (or Bergsonian) memory-images, particularly convincing in the writing of Julian Bell.

Each of these contested interpretations can help us to acknowledge the many-sidedness of his complex art. But his special contribution to twentieth-century painting may be his use of space. The manipulation and reinvention of pictorial space, as a central carrier of intensely felt emotion, occurs in only a few twentieth-century painters. Kirchner and Beckmann both offer something of this. But I think Bonnard does it more exactly, with more feeling, than any other artist of recent times. He shows us how a painting may have a witty space, a tender space, a joyous space, a troubled space: a space at every point charged with and expressive of human emotion.

As a young man, along with so many other 'advanced' painters towards the end of the last century, Bonnard began by embracing flatness. Subsequent avant-garde painting has almost uniformly denied us entry into perceptual space. A door closed; and meanwhile, the new medium of cinema flourished, seeming to supersede all painterly attempts to move

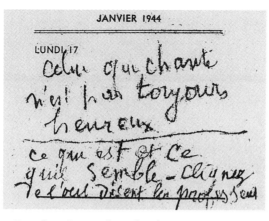

3 Page from Bonnard's pocket diary, 1944

the spectator about in space. Painting stayed flat, until its flatness became, for some, the very mark of its identity. My theme, in much of what follows, is how Bonnard almost alone in his time reopened that door, and especially in his later compositions, offers the wonderful possibility of a renewed spatial penetration, with all that could mean for the painting of the next century.

I have never forgotten the impact of the enormous Bonnard retrospective at the Royal Academy in London in 1966, when I was a twenty-year-old art student. I had expected to find a painter of modest domestic pleasures – of gingham table-cloths and garden repasts, of charming pets and pretty women. This was the Bonnard whose name, as early as 1912, was rhymed with *bonheur*; and of whom his nephew Charles Terrasse wrote shortly after his death that he 'wished to paint only happy things'. Yet what hit me instead was a painter of the most poignant psychological insight, whose perceptual and spatial invention matched the complexity of his emotional resonance.

Over the subsequent thirty years, that more compelling and disquieting Bonnard has come to dislodge the earlier reputation. By 1984, when Jean Clair mounted in Paris another major Bonnard exhibition, he emphasized the (often anguished) later works – the bathroom scenes and the self-portraits (not forgetting *The Circus Horse*). In the square outside, across the Centre Pompidou, hung a banner with a quotation from Bonnard's *Notes*: 'Celui qui chante n'est pas toujours heureux' ('One does not always sing out of happiness'). We have learnt that however radiant or refulgent in colour, however lyrical in expression, the art of Pierre Bonnard provokes complex responses.

4 Bonnard *c.* 1892. Photograph by Alfred Natanson

Flatness and the Floating World

Throughout his life, Pierre Bonnard felt the impact of two early and interrelated encounters – with the paintings of Paul Gauguin (1848–1903), and with Japanese woodblock prints. Both pointed towards an aesthetic of flatness. In a photograph of Bonnard's studio taken shortly before his death, we can make out tacked to the wall a Japanese print, together with a postcard of Gauguin's manifesto-picture of 1888, *La Vision après le sermon* (The Vision After the Sermon). Gauguin repudiated the landscape-naturalism that had dominated so much recent French art: 'Painting must return to its original purpose – the examination of the interior life of human beings.' *The Vision* offers almost a recipe for uniting interior and exterior worlds; the field of flat red allows Gauguin's unspoilt Bretons to experience the real-life cow alongside Jacob wrestling with the angel, all rendered together into symbol, literally 'on the same plane'. For the heirs of Gauguin – for Munch, Matisse and Bonnard among so many others – flatness would become a kind of short cut to the interior.

This gospel of flatness first reached Bonnard as a twenty-one-year-old, at the Académie Julian in Paris in the autumn of 1888. His fellow-student Paul Sérusier (1863–1927) had been indoctrinated by Gauguin in Brittany that summer. Fuzzy naturalism must be renounced; every pictorial element – strong colour, defined shape, emphatic line – should drive the image towards a 'synthesis'. Gauguin painted *The Vision After the Sermon* in Brittany in late September 1888, and in October it was already at Goupil's (the gallery managed by Theo van Gogh on the boulevard Montmartre) where there is every reason to suppose Bonnard and his circle of young Parisian art students saw it. They began to construct a kind of mock secret society, looking to Gauguin as their absent leader. The little cigar-box lid which Sérusier had painted under Gauguin's instruction became a cult-object, known as 'The Talisman'; the ordinary room where they often met was 'The Temple'; they themselves became 'Nabiim' – that is, in Hebrew, prophets, or reformers, or messengers.

But of all the Nabis, Bonnard was perhaps the most secular and worldly, the least receptive to the aura of archaic revivalism that attached itself to Gauguin and Brittany. Whereas Gauguin's denial of space was taken by

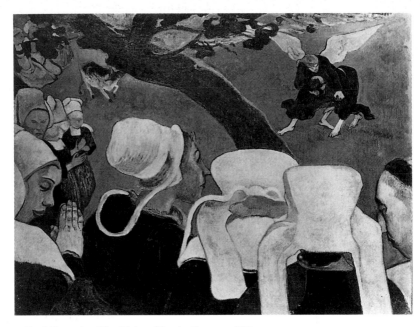

5 Paul Gauguin, *The Vision After the Sermon*, 1888

most of the Nabis to imply transcendence of the everyday world, flatness would become for Bonnard a means by which to grasp it all the more firmly. In April 1890, after several months of military service, Bonnard returned to the Ecole des Beaux-Arts, to find installed there a vast exhibition of over seven hundred Japanese prints. This proved an even more decisive encounter than with Gauguin's work (whose flatness owed much, in any case, to Japan). Bonnard began to collect: 'I covered the walls of my room...To me Gauguin and Sérusier alluded to the past. But what I had in front of me was something tremendously alive...' The subject-matter of the Japanese printmakers was *Ukiyo-e*, the 'floating world' of ephemeral and fugitive experience, centred on the pleasure quarter of the city of Edo. Yet in making their imagery of street and journey, of spectacle and theatre, of prostitutes and amatory adventures, they used a medium of absolute fixity: the hard linear cutting-out of the woodblock. This was exactly the paradox from which Bonnard's art would take its cue. Flatness can concentrate and essentialize the fugitive

6 Bonnard's studio wall at Le Cannet, 1946. Visible are Gauguin's *Vision After the Sermon*, Seurat's *Bathers* (see p. 106), Monet's *Morning* (p. 103), Bonnard's *The Window* (p. 130), a recent Picasso (p. 186), and some sweet wrappers (p. 155).

14

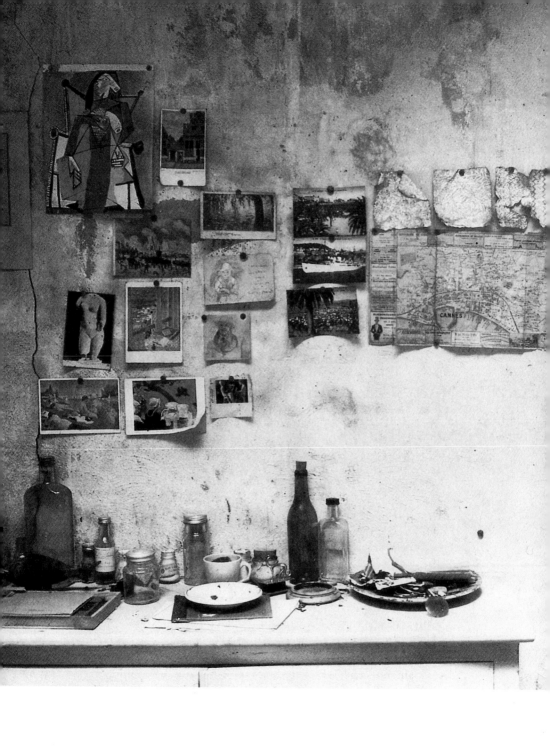

moment, and the colour woodblock presented Bonnard with an astonishingly inventive and flexible language. 'I realized that colour could express everything...That it was possible to translate light and shapes and character by colour alone.'

By 1892, when Bonnard completed his first large and ambitious composition, the over five-foot *La Partie de Croquet* (The Game of Croquet), Gauguin and Japan had both been assimilated. The subject is a family group with his sister Andrée the central player, and his father, in deer-stalker hat, the grizzled profile nearest to us. Perhaps the original title, *Crépuscule* (Twilight), would seem to promise some more atmospheric image than this stylized patchwork, these clumps of fretted foliage so insistently flattened into cut-out shapes. Yet as we look longer, the areas of gold sky, bursting through the prevailing greens and browns, do create a mysterious, 'poetic' mood. *The Game of Croquet* turns out to be a young man's internalization of Gauguin's *Vision*, but secularized, and patterned 'in the Japanese manner'. In place of those pious foreground Bretons, we are plunged here among garden shrubs and elegant modern people at play. Behind them, in a glade of *jeunes filles en fleur* (Proust's *Budding Grove*) silhouetted against the encroaching night, the wings of Gauguin's wrestling angel are transposed, almost wickedly, into the fluttering arms of a romping girl.

Pierre Bonnard was born on 3 October 1867, the second of three children, in Fontenay-aux-Roses, a suburb of Paris. Both parents were from the provinces: Eugène Bonnard from the Dauphiné (where each summer the family would return to roots); Elisabeth, née Mertzdorff, from Alsace (the disputed region which through much of Bonnard's life was part of Germany). At the age of ten, Pierre was sent away to boarding school, and then attended two élite Paris lycées. By his late teens, having passed his baccalauréat, he was enrolled at the Faculty of Law, and his feet set on the conventional path marked out for him by his father, a civil servant who would rise to be *chef de bureau* at the Ministry of War.

But Bonnard, in his holidays in the Dauphiné, had begun to paint in the open air. Back in Paris, he spent much of his spare time at the Académie Julian, an informal art school where students drew and painted from the model with the minimum of instruction. It was seen as a stepping-stone to the more traditionalist Ecole des Beaux-Arts, but also as a liberal alternative; several students, including Bonnard himself, chose to attend both. The twenty-year-old seized on art, as he later recalled, partly as a way of dodging a Civil Service career.

I am not sure whether the word 'vocation' exactly applies to me. What attracted me then was less art itself than the artist's life, with all

16

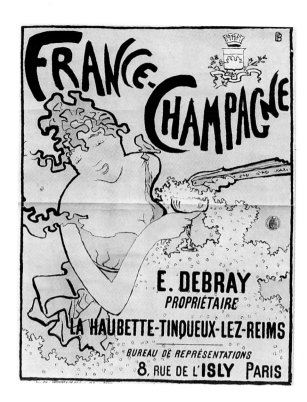

7 Poster for France-
Champagne, 1889

that I thought it meant in terms of free expression, of imagination and
liberty to live as one pleased…I wanted, at all costs, to escape from
a monotonous existence.

He now pursued two parallel lives: one in law firm and registry office,
culminating in his failing his Civil Service exam in 1889; the other at art
school, where he soon met the two closest friends of his life, Edouard
Vuillard (1868–1940), and Ker-Xavier Roussel (1867–1944). Bonnard's
earliest paintings had been the work of a talented amateur, fresh and true
in tone, but rather anonymous. Now, with the excitement generated by
a vortex of like-minded friends, and the impact of Gauguin and Japan, a
more distinctive identity began to emerge.

In 1889 Bonnard won first prize in a competition for a poster advertis-
ing a popular brand of champagne. A jolly young woman tips her glass
towards us; the entire surface fizzes. His design for France-Champagne
would not be published until 1891, but it pushed him towards the key
medium of colour lithography. More importantly, at this difficult

8 *The Game of Croquet*, 1892

moment, the 'glorious event' earned the young artist his first hundred francs, and his mother wrote of his father 'enchanted' at the news, dancing out in the garden. A sceptical bourgeois was persuaded to back his second son in an uncertain calling. Bonnard had escaped.

THE NABI PATCHWORK

The circle of young comrades-in-art to which Bonnard was now affiliated met formally at their 'Temple' in Ranson's studio – sometimes in full mystical garb – once a month; and informally, for beer and sandwiches, most Saturday afternoons. The Nabis' apostolate eventually numbered twelve (Bonnard, Denis, Ibels, Lacombe, Maillol, Ranson, Rippl-Ronnaï, Roussel, Sérusier, Vallotton, Verkade, Vuillard) and they were occasionally joined by musicians and other associates, and sympathetic elders such as Odilon Redon, as well as – when not in Brittany or the South Seas – Gauguin. The group were united by their sense of the possibilities of

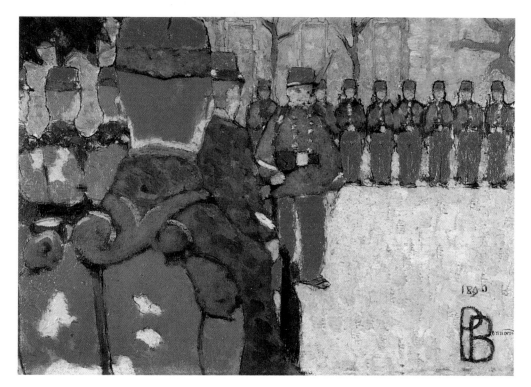

9 *On the Parade Ground*, 1890

Gauguin's 'synthesis', by his reaching beyond style towards some more primal and fundamental condition of image-making. As Maurice Denis (1870–1943) would recall, 'Nobody was teaching us anything at that time, and the secret of Gauguin's ascendancy was that he put before us one or two very simple ideas, and that those ideas were true, and that they were just what we needed. The idea of copying nature had been like a ball and chain for our pictorial instincts. Gauguin set us free.' The Nabis spoke of their own work as 'icons'. This was a moment when the canon of Western tradition was being reassessed; when the so-called Primitives – early Italians and Byzantines – began to seem more exemplary than any Classical or High Renaissance ideal. At the end of the century, after so many academic and realist conventions had become unworkable, there opened a new vista – a kind of transcultural vernacular. Gauguin himself had prepared an album which juxtaposed Giotto, Hokusai and Daumier. He painted, he explained, 'with no other thought in mind but to render, the way a child would, the concepts formed in my brain, and to do this

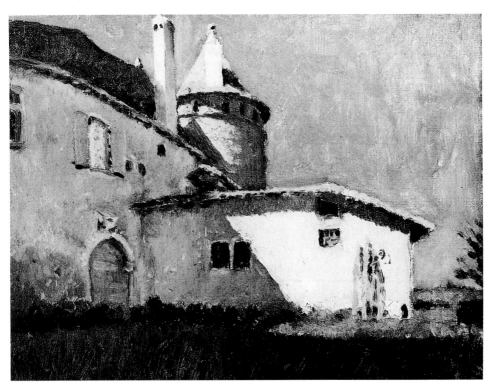

10 *House with Tower (near Le Grand-Lemps)*, 1888

with nothing but the primitive means of art, the only means that are good and true'.

In 1890, Denis (at twenty the youngest of the Nabis) published their theoretical underpinning. He starts out with a famous assertion of the autonomy of colour and line, independent of its representational function. 'Remember that a painting – before being a battle horse, a nude woman or some anecdote – is essentially a flat surface covered with colours arranged in a certain order.' *Patches of Sunlight on the Terrace* shows Denis at his most explicitly patchwork-doctrinaire. The tendency in Gauguin's work, characterized as *cloisonné* (from *cloisons*, partitions; the process by which coloured enamel is poured into a raised metal enclosure or 'setting'), is here taken to its very limit; red, green, black, orange, all pitched to absolute purity and flatness.

Bonnard and his comrades would need to unlearn much of their academic training. Vuillard in his journal (26 November 1890) writes of his

20

difficulty in ridding himself of the habit of tonal gradation and shading, the very foundation of his 'detestable education'. Now he must begin 'to see form simply as flat silhouette'. Yet, as both Gauguin and Japanese art had shown, flatness need not rule out spatial illusion. In Bonnard's little *La Revue* (On the Parade Ground) of 1890, recalling his military service of the previous year, the blue-and-red ranks are invaded in the foreground by yellow blobs, as though sunlight had sewn patches on the uniforms; yet all this flat pattern is set within a space that powerfully asserts his (or our) own place in the scene. We find ourselves both blocked, and pulled close in; with hindsight, much of Bonnard is prefigured in this tension. 9

The little panel, barely a foot high, of *Deux chiens jouant* (Two Dogs Playing), hilariously exploits the comic potential of ragged, manic silhouette. The Nabis are known to have attended the shadow cabarets at the *Chat Noir*, designed by such Montmartre caricaturists as Steinlen and Caran d'Ache, where disreputable silhouetted street-dogs were frequently part of the shadow-cast. But Bonnard's animals are more formalized, and more emblematic. *Two Dogs* started out as one of four painted doors designed for an elaborate cabinet; we might see them as transmogrified Japanese lacquer dragons, but still retaining a wonderfully vivid and sympathetic canine identity. 16

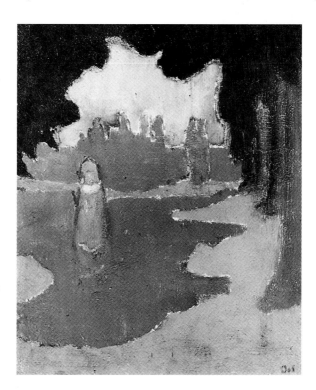

11 Maurice Denis,
*Patches of Sunlight on
the Terrace*, 1890

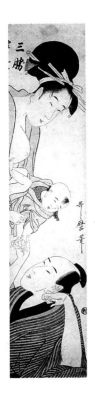

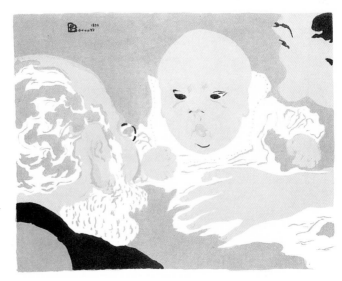

12 Kitagawa Utamaro, *Sankatsu and Hanhichi with their Baby, c.* 1790

13 *Family Scene,* 1892

14 *Nannies Out for a Walk, Frieze of Carriages,* 1894

15 *Nannies Out for a Walk, Frieze of Carriages* (lithograph), 1899

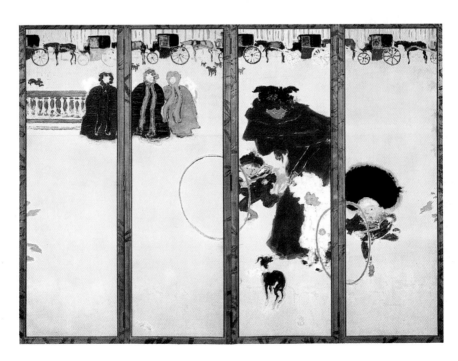

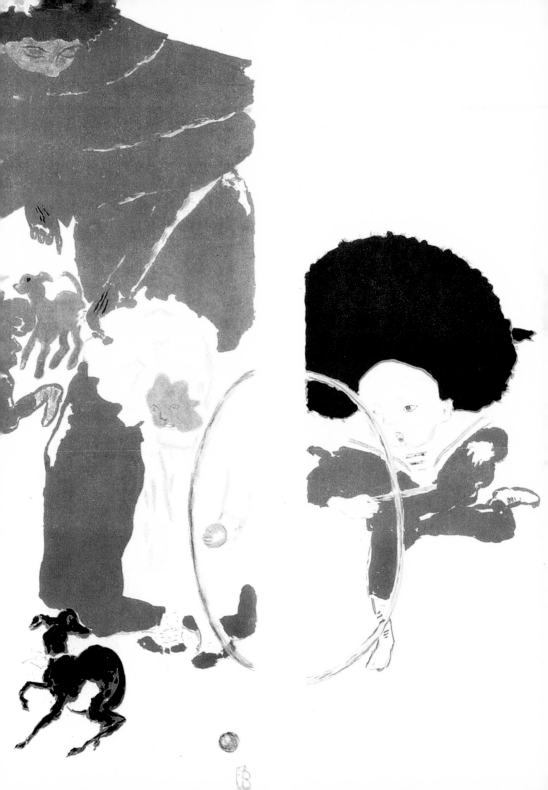

'Painting must, above all, be decorative', Bonnard declared in his first interview. It was part of the Nabis' aspiration to move 'beyond' easel-painting and picture-making. As Bonnard later recalled, 'Our generation always sought to link art with life. At that time I myself envisaged a popular art that was of everyday application: prints, fans, furniture, screens...' His involvement with poster design was an aspect of this wider quest. When *France-Champagne* first appeared on the streets in 1891, colour lithography had as yet scarcely been used by a 'serious' artist, and it was the success of Bonnard's poster that would steer Toulouse-Lautrec towards the new medium. For Bonnard also it would be central, and by 1902 he had completed more than 250 lithographs. The stone offered the nearest Parisian equivalent to the woodblock – popular and artisanal in character, and similar in procedure. Four separate stones would be need-

13 ed for *Scène de famille* (Family Scene, 1892): three for the delicate brown-ochre-pink harmonies, and one more, almost empty, for the crucial accents of black. This analytical procedure influenced Bonnard's whole attitude to colour. 'I have learned a great deal about painting from making coloured lithographs. When one sets oneself to study the rapports between colours, by exploring the interaction between only four or five – overlaying, or juxtaposing them – one makes a host of discoveries.' *Family Scene* marvellously evokes the comedy of infancy: the huge squinting helpless head suspended so close to us, framed by the doting adults (the artist's father and sister, with her son Jean Terrasse). The extreme formal elegance is close to Japan, yet compared to the Utamaro print which is one of its probable sources, Bonnard is much the funnier, more imbued with naïve caricature, with the comical strangeness of the child's experience. The 'primitive' style is here at one with his subject-matter; so many of his finest Nabi images embody animals or children. As Denis recalled, 'The critics used to charge us with being infantile. It was true. We were children once more, acting like fools; and that was perhaps the moment when the best work was done...'

In 1894 Bonnard completed an early masterpiece, *Promenade des nour-*

14 *rices; frise de fiacres* (Nannies Out for a Walk; Frieze of Carriages) – a folding screen, five feet high and seven long, painted in the distemper technique he had recently learned from working in the theatre. A letter establishes the setting as place de la Concorde 'when it is dusty and resembles a little Sahara'. The cab-rank and attendant stray dogs, and the equally formalized nannies and balustrade, suggest a very well regulated leisure; yet into the 'desert' that opens up below there suddenly intrudes a circle; then across the fold, in astonishingly mobile silhouette, children, dogs, hoops rush at us all together. The design jumps the breaks in the

16　*Two Dogs Playing*, 1891

screen with an effect close to cinematic shuttering – Lumière's first pub-
lic showing would take place in Paris a year later – and marvellously fuses
an instant of modernity with a homage to Japan. Some of Bonnard's ear-
lier vertical panels had seemed forced and stylized, so near to their
Japanese sources as to verge on pastiche. But here (partly through his
visual rhyming of the young mother's layered Parisian mantle, with the
stepped silhouette of samurai armour) Bonnard conjures a genuine affin-
ity with the world of the woodblock masters. Essentially a graphic image,
it could easily be translated onto five large lithographic stones, and by 15
1896, the screen was on sale in an edition of 110.

Bonnard's Paris was always centred on the area at the foot of Montmartre – the streets and public spaces of Pigalle and Clichy. In the 1890s the Butte had a distinct identity; if the Right Bank represented money, and the Left intellect, then Montmartre was a third realm, of imaginative freedom as well as of sensual pleasure, outside the city boundaries. (Its affinity to that licensed pleasure quarter of Edo, represented in so many Japanese prints, was sometimes noted.) Montmartre was an artist's quarter: Degas, Renoir, Toulouse-Lautrec, Seurat, Signac and Van Gogh had all worked there. But it was also the nexus for the new libertarian politics of anarchism, often conceived as a 'free city', a cloud-castle floating above Paris.

Bonnard participated in this libertarian milieu. Several of the individuals and institutions that shaped his art in these years – *La Revue blanche*, the Théâtre de l'Oeuvre, Fénéon, Jarry – were directly associated with anarchism. Following the abortive coup of General Boulanger in 1889, anarchy had become a fashionable creed; with the Republic discredited, all systems of organized government were widely seen as corrupt and unworkable. In Zola's panoramic novel of the 1890s, *Paris*, the city is spread out as a battleground of anarchist and socialist utopias, viewed from the perspective of Montmartre. Anarchism could mean bomb-throwing terrorists; but among artists it was more likely to signify their hope of a new dispensation – a return to the Golden Age. In the words of the historian Richard Sonn, 'all of anarchism played upon the desire to escape from historical time and to enter the future paradise that would cyclically return men and women to their primal innocence and goodness.'

This is the vision implicit in much of Gauguin's work, and embodied most conclusively by Paul Signac (1863–1935) in his large public decoration of 1894, *Au Temps d'harmonie* (In the Time of Harmony), whose full title reads: 'The Golden Age is not in the Past, it is in the Future'. Following the lead of his friend Seurat (who had died in 1891) Signac attempted to rescue the pastoral from the classical nude – from the reactionary and nostalgic genre exemplified by Ingres. Signac imagines a kind of post-urban future, in modern dress, where work is present (digging, sowing, laundry – and even painting) but where existence is above all the enjoyment of leisure: bowls, dancing, love-making. The distant locomotive is so marginalized as to be no more than a token. Echoes of this millenarian dream will be heard in French painting well into the twentieth century, in the Matisse of *La Bonheur de vivre* (The Happiness of Living)

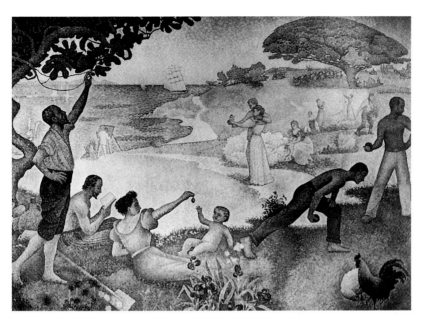

17 Paul Signac, *In the Time of Harmony*, 1894

and *La Danse* (The Dance), and in Bonnard's large mythological decorations. But in his case the Golden Age becomes fused with another early enthusiasm: his visits with Vuillard to see the great fifteenth-century *millefleurs* tapestries at the Musée Cluny. That paradisal wallpaper became the model for the all-over surface of many Nabi pictures, and it remained with Bonnard all his life.

The complexity of interaction between Symbolist art and ideology becomes evident when one examines the early career of Bonnard's life-long friend, Félix Fénéon (1861–1944). In 1892, reviewing the Salon des Indépendants, he comments teasingly: 'Bonnard, très Japonard'. The phrase caught on, as a kind of honorific; Bonnard became the 'very Japanesy' Nabi. Fénéon's own achievement was already substantial. By day he worked, like Bonnard's father, in the Ministry of War; but he found time for a tireless literary activity. It was Fénéon who had first edited Rimbaud's *Les Illuminations* in 1886; and who had become, in articles and monographs, the most eloquent champion of Seurat and Signac, coining the term 'neo-Impressionism'. He also planned a volume on Japanese prints. But after 1892, he ceased to write on art. His focus had shifted. Fénéon perfected a new anarchist journalism, made up of

anti-authoritarian snippets; for example: 'The Japanese who have had such a positive influence on our painting, would that they could influence our political ways! Yokohama, 23 May 1892: one thousand residents refuse to pay their taxes.' He wrote in support of terrorism, whose function was 'to awaken our contemporaries from our torpor'. By April 1894, when Fénéon himself was arrested (detonators had been found in his work-space at the Ministry of War), eleven bombs had exploded in Paris in the previous two years. Opinion remains divided as to whether Fénéon was himself a bomber, but he was certainly an associate.

His brilliant self-defence at the 'Trial of the Thirty' made him a celebrity; jobless after his acquittal, he accepted a post at the *Revue blanche* – a magazine already identified in a police report as 'the most important source of literary anarchism'. A monthly founded in 1889, it aimed to be 'white' in the sense of white light – to bring together the entire spectrum of contemporary talent. Bonnard contributed his first drawing in 1892; over the following decade the magazine would publish images by Vuillard, Toulouse-Lautrec, Munch, Vallotton, Denis, Redon, Whistler, Sérusier and Gauguin. The literary roll-call was equally impressive: Proust, Gide, Valéry, Verhaeren, Péguy, Jarry, Claudel, Apollinaire all published early work, with Debussy as music critic, and Mallarmé as presiding elder.

The proprietors were three rich Jewish brothers, the Natansons; all would become significant patrons for Bonnard, and Thadée Natanson (1868–1951) a close friend, completing an important memoir, *Le Bonnard que je propose*, just before his death. Thadée had attended the Lycée Condorcet, along with many of the Nabis, and then trained as a lawyer. In 1893, he married Misia Godebska, a gifted pianist who had been a favourite pupil of Fauré, and now used her new influence and money to create around her a kind of cultural circus. For the next ten years, Bonnard's life could be said to have revolved around Misia and Thadée. He accompanied them to dinner and theatre; he stayed with them for weeks on end in their country retreat (where Mallarmé was a revered neighbour). Bonnard carried out the Natansons' decorative commissions, and designed all kinds of material for *La Revue blanche*, which in turn promoted his reputation. Misia was muse or lover to many artists in the course of her long life; the fascinating salesgirl-vamp who looks out from Bonnard's wintry poster for the *Revue blanche* of 1894 – a variant of that 'very Japanesy' mantled woman already encountered on his screen – has sometimes been identified with her. Now she is embedded in words; the foreground letters seem to jump with excitement, sung out by the gamin-newsboy, who jerks his thumb towards them. Behind her,

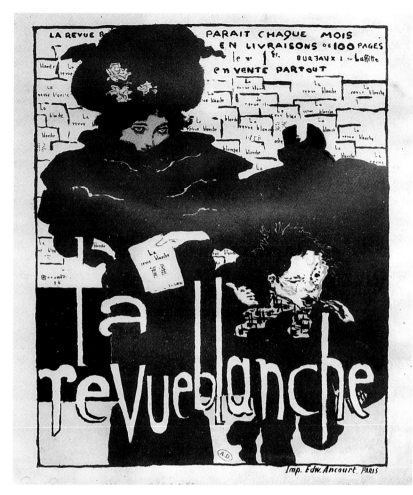

18 Poster for *La Revue blanche*, 1894

what appears at first to be a winged bat resolves itself, with difficulty, into a top-hatted boulevardier.

From February 1891, Bonnard, Vuillard and Denis shared a studio 'as big as a handkerchief' in the rue Pigalle, together with the young actor Aurélien Lugné-Poë. Lugné remembered Bonnard as 'the humorist among us; his nonchalant gaiety, his wit was evident in his pictures, where a satirical element was always implanted in the decorative'.

Of Bonnard's intense engagement in avant-garde theatre, little now remains. He participated with Lugné and Vuillard in the amateur-based Théâtre Libre, and in the Théâtre de l'Art, founded by the eighteen-year-old Paul Fort. In October 1893, Lugné opened his own company, the Théâtre de l'Oeuvre, in the première of Ibsen's *Rosmersholm* (designed by Vuillard and Sérusier, assisted by Bonnard among others). The Oeuvre was a subscription theatre, and each performance was preceded by a lecture; it was characterized by a police informer as an 'anarchist literary society'. They soon ran into trouble; a Hauptmann play (in Fénéon's translation, and designed by Vuillard) was closed by public order.

The excitement of working in the theatre was that of a collective activity; long hours were spent together covering huge backdrops, attending rehearsals, and later, creating a puppet-theatre also. (When Bonnard remembers the scene in a drawing of 1910, he shows himself actually fashioning the marionettes.) Less easy to define is what Bonnard received from all this, as a painter; perhaps a sense of pictorial space as a stage, and the placing of figures – actors, puppets – within each space, as a kind of staging; while the table-top, in so many of his pictures, might be seen as a miniature stage. In 1894 Lugné toured his company in Scandinavia, and made a pilgrimage with Thadée and Misia to meet Ibsen in Norway. Ibsen's example may have been especially suggestive to both Bonnard and Vuillard, as their art began to pull away from the other Nabis; a symbolist, but whose 'poetic dramas' take place in a contemporary social and psychological setting, the 'interior life' unfolding within the bourgeois interior.

FUGITIVE BEAUTY

A new subject-matter, a new attitude to the street, appeared among painters in Paris in the mid-nineteenth century, embodying the experience of the *flâneur* – solitary in the street, aimless, enjoying the spectacle for its own sake. Baudelaire, in *The Painter of Modern Life*, proposed an art that would mirror not only the passing moment, but 'all the suggestions of eternity that it contains'. The *bon bourgeois* was hard-working, but the *flâneur* claimed that freedom defended by Paul Lafargue in a famous pamphlet, *Le Droit de la Paresse* – The Right to be Lazy. Bonnard, as a recent escapee from the Civil Service, celebrates his new-found freedom. And will continue to do so: across more than two thousand paintings, hardly anyone will ever do a stroke of work.

In his *Tableaux Parisiens* Baudelaire dedicates a poem 'A une Passante' ('To a Passer-By'):

Un éclair…puis la nuit! – Fugitive beauté
Dont le regard m'a fait soudainement renaître
Ne te verrai-je plus que dans l'éternité?
[A flash…then night! Fugitive beauty
Whose sight has made me suddenly reborn
Shall I never see you again except in eternity?]

Bonnard, in his Parisian street scenes of the 1890s, registers many similar transitory encounters. Japanese prints had suggested new ways of composing – close-ups, fragmentations – for the floating world; and from 1888, the new portable Kodak camera allowed instantaneous snapshots. (Bonnard was probably using a Kodak by 1890.) Among artists Degas had been one of the first to exploit this taking the world unawares, or impromptu; and Fénéon wrote in 1886 of his 'unerring kinematics. The tricks of artificial lights, taken by surprise. The expression of modernity'. But in Bonnard's apprehension of the passing moment, modernity would always count for less than the intimations of 'eternity'. In *L'Omnibus* 20
(The Omnibus) the vast radiant yellow wheel creates a kind of halo for the young woman; her wild silhouette locked within the golden hub, whose shafts both pierce as spears, and radiate from her, as light. An earlier apparition, *La Passante* (The Passer-By), was more wittily flat- 19
tened, in that play of negative and positive shape that is the hallmark of Nabi style – hat-feathers and cloud, hair and houses, all made to wriggle together in flattened outline, to create the delicious close-up. By contrast, *The Omnibus* is one of his first pictures where paint handling and touch take on full power. The fragile flat-mantled woman of his earlier images now hurries forward against a surface of extraordinary richness, broken and impasted, yellow upon yellow, black upon black. The flat Nabi 'icon' is given a new expressive resource, and even her little dog cannot trivialize the metaphoric resonance of this perfected emblem.

It has been suggested that all Bonnard's *Passers-By* may relate to a single street-encounter of 1893. According to Hans Hahnloser, Bonnard 'saw a young woman alight from a Paris tram, followed her to her job (sewing artificial pearls onto funeral wreaths) and persuaded her to leave her work, her family and friends, to share his life until she died in 1942.' This young woman was something of a waif, barely five feet tall; she said she was sixteen; she called herself Marthe de Méligny. Much later, Bonnard would learn her real name – Maria Boursin – and find that she was, like him, in her mid-twenties. Marthe was always something of a mystery, even to Bonnard's closest friends. As Thadée Natanson recalled: 'Fluttering, close to him, in cramped quarters, we saw that young

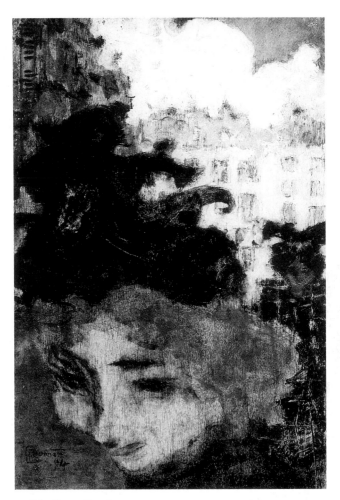

19 *The Passer-By*, 1894

woman, then still a child, with whom he spent his life. She already had, and kept always, her wild look of a bird, her movement on tiptoe'. The facts of Marthe's background are still in question. Did she, like many girls who had 'got into trouble' in the provinces, come to Paris with a new identity? Did she and Bonnard immediately begin living together? Was she already ill? In any case, Marthe would become, over the following half-century, the defining figure of his life and work.

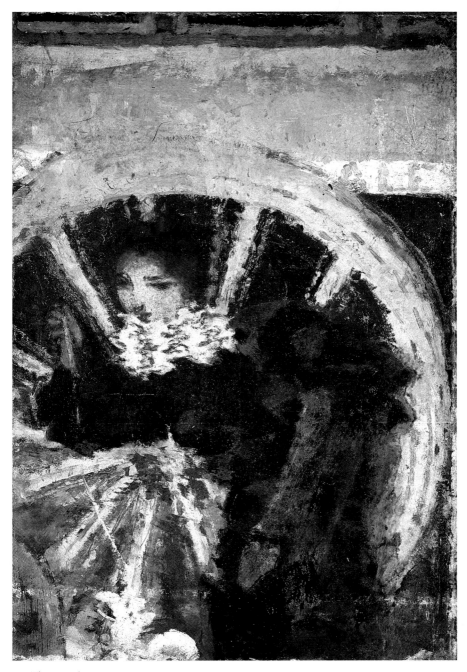

20 *The Omnibus*, 1895

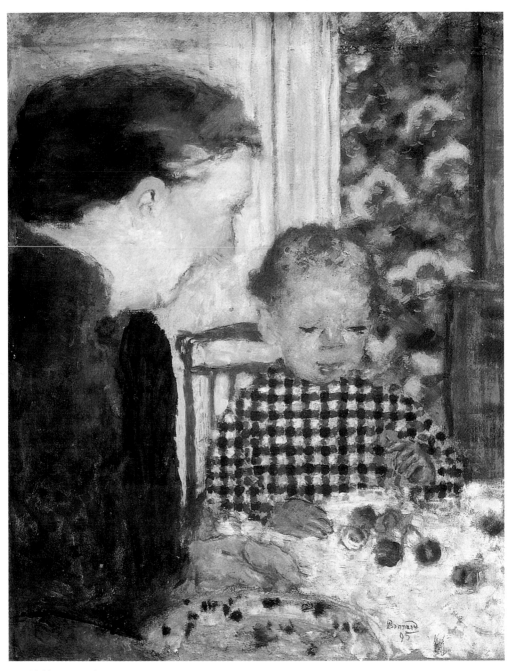

21 *Child Eating Cherries*, 1895

Intimacy and Interiority

Bonnard himself dated his first crystallization of full painterly identity to a summer in the Dauphiné in 1895. As he explained to Raymond Cogniat,

> One day all the words and theories which formed the basis of our conversation – colour, harmony, the relationship between line and tone, balance – seemed to have lost their abstract application and become concrete. In a flash I understood what I was looking for and how I would set about achieving it.

Enfant mangeant des cerises (Child Eating Cherries) was one of the paintings begun that summer. Bonnard's Alsatian grandmother, Madame Mertzdorff, is portrayed with a new naturalism, and a loose atmospheric touch, very different from the assertive flatness of his earliest Nabi pictures. Flat pattern still lingers in the little boy's blue smock, and, beneath the general air of informality, the surface is as consciously structured as ever. Yet what Bonnard has gained is a possibility of entering into the specifics of person and place with a new tenderness, unattainable within Denis's shape-making aesthetic.

This 'Intimisme', sometimes defined as a 'modified Impressionism', set both Bonnard and Vuillard apart as a kind of apostate subgroup within the Nabi circle. Naturalism had been condemned by Denis as a 'false witness'; flatness had seemed to promise a truer relation between painting and the world. But this insistent flatness was in each of the Nabis inflected very differently. In Sérusier and Denis, flatness led to wistfully disembodied friezes; for Félix Vallotton (1865–1925), the Swiss anarchist painter who had joined the group in 1893, flatness became a cynical device, allowing him to recreate society as a hard-edged formalized absurdity; while in Vuillard, Nabi flatness was, from about 1894 onward, overlaid with flurries of small wild marks. In a picture like *Misia et Cipa Godebski* (1897) pattern invades the figures and becomes a vehicle for feeling. This combination of a very deliberated underlying structure, and an unsystematized broken surface, gave Vuillard's interiors an extraordinary formal and psychological tension, allowing him to trap

22

35

extremely elusive emotions. (A painting might need to be 'formal' in structure, in order to be 'informal' in its social atmosphere.) Bonnard, in his own interiors, is occasionally so close to Vuillard as to be nearly indistinguishable; yet he created no parallel in the 1890s to Vuillard's magnificent sequence of large-scale *décorations*. (By contrast with the large easel painting, or *machine*, a *décoration* was designed to enhance the walls of a specific room.) Vuillard had been from the outset the more experimental and formally daring, and now emerged as by far the more achieved, painter.

When Bonnard returned to Montmartre he found a rift opening between those Nabis who saw their art as a religious quest, and those who shared his own secular emphasis. Sérusier was about to adopt a cranky aesthetic-mystical system invented by Father Desiderius of Beuron; Verkade had already succumbed to those 'holy measures' and become a monk. Denis reproached Bonnard, along with Vuillard and Vallotton, for moving away from the Nabis' collective ideal, towards 'individualism', whereas he was drawn more and more to an art built on classical foundations. In Rome, thrilled by Raphael, Denis wrote to Vuillard: 'I know of no atmosphere so far removed from Impressionism'. But in a famous and very moving reply, Vuillard declares his 'horror, cold fear, of general ideas that I have not arrived at by myself'. A recent crisis had clarified that his own paintings must be made without such props: 'There was in my life a moment in which, either through personal weakness, or through a lack of solidity in my basic principles, everything was demolished... A sort of intimate whirlwind took over. The only guide left to me was instinct, pleasure, satisfaction. The area in which I was quite certain of anything got smaller and smaller; all I could do was the simplest possible kind of work. Luckily, I had good friends. They helped me to believe that simple accords of colour and form could be meaningful in themselves... And I allowed this to be called my work.'

Two intellectual influences endorsed Bonnard and Vuillard in their adherence to an art built upon fragile and fugitive sensations, vulnerable to uncertainty. There is evidence that the Nabis discussed together the ideas of the philosopher Henri Bergson (1859–1941) and especially his essay of 1889, *Essai sur les données immédiates de conscience* (On the Immediate Data of Consciousness). Bergson emphasized the subjectivity of sensory experience; of consciousness always mediated through memory. We grasp the world only intermittently, through a momentary and essentially involuntary 'intuition', which Bergson defines as 'the sympathy by which one is transported to the interior of an object... its unique, and consequently inexplicable, identity'. As Bonnard moved closer to

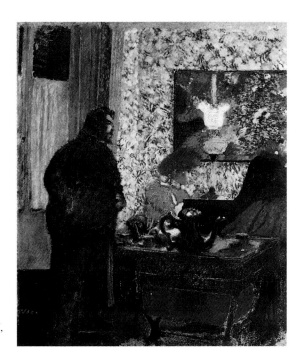

22 Edouard Vuillard,
Misia and Cipa Godebski,
c. 1897

Impressionism, Bergson's ideas contributed a helpful corrective against any too simple view of perception.

But for all the Nabis, the chief literary exemplar was not a philosopher, but a poet. Stéphane Mallarmé (1842–1897) declared in his early twenties that 'poetry should paint not the object, but the effect it produces'. By the time Thadée Natanson and Maurice Denis began to attend Mallarmé's regular Tuesday gatherings (sometimes with other Nabis in tow) the poet had emerged as the leader of that reaction against naturalism in literature which we now call Symbolism. Mallarmé saw the artist's task as a purification of language. 'One desire of my epoch which cannot be dismissed', he wrote in the late 1880s, 'is to separate...the double state of the immediate or unrefined word on one hand, the essential on the other'. And this 'essential word' is to be found by indirection, by suggestion. 'To *name* an object is to suppress three quarters of the enjoyment of the poem, which lies in the delight of gradually guessing; to *suggest* it, that is the dream.'

Part of the Nabi project was to transpose Mallarmé's poetics into a painting of suggestion; and Intimism likewise entailed a merging of the separateness of things, the recasting of the everyday as a mystery of light and pattern. Bonnard's *Breakfast by Lamplight* (1898) marvellously creates 26

an intensity and inwardness of mood, a sense of mystery that precedes any more logical reading of the scene. The yellow swirl that emanates – like some occult ectoplasm or thought-form – from the very dark oval head of the child, does not describe or 'name' the lamp, though it may convey the experience of its brightness for a half-awake little boy emerging from night. Bonnard pushes us up close to the mother (his sister Andrée, who still retains her earlier Japanese stylization); perhaps only later will we make out another child's head in the dark foreground. Across the orange table, Andrée's hand and spoon are reversed, as another, unseen, adult feeds the baby; the infant's brightly illuminated gaze turns towards us. Space has been used to force us into intimate relationship, and we find ourselves at table, part of the family, perceived through that visual blur which, in all his mature work, will signal both physical proximity and tenderness, as well as the visual uncertainties of memory, and of reverie.

Bonnard is a soft-focus subjectivist, sometimes verging on sentimentality; for an alternative Intimist meal, we can turn to Vallotton's brilliant *Dinner* of the following year, whose stooping black silhouette makes the authorial presence even more explicit. But Vallotton paints not so much the family, as the bourgeois unit, spotlit with the cruel astringency of the unblinking little girl; and his foreground self creates not closeness, but distance.

25 Of all Bonnard's lithographs *Enfant à la lampe* (Child in Lamplight), published by Vollard in an edition of 100 in 1897, is perhaps the most compelling. The five stones interact more fluidly than in the earlier 'woodblock' style, the main expanse of brownish pink scribbled into by the other colours. The lamp itself is the darkest element, a massive fan-like wedge of greenish black; while the little child's illuminated face – totally spellbound in an imagined toy-world – is conjured in just a few wonderfully fugitive airborne marks. The edge of the image is left imprecise, like a stain, and the red of the table extends far below, anticipating the uncertain edge of his later unstretched canvases.

It is hard to know what value to place, in our own lives, on those little domestic 'intuitions' or epiphanies which are Intimism's chief subject-matter. Are such moments the special prerogative of the cultivated bourgeois with time on his hands; even more, of the bourgeois wife, whose interior is her realm? Bonnard and Vuillard now went back to the great bourgeois masters of the past, to Dutch seventeenth-century interiors, with their very conscious geometrical structuring of the rectangle; and also to French eighteenth-century painting – Chardin, Watteau, Fragonard – with their more cursive painterly touch. In raising up the domestic, into

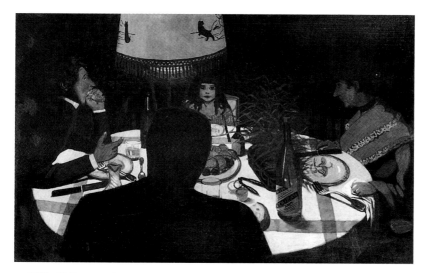

23 Félix Vallotton, *Dinner*, 1899

a kind of abstract transcendence, the two young painters were pushing beyond the bourgeois setting into a new territory of feeling, that prefigures the novels of Proust, or later, of Virginia Woolf and Robert Musil.

Mallarmé was the mystagogue of the religion of art. He aestheticized politics; he sincerely believed that the 'freedom' of the artist was the best exemplar for political life. As a witness at Fénéon's trial in 1894, he had declared: 'certainly there were no better detonators for Fénéon than his articles. And I do not think one can use a more effective weapon than literature.' In the Symbolist poetics of Mallarmé, as in Nabi theory, the autonomous language became more real than any world it might depict. But Bonnard's allegiance was to fact as well as to feeling, and by the early 1900s, he would discover just how much his own path diverged from those Symbolist beginnings.

THE RADICAL BOURGEOIS

In November 1895 Bonnard's father died. The twenty-eight-year-old artist probably inherited substantially (although his mother would live on until 1919). His first one-man exhibition was held at Durand-Ruel's in January 1896, comprising some fifty works. The warmest review came from Gustave Geffroy: 'In everything he sets down, there is a charmingly malicious individual observation, a touch of impudent gaiety.' But Camille

39

Pissarro (1831–1903) wrote to his son Lucien that the work of 'the Symbolist named Bonnard' was 'hideous in the extreme', and that 'every painter of any merit – Puvis, Degas, Renoir, Monet, and your humble servant, agreed. The show was a complete fiasco.' Pissarro had been the most politically aware painter of his generation, a committed anarchist, and he saw in Impressionism a revolutionary art. By 1891, he was condemning the new culture of Symbolism as a 'counter-revolution', as a kind of bourgeois backsliding towards the mystical and the literary, for which Gauguin was largely to blame.

Bonnard's life centred more and more on the *Revue blanche*, whose support was mostly restricted to the 'secular' Nabis. When Bonnard and Marthe stayed with Thadée and Misia for several weeks (they are seen together in front of the Natansons' country house, in a Vuillard decoration of 1898), they were in company with other painters and writers, and it became something of a utopian community. Vuillard writes to Vallotton in 1899 of the Natanson household as a *Thélème*; the reference is to Rabelais's convivial 'Abbey', where men and women lived together under only one Rule: 'Do what you want.' But Misia presided. *Le Petit Déjeuner de Misia Natanson* (Misia's Breakfast, 1896) is a composition of extraordinary wit and intelligence. Her tiny delicate face is a fragile mask; it floats, still half asleep, on a brown starry ocean of gown and hair. Blurrily, she contemplates the heaped platter of luscious fruits. Across the table, lost at first among the other still-life elements, we identify a fragmentary hand, perhaps Thadée's. As so often in Bonnard's compositions, the appearance of boneless informality overlays a steely armature. The sideboard's horizontal, a lustrous dark green bar, is interrupted by the black silhouette of the headless, aproned servant; then, further on, it meets Misia's hands, and the two vertical stripes of her long bare forearms, which support her head. The circuit is wonderfully complete.

The Intimist world is predominately feminine. As Vuillard observed in his journal entry of 27 July 1894, 'When I turn my attention towards men, I can see only infamous calumnies…It's never so in the case of women, where I always find some way of isolating a few elements that satisfy the painter in me. When I want to imagine a composition for the Natansons, for example, I can think only of feminine objects.' Bonnard's little image of Thadée, painted in 1897, borders on caricature, his raised hand the gesture of a ridiculous puppet; the effete Assyrian cousin, perhaps, of Jarry's character Père Ubu. Bonnard was chief designer for the burlesque farce *Ubu Roi* when it opened at the Théâtre de l'Oeuvre on 10 December 1896. He had first met Alfred Jarry (1873–1907) as a protégé of Fénéon's, and over the next five years he would complete more

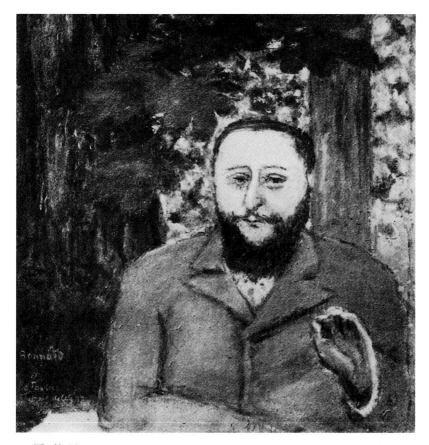

24 *Thadée Natanson*, 1897

than one hundred mordant pen drawings around the Ubu theme. *Ubu Roi* originated in Jarry's schooldays at the Lycée Condorcet, and retains the ferocity of adolescent anarchy; its first word, *merdre*, merges excrement with murder. Ubu is the ubiquitous, the archetype of the bourgeois paterfamilias in all his greed and cruelty, a kind of monstrous modern Mister Punch. In 1898 the play was given a new production for marionettes at the Théâtre des Pantins (a salon in the home of the artist's composer brother-in-law Claude Terrasse), where Bonnard took full charge of sets and costumes.

It was perhaps the infantile aspect of Jarry that drew Bonnard to him – Jarry's regression to a more primitive mode, in the tradition of Rabelais,

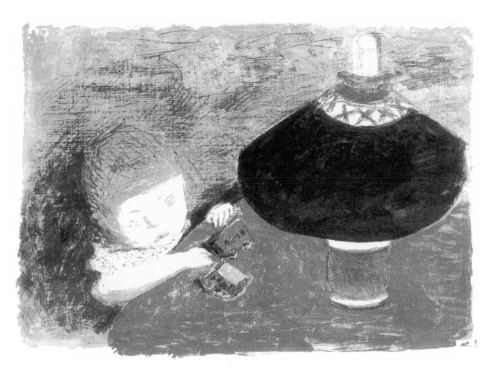

25 *Child in Lamplight*, 1897

and of carnival. From 1899 they collaborated with the publisher Ambroise Vollard on *L'Almanach de Père Ubu* (Father Ubu's Almanac), where in 1901 we find a calendar of Saints' Days, whose Observance includes St Marmalade, St Profit, St Anal, and St Giraffe, as well as the Feasts of the Copulation and the Repopulation; and at the foot of the list, Bonnard's savage little vignette – a haloed pig, leading an abject bearded worshipper on a string. A few pages later, Jarry publishes an honours list, with Bonnard at its head – Grand Cross of the Order of the Belly. (It was to be his only title; in 1912, along with Roussel and Vuillard, Bonnard would refuse the Légion d'Honneur.) As for Jarry, he died an alcoholic, aged only thirty-four; years later, Bonnard would name one of his dogs Ubu.

Bonnard's long collaboration with Jarry places him among the anti-clerical left, at a very politicized moment in French cultural life. The Natanson milieu has been characterized as combining 'social comfort and emotional dissatisfaction'. But the left/anarchist sympathies of these

26 *Breakfast by Lamplight*, 1898

27 *Misia's Breakfast*, 1896

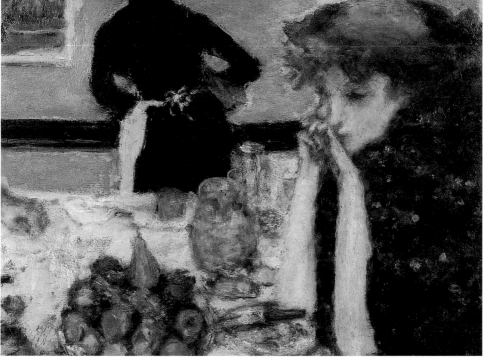

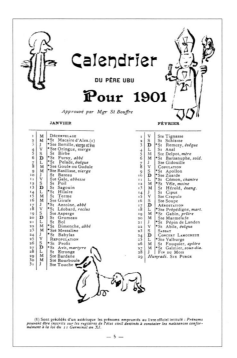

28 *Calendar of Saints Days* from *L'Almanach illustré du Père Ubu* by Alfred Jarry, 1901

boho-bourgeois should not be too easily discounted as a kind of 1890s radical chic. Bonnard and other prominent contributors to the *Revue blanche* had become representatives of a new democratic culture, led by cultivated nouveaux riches, and, often, Jews, who defended the French Republic at a dangerous moment, and who would eventually defeat the forces of reaction. Fénéon was one of the first to get wind of a conspiracy after Dreyfus was condemned in 1894; by 1898, the *Revue blanche* was an important voice in the campaign for a retrial. Thadée Natanson became one of the founders of the League of the Rights of Man; Lugné and the Théâtre de l'Oeuvre turned away from Symbolism towards a theatre of social comment. Among the Nabis, Bonnard, Vuillard and Vallotton were Dreyfusards, while Denis (whose patrons were mostly of the Catholic Right) broke off all relations with the *Revue blanche*. In his journal of 1899, at the height of The Crisis, Denis made an ugly distinction between his own art, which he called 'le goût Latin' (the Latin taste), and that of Bonnard, Vuillard and Vallotton, 'le goût Sémite' (the Semitic taste). The sense everywhere was of a world tearing itself apart.

Bonnard never again found a social milieu so sympathetic as that of *La Revue blanche* in its Symbolist heyday. It shaped him, and his subsequent art would be woven chiefly out of the aesthetic and intellectual strands he first laid hold of there. But when that world fell apart, it left him, in his early thirties, essentially alone with Marthe. Like most very precocious young artists, Bonnard and his friends found themselves running aground in their mid-thirties. Vuillard and Vallotton never entirely recovered their early brilliance. Bonnard – perhaps the least brilliant of the three in the 1890s – also had a difficult passage ahead.

THE PASSING SHOW

Among the many vignettes from the Jarry/Bonnard Almanacs is a three-levelled scene. At the bottom, the monuments of Paris, including the Eiffel Tower, are strung out in line. In the sky above, a crowded horse-drawn omnibus; and on the roof, the Gargantuan Ubu, bestial as ever, surmounted by a neat little bourgeois hat, and accompanied by his side-kick, Monsieur Fourneau (Mr Stove). In the topmost segment is a frieze of passers-by – the anonymous crowd, both child and adult, surveyed by Ubu as *flâneur*.

Bonnard painted well over one hundred street scenes. A splendid exhibition could be mounted of Bonnard only as an artist of Paris, arguably

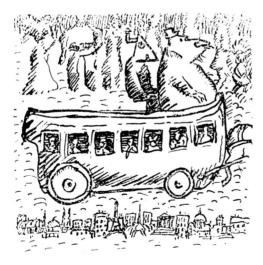

29 *Ubu in Paris* from *Petit Almanach du Père Ubu* by Alfred Jarry, 1899

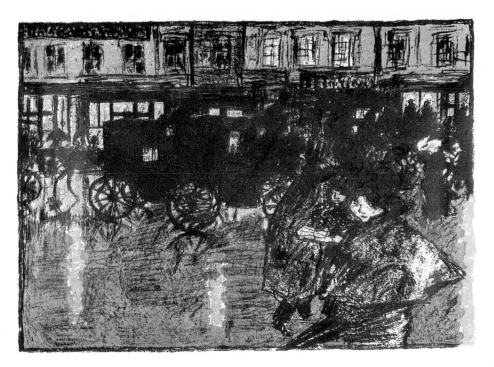

30 *Street at Evening in the Rain, c.* 1897

the most inventive of modern times. He attempts an enormous variety
of format and scale, ranging from tiny cardboard pochoirs to triptychs,
such as the 1896 *Ages of Life*. Every morning early Bonnard went out
walking – as he would do, ritualistically, all his life; and it was in the
metropolis that he first developed the faculty of passive attention, of
waiting for that sudden welling-up of excited recognition, when a spatial
arrangement locks perfectly into place, and a situation becomes an
image. *Le Joueur d'orgue* (The Organ Grinder, 1895) shows Bonnard's
enjoyment of the formal division of the surface – the yellow building, the
cool white shutters, the sudden deep black of an open window – by
which a genre scene is raised to a stilled abstract harmony. In the silence
of the emptied grid, the solitary music-maker embodies a delicate pathos.

There must have been sketchbooks in which Bonnard first recorded
each of these given images, but few of his early drawings seem of much
substance or interest. Such compositions as the beautiful *Quatorze Juillet*

46

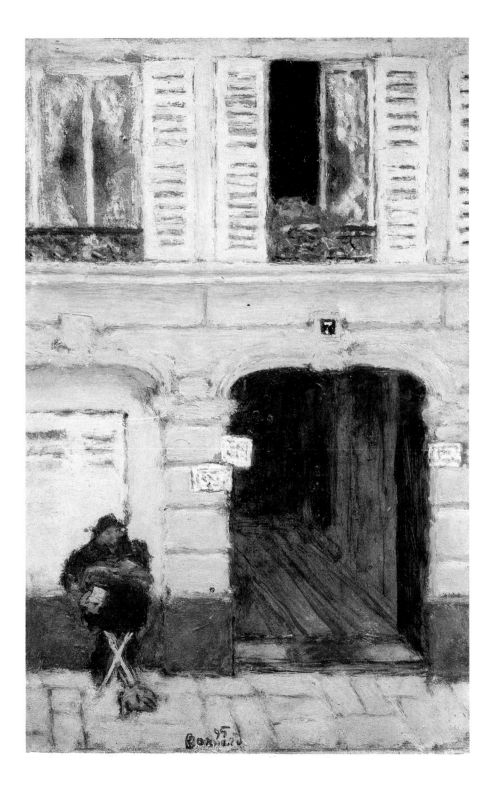

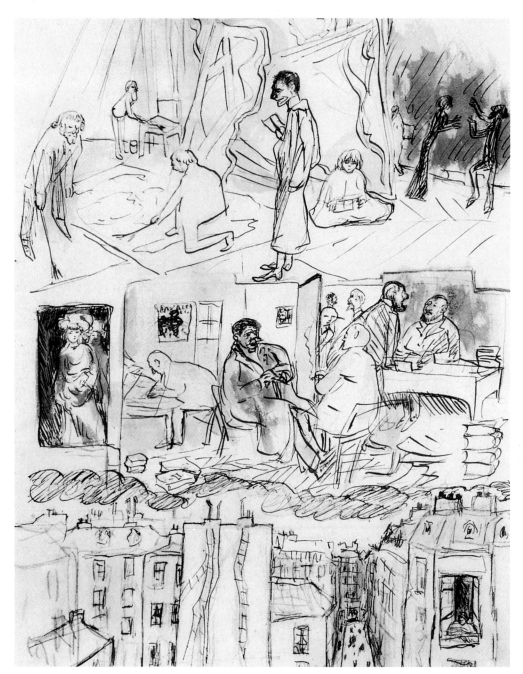

32 Drawing from *La Vie du Peintre, c.* 1910. Top: backstage at the Théâtre de l'Oeuvre, with Bonnard (on one knee) painting a set, and Lugné-Poë standing. Middle: the offices of *La Revue blanche*, with Fénéon (second left) writing at his desk; Natanson presides (right). Bottom: view from Bonnard's studio, including the street of illustration 36.

33 *The Fourteenth of July*, 1896

(The Fourteenth of July, 1896) were probably drawn, but certainly not painted, from life. Bonnard's subject was more novel than it now appears. True, Renoir had declared: 'What I love in painting, is when it has that air of the eternal... that is, an eternity of the everyday, seized at the corner of the next street.' Yet although the Impressionists spent much of their lives in the city, they mostly neglected it as subject-matter. Even Degas paid little attention to the specifics of place and architecture; and although Pissarro and Caillebotte did of course create a memorable imagery of Haussmann's imposing new boulevards, it was left to Bonnard and Vuillard to present the everyday Parisian street more intimately. Bonnard, looking back on his own Intimist years from the standpoint of 1937,

49

accepted the label only in so far as it identified 'those artists who have a taste for the theatre of the everyday, the faculty of distilling emotion from the most modest acts of life'. His subjectivity is essential here. The experience of the passing show implies a perception of the street as a dreamlike pageant, a procession of shadows; the world moves but I stand still. Bonnard's Paris is seen mostly in terms of processions – of schoolchildren, *midinettes*, signs; of wheels, windows, hats, dogs. *Place Blanche* (1902) is one of several views of the ragged Montmartre cityscape, here scrawled with a Pernod sign, peopled with tiny schoolchildren, filing at liberty through the grey streets.

30 The twelve lithographs commissioned by the dealer and publisher Ambroise Vollard (1867–1939) in 1896, and finally published in 1899 as *Quelques Aspects de la vie de Paris* (Some Glimpses of the Life of Paris), are among Bonnard's defining achievements of the 1890s. He used five colours for *Rue, le soir, sous la pluie* (Street at Evening in the Rain), but three of them are very close browns and blacks, set off with great subtlety against the dominant grey-green, and the bright yellow of lighted windows and reflections. According to the American scholar Colta Ives, the image suggests Bonnard's 'increasing restlessness and anxiety about living in the city', but there is also a relish in mobility, of being plunged

36 into the mêlée. *Coin de rue vue d'en haut* (Street Corner Seen From Above) shows the rue Tholozé, probably viewed distantly from his studio window, recreated with wonderful formal intelligence. The colour is too understated to be any longer 'Japanese': there are three greys, plus the white of the paper, but otherwise only the single orange-red that marks off the end of the street, very sparingly used elsewhere. Seen from above (but probably not using a photograph) the figures become strange black

38 shapes. In *Coin de rue* (Street Corner) he zooms in closer, choreographing individual performers (including the workman carrying his plank) as they move down the shadowed stage; and then, for the sunlit chorus behind, switches to his phantasmal-processional mode.

37 *The Boulevards*, a lithograph of 1900, was commissioned by a German publisher for a portfolio that included James Ensor and William Nicholson, as well as Denis and Vuillard. There is, even more than in the earlier scenes, a calculated wildness in the marks – a façade slashed in with the same bravura as the scrambled foliage. The drawing has some of that 'childish' quality (not faux-naïf, but a humanizing transformation of the city) which reappears in Kirchner's Berlin street scenes of 1912, and in our own time, in the London of Leon Kossoff. The colour, a deep resonant green set against pale greys and browns, is of a sophistication marvellously at one with the elegant quartier.

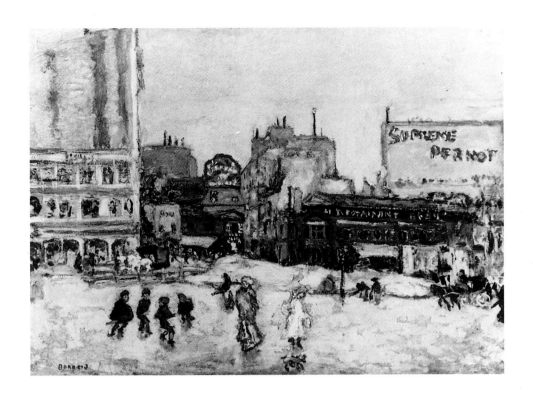

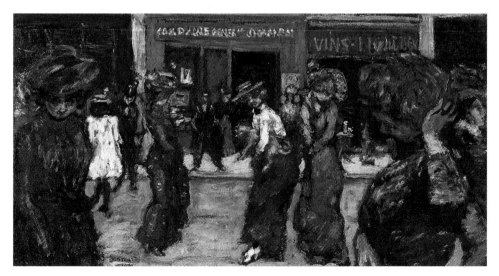

34 *Place Blanche*, 1902

35 *Place Pigalle*, 1900

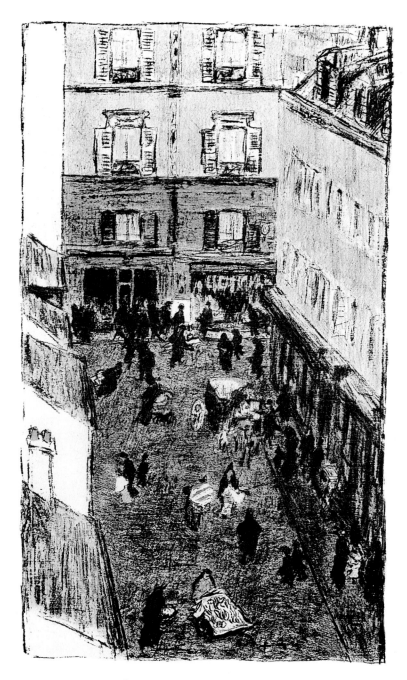

36 *Street Corner Seen from Above, c.* 1897

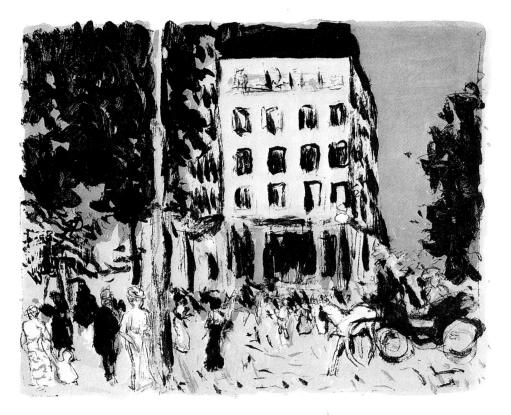

37 *The Boulevards*, 1900

38 *Street Corner*, c. 1897

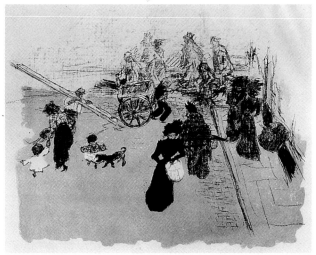

In his first masterpiece of the new century, *L'Homme et la Femme* (Man and Woman), Bonnard achieves a solemnity and gravitas previously unsuspected, anticipating the great sequence of bathroom scenes of the 1930s. The picture has a prehistory of at least two years, starting out from a small and typically Intimist bedroom scene of 1898, followed by a more vibrant and larger version some months later. In both, the polarity is already explicit: between the woman's rounded and illuminated warmth, and the man's vertical darkness. But it is only in the final almost four-foot restatement of 1900 that they are divided by a screen. The image comes into focus, as autobiographical narrative, as a nude self-portrait (unusual in art, and especially at this scale) and as a way of speaking about the difficult relations between male and female.

In the 1890s a new culture of sexual pessimism became prevalent in Paris, of Nordic origin, with Bonnard's circle as the chief intermediaries. Thadée Natanson had reviewed Munch's Oslo exhibition in the *Revue blanche* in 1895, and *The Scream* appeared later the same year; in 1896, it was Strindberg who had reviewed Munch's Paris show. At the Oeuvre, Vuillard drew a programme for Strindberg's *The Father* and Munch designed sets for two Ibsen productions. From 1895, Bonnard and Munch sometimes shared the same lithographic printer, Auguste Clot. Set alongside Bonnard's *Man and Woman*, Munch's *Ashes* of 1894 articulates a much more obviously lurid image of sexual distress; indeed one possible

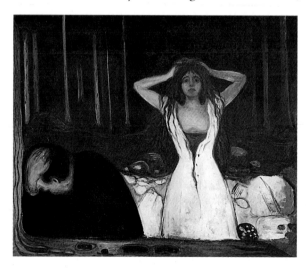

39 Edvard Munch, *Ashes*, 1894

40 *Man and Woman*, 1900

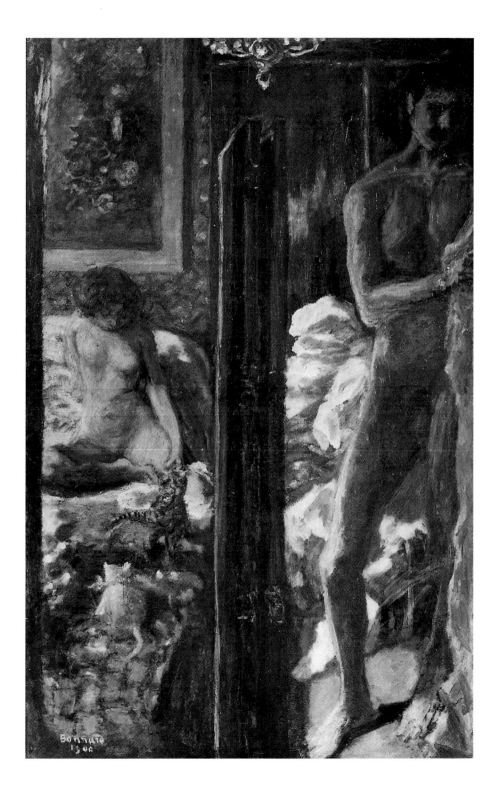

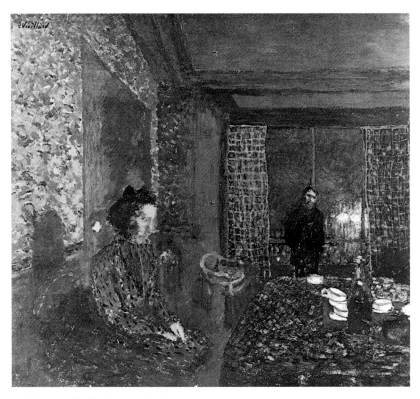

41 Edouard Vuillard, *Married Life*, 1900

interpretation focuses on the shame of premature ejaculation, the 'tree-trunk' at the left incorporating a flow of sperm. But both pictures should be seen as part of a wider commentary. Vuillard's devastating *Married Life* of 1900 owes much to his work as a designer for Ibsen's dramas of domestic desolation and strife and incarceration. (The painting may witness the failing marriage of Vuillard's sister to Ker Roussel.) While gas-lamps blaze outside in the urban night, within the room there opens between this couple also a terrible, shameful distance.

Man and Woman is among the most densely painted of all Bonnard's surfaces (today it is badly cracked), and I suspect scientific examination would reveal several radical changes as he groped towards his meaning. At the lower right, a wiped mark seems to indicate we are looking in a mirror, and along the entire left edge is a band of green (becoming lighter at the top) which may be the mirror frame. The very dark folded

screen stands almost as a third presence and establishes this as an image of division. In one recent account of the picture, Nicholas Watkins writes: 'Sex as the primal connection between man and woman is over, and the screen indicates a barrier has come down.' Bonnard would have known the many *shunga* (erotic prints) by Utamaro and other Japanese woodblock artists depicting post-coital couples; his reaching for a towel, and the pile of linen behind, might be likened to the crumpled tissues that surround the sated in the pillow-books. Yet Marthe's lowered head may suggest sadness, as Bonnard turns away from her light-filled world, to confront the self; and in this first great self-portrait, the face fragments, to be swallowed by the dense surrounding red.

Some of Bonnard's first drawings of Marthe appeared in 1897 in the *Revue blanche*, as brush and ink illustrations to the Danish novel *Marie* by Peter Nansen. Marie is a young midinette, almost a child, seduced by her upper-class lover, then abandoned; only when she becomes ill does he reappear. (That plot would one day return to haunt Bonnard.) Marthe,

42 Illustration from *Marie* by Peter Nansen, 1897

57

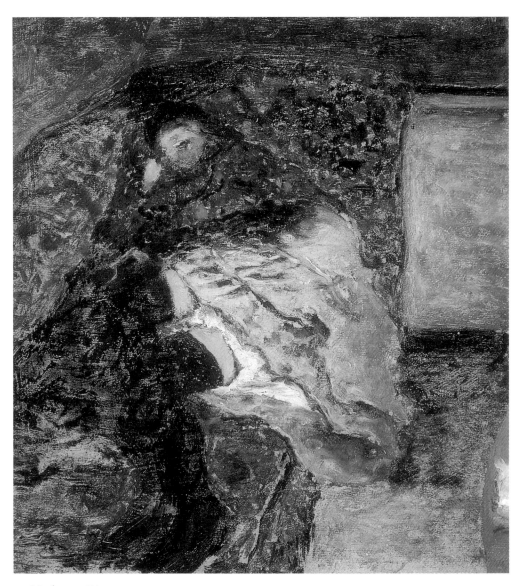

43 *Marthe on a Divan, c.* 1900

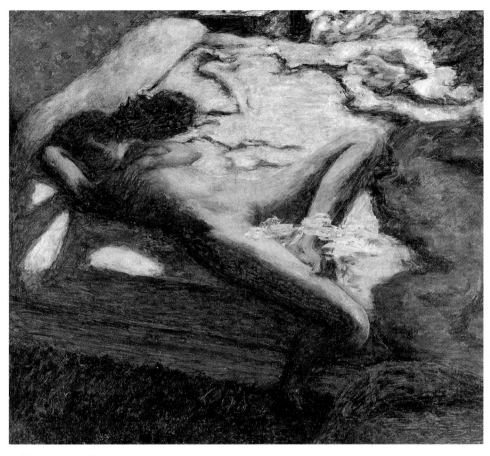

44 *The Indolent Woman*, 1899

who still passed for a teenager, became the focus for an erotic art of black
stockings and unmade beds, which culminated in 1899 in two powerful
large-scale canvases, closely similar in composition, entitled *L'Indolente*
(The Indolent Woman). The first oil sketch is usually dated 1897; in the
next version (Josefowitz Collection) the blue-ribboned cat nibbling at
her ear disappears, to be reinstated in the final variant illustrated here.
Marthe's pose is starkly sexual – her lifted arms exposing the belly, legs
apart, big toe hooked over the thigh. She could be alone, lost in some
'wanton' reverie, yet I believe the image is as much about relationship as

59

Man and Woman. The clay pipe on the bedside table has been seen as one evidence of a male companion; the emphatically angled space, and the brown area lapping like a dark sea at her feet, may establish Bonnard's own presence, standing above her.

The near monochrome of yellow and brown is characteristic of Bonnard's palette in these years. Verlaine in his *Art Poétique* had declared the supremacy of nuance over colour; in a line perhaps especially apposite to *L'Indolente*, he had rhymed 'amber' and 'shadow' ('Elle en a l'ambre, elle en a l'ombre'). In 1898, two years after Verlaine's death, Vollard commissioned from Bonnard an *édition de luxe* of the poet's last major collection, *Parallèlement*, with over one hundred images. The text was already printed when Bonnard began to draw around it in a kind of marginal improvisation. Verlaine had once composed transpositions of Watteau's *Fêtes Galantes*, and a rococo sweetness lingers here, further reinforced by Bonnard's choice of pink. 'I wanted the lithographs to be *en rose*, because it allowed me to convey more of the poetic atmosphere of Verlaine.' Several illustrate sonnets of lesbian love between young girls, with Marthe sometimes as model. The pose of *L'Indolente* also reappears, in a drawing first intended for 'The Sandman'. Verlaine's title refers to E. T. A. Hoffmann's tale of a man in love with a mechanical doll, and the sonnet laments a woman 'indifferent to everything', concluding bitterly 'la créature était en bois' ('the creature was made of wood'), a line which may identify the mood of *L'Indolente*.

Parallèlement sold few copies when it appeared in 1900, but Vollard, undeterred, commissioned an even larger project. Longus's third-century pastoral tale *Daphnis and Chloe* marks the end of pagan literature. It begins with the narrator in a wood sacred to the nymphs, stumbling across a forgotten picture, 'which repeated the incidents of a tale of love'. In Bonnard's
46 156 lithographs, the lost narrative becomes image again, in an almost cinematic unfolding. Individual figures (some based on photographs of himself and Marthe naked in the garden, or his little nephews frolicking in a pool) can seem flimsy almost to the point of feebleness; yet the cumulative sense is of a distant world summoned tentatively to life. The young classical lovers (aged fifteen and thirteen) inspired joyous memories of his own childhood summers in the Dauphiné. 'I worked rapidly, with joy…On every page I evoked the shepherd of Lesbos, in a kind of happy fever, that carried me along in spite of myself!' The mood of the *Daphnis and Chloe* illustrations and of the contemporaneous little paint-
47 ing *Pan and the Nymphs* locates Bonnard in the 1890s revival of pantheism in Paris, embracing both the Nietzsche of *Also Sprach Zarathustra* (Thus Spake Zarathustra) and the Mallarmé of *L'Après-midi d'un Faune*

Puis tombe à genoux, puis devient farouche
Et tumultueufe & folle, & sa bouche
Plonge sous l'or blond, dans les ombres grises;

Et l'enfant, pendant ce temps-là, recense
Sur ses doigts mignons des valses promises,
Et, rose, sourit avec innocence.

45 Illustration from
Parallèlement by
Paul Verlaine, 1900

(The Afternoon of a Faun). Sometimes claimed to be the greatest of all poems in French, *The Afternoon of a Faun* (1865) had already been given new currency in Debussy's musical interpretation of 1894. The mood is of a southern yellow siesta hour: 'Inerte, tout brûle dans l'heure fauve' ('Inert, all is burning in the fallow hour'). The faun is human above, goat below. It has been suggested that Bonnard's self-portrait in *Man and Woman* is a similarly divided figure; and certainly his little picture of 1899, *Pan and the Nymphs*, implies the self as faun. In Mallarmé's poem, the faun does not succeed in his rape of the two nymphs; instead, he relishes the memory of his sexual failure, and experience is thereby transmuted into art. Bonnard's early imagery of Marthe, when set in the contemporary world, conveys a kind of animal sexuality, often with negative overtones. By contrast, the bucolic nudes are less sharply erotic, and this diffuse sexuality is nearer to the mature Bonnard of the late bathroom

46 Illustration from *Daphnis and Chloe* by Longus, 1902

nudes. Among the Nabis, not only Bonnard but Roussel and Maillol also
would see in the Arcadian faun a potent counter image to the difficulty
of sexuality in the contemporary urban setting. As Bonnard's metropoli-
tan circle imploded, and the new century opened, his own utopian
yearnings were realized in this vision of a world opposed to bourgeois
society, and in which Eros would be once more unbound.

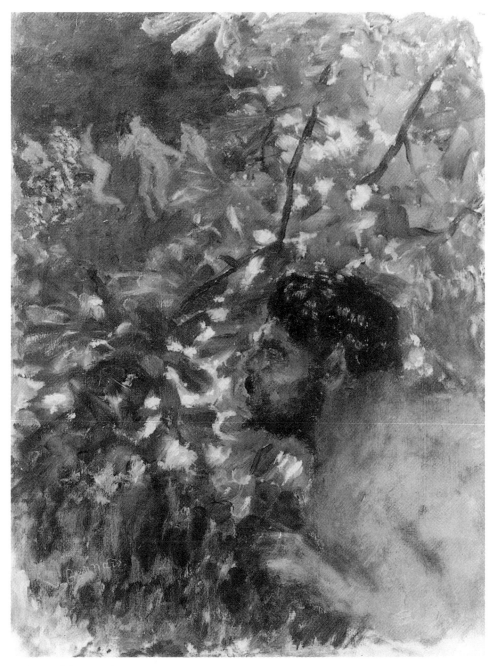

47 *Pan and the Nymphs*, 1899

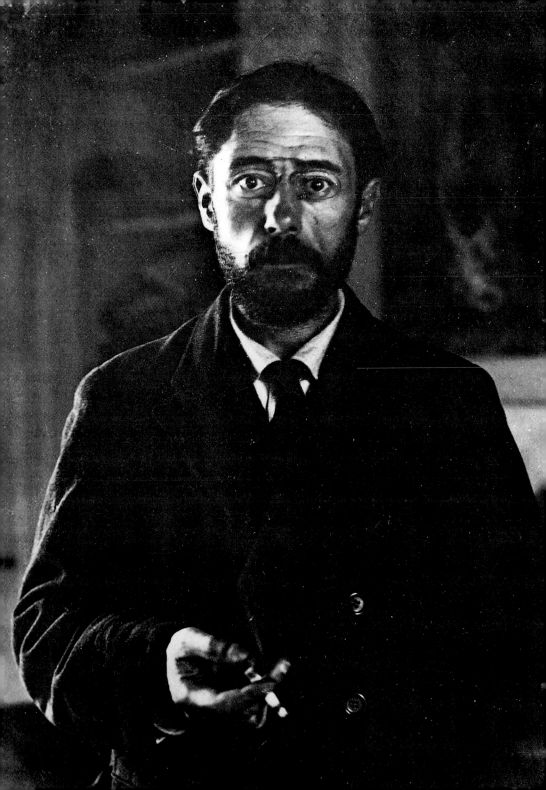

'To Pick Up the Research of the Impressionists'

Bonnard has often been classed as some kind of belated Impressionist. Certainly between 1900 and 1914 he came to adopt many of the hall-marks – the white ground, the broken and visible brush mark, and even the open-air subject-matter – which had characterized Impressionism in its heyday. When the Nabis first began to meet, the prime of Impressionism was already past. According to Albert Aurier, a young apologist for Gauguin writing in 1891, 'the word "Impressionism" suggested an entire aesthetic programme based upon sensation'; and he invoked the 'poor stupid prisoners' of Plato's Cave, who mistook shadows for reality.

The special task of the new generation, Aurier implied, would be to go beyond sensation, beyond naturalism, in the same way that the Platonic philosopher must climb out of the world of shadows. Yet Cézanne, Van Gogh and Seurat had meanwhile, each in their different way, confirmed how a response to sensation could still be a fertile territory for painting; how it was possible to become a kind of 'philosopher' through the very processes of perception. For Bonnard (as for Vuillard and Roussel), the Impressionists came *after* Gauguin. 'When we discovered Impressionism a little later, it came as a new enthusiasm, a sense of revelation and libera-tion. Impressionism brought us freedom.'

The shimmering surface of *Canotage sur la Seine, le pont à Chatou* (Boating on the Seine, the Bridge at Chatou) suggests Bonnard's affinity to the river scenes of Monet and Renoir, even as early as 1896. But the colour, laid on a reddish ground, remains very muted, a near mono-chrome of browns and blacks. Something of Symbolism remains in the accentuated contrast of water and land – between the stolidity of those seated on the sombre river-bank, as against the freedom of the couple afloat on the bright stream. For Bonnard, Impressionism was a new starting-point:

49

> When my friends and I decided to pick up the research of the Impressionists, and to attempt to take it further, we wanted to outshine them in their naturalistic impressions of colour. Art is not Nature. We were stricter in composition. There was a lot more to be got out of colour as a means of expression.

48 Bonnard *c.* 1909, photographer unknown

49 *Boating on the Seine,*
the Bridge at Chatou, 1896

Symbolism had been emphatically inward; Impressionism too empiri-
cal. There had to be some way of integrating external and internal
experience, and this was Bonnard's 'research' through much of the early
1900s. He became unclear what painting procedure suited him best; after
1900 he probably never set up an easel in the open air, but he did paint
directly from the posed model, as we can see in a photo of his studio in
about 1905. The resulting paintings seem, with few exceptions, dismay-
ingly drab and commonplace. Even if Impressionism promised a way
out of the Symbolist cul-de-sac, its actual procedures were totally inap-
propriate.

Of all the Impressionists, it was the least empirical, Auguste Renoir
(1841–1919), who proved of most importance for Bonnard. They had
first met in the circle of the *Revue blanche*. 'Renoir's relation to me', he

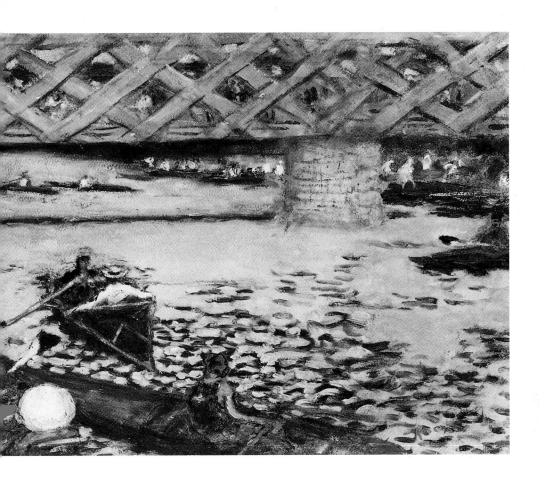

later recalled, 'was that of a rather severe father.' In the early years of the century, something of Renoir's tender touch fed into his own mark-making, along with a love of French Rococo painting in its most 'feminine' aspect. He learnt much from the older artist's insistence that nature needed to be improved upon: 'It's true, isn't it Bonnard, we must always embellish.' What Bonnard most admired in Renoir was his ability, when working directly from the motif, 'to project, even upon a model and lighting somewhat lacking in lustre, his recollections of more joyous times. He created a magnificent universe for himself.' That fusion of sense-data with memory to make a new reality would be at the heart of Bonnard's own mature aesthetic.

But for Bonnard to adopt so much of Impressionist style at the turn of the century was to invite misidentification. In 1898 W. B. Yeats had

written of 'artists all over Europe struggling against externality'. Bonnard found himself bypassed by Modernism – by the emergence of the Fauves in 1905, and by Cubism shortly after. His place in the story of Modern Art, as it began to be codified, now lay far back in the 1890s. He was excluded from Roger Fry's first Post-Impressionist exhibition in London in 1910, as from the Armory Show in New York in 1913; and in Paris in 1913, Apollinaire was praising Matisse's portrait of his wife (*Madame Matisse*, 1913) as 'internal art...which is today's art. He has not remained the slave of resemblance'. By 1914, Bonnard was being 'denounced' (according to Leon Werth) as 'the bearer of the taint of Impressionism in its degeneracy'. Beside Cubism, Impressionist language appeared 'invertebrate'; it had lost any radical edge, and begun its long reign as a kind of bourgeois vernacular within twentieth-century painting, in contrast to the 'difficult' languages of the avant-garde. Those writers who still praised Bonnard often used his work as a weapon against the new, and as affirming an unchanging France. He never entirely shook off the reputation he acquired in these years, as a 'retrograde' artist, who had turned back from a more arduous path, and he watched the process helplessly: 'The march of progress has accelerated. Society was ready to admit Cubism and Surrealism even before we had reached the goal we had set for ourselves. We were left, so to speak, dangling in mid-air...' Yet from about 1910, Bonnard began to develop some very original procedures, which were partly strategies; holding on to his 'sensation', but never again a poor stupid prisoner, never a slave to resemblance.

EMBOURGEOISIFICATION

52 The large composition of 1900 usually known as *L'Après-midi bourgeoise* (The Bourgeois Afternoon) strikes an unexpected note in Bonnard's oeuvre – it is without any trace of Gauguin and Symbolism, totally un-Japanese, and has even less to do with Impressionism. Bonnard seems here to be essaying some kind of social satire: perhaps, how young bohemians become middle-aged bourgeois. Claude Terrasse, Bonnard's composer brother-in-law, proprietor of the Théâtre des Pantins in Paris and collaborator with Jarry, is shown here a few years later, installed on his provincial lawn in post-prandial torpor, bored by his fat and worthy visitors Monsieur and Madame Prudhomme. He has all the trappings of the bourgeois paterfamilias; there seem to be children in all directions as well as innumerable pets, though only one face looks out at us – the cat in the foreground, whose malicious grin makes us complicit in the whole absurd set piece. The colour is keyed to a peculiar grey-green, of

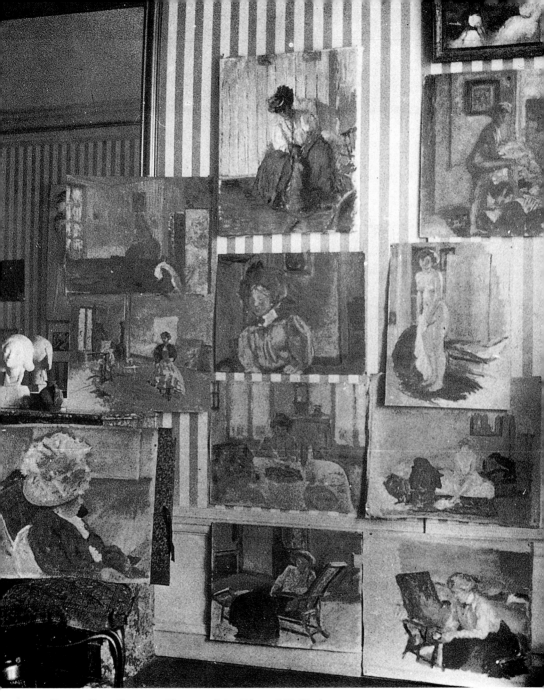

50 Bonnard's studio, 1905. Photograph by Edouard Vuillard

a muted acidity; and reframing at the Musée d'Orsay has revealed a patterned border to right and left.

The setting is the big yellow ancestral Bonnard house in the Dauphiné, one of the fixed points of the artist's existence from his childhood until well into his fifties. (It would finally be sold only in 1929.) His sister Andrée now had three children, and they became his surrogate family. Every spring he would come for a stay of several weeks, sometimes returning again in autumn; often he arrived with friends – Misia and Thadée Natanson, Vuillard and Jarry. But Marthe did not visit Le Grand-Lemps until 1913; that is, she endured at least a month or two each year of solitude, and perhaps of exclusion, over a twenty-year period.

With its frieze-like composition, *The Bourgeois Afternoon* may be seen as Bonnard's first attempt at a formal *décoration*, but also as one of a series of caricatural assemblies, a new vein he was developing in the early 1900s. The central figures in *Le Jardin de Paris* are two ridiculous males: the fat man in moustache and hat, whose profile is juxtaposed with comical awkwardness to the rigid frontality of the much smaller *maître d'*. The *Jardin*, off the Champs Elysées, was a summer branch of the Moulin Rouge; the lights suggest some reminiscence of Renoir's tender *Moulin de la Galette* of 1876, though the *ambiance* is much more louche.

51 Auguste Renoir, *Moulin de la Galette*, 1876

52 *The Bourgeois Afternoon*, 1900

53 *Le Jardin de Paris, c.* 1900

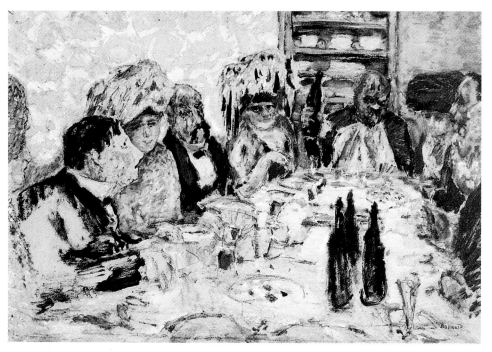

54 *Vollard's Dinner, c.* 1907

In similar vein, Bonnard records one of Vollard's famous dinners in the cellar of his gallery, where he and Bonnard had hatched with Jarry their various Ubu projects. The rue Lafitte, with Vollard's and Durand-Ruel's galleries and the *Revue blanche* as neighbours, was known to young artists at the turn of the century as 'our second Louvre', the place to see a great recent Degas or Cézanne hanging alongside a new Picasso. The host is unmistakable at the head of the table, napkin tucked in and brandishing a bottle. The white-whiskered old gentleman on the right is Redon, while on the left is Forain – both of them resolutely independent and non-establishment artists. Misia is also present, and so is Count Harry Kessler, whose diary gives a fascinating account of two such dinners attended by Bonnard in 1907. At the first, conversation turned to a possible fraud involving Vollard's fellow-dealer Bernheim, prompting a hideous outburst from Degas ('A Belgian Jew who's a naturalized Frenchman...These people aren't of the same humanity as us'). At the second, Renoir spoke eloquently against the pursuit of unembellished 'truth' in

painting. Bonnard's little picture suggests a subterranean banquet of trolls and sacred monsters, in all their unbuttoned licence. The main course was always a burning chicken creole, the national dish of Vollard's *pays natal*, La Réunion; perhaps the circular marks above the guests stand neither for wallpaper nor for cigar smoke, but spicy heat. Bonnard never lost his affection for Vollard, and would later complete a succession of sympathetic portraits of him with his cat, as well as a superb etching.

But in the early 1900s, Bonnard found his Parisian milieu changing. *La Revue blanche* suddenly folded in 1903, after Thadée Natanson's financial collapse; Misia had meanwhile abandoned him for one of the richest men in France, the newspaper proprietor and high financier of dubious

55 *Portrait of Vollard*, 1924

reputation, Alfred Edwards. In 1901, Félix Vallotton had shocked his anarchist associates by announcing his marriage to a rich widow, sister to the Bernheims, who promptly became his dealers. Vuillard made a similar shift, transferring his devotion from Misia (muse for so many of his greatest pictures) to the more conventional Lucie Hessel, yet another Bernheim connection; he remained to some extent displaced ever after. Alexandre Bernheim had been a friend of Courbet, and dealer for Monet and Renoir. When his sons Gaston and Josse took over as Bernheim-Jeune in 1899, their very grand premises in the suitably named rue Richepanse (literally 'rich-paunch') became a haven for several of the ex-Nabis. Bonnard had exhibited in April 1906 at Vollard's, but in November his next one-man show was at Bernheim-Jeune, and they would remain his dealers until the Second World War. Bernheim's manager was, by 1906, another refugee from the *Revue blanche*, Félix Fénéon. Signac wrote sceptically: 'You know the news, Fénéon has joined monkey-nut Bernheim. I can't work up much enthusiasm about it; I don't see our friend winning out over the boorishness of these industrialists...' In fact Fénéon lasted until 1924, becoming the ideal intermediary between artist and dealer, co-opting Signac and later, Matisse. Bonnard never made a contract, but gave Fénéon first refusal; and each year he would exhibit some thirty new canvases. The firm seems also to have acted as Bonnard's banker, taking care of all his financial affairs.

Gradually Bonnard was drawn into the Bernheims' social world (though it is known to have been a milieu Marthe particularly disliked). *La Loge* (The Box, 1908) started out as a commissioned group portrait – the brothers with their wives at the Opéra. Yet in the eventual unsettling composition, the men almost disappear (Josse masked, Gaston more or less decapitated) and the women bloom into prominence. Josse's wife, the calmly beautiful Mathilde, is protagonist in one half; on the left, Gaston's wife Suzanne (her weirdly drawn arm draped over the empty chair) is set off against an astonishingly vivid, almost infernal, vermilion red. The mood as a whole is one of suspension; Gaston dandles his unused opera glasses, Mathilde her fan. For this antipathetically elegant world Bonnard conjured a colour-realm to which he would never return, of deep plush crimsons and hot velvety darks, where even the blues are fiery.

Although Bonnard still kept his modest studio in Clichy, his social life had become increasingly grand. In 1901, for example, he and Vuillard had joined the Bibescu princes on a trip to Portugal and Spain; in 1906 he accompanied Misia for the second time on Edwards's luxurious yacht, with Maurice Ravel as a fellow guest. (It is tempting to imagine them on

61, 62

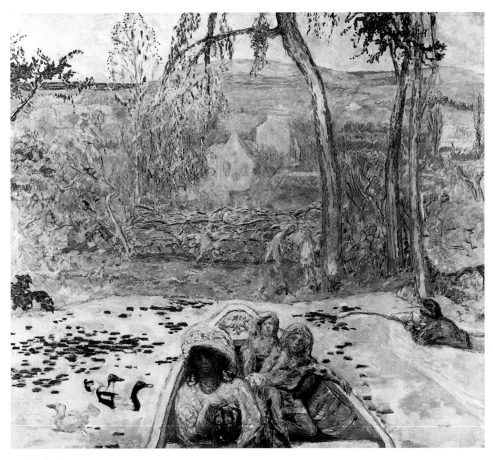

56 *In the Boat*, 1910

deck together, discussing their different versions of the Arcadian idyll made modern; Ravel's *Daphnis et Chloé* would be performed not long after.) Yet from all Bonnard's travel abroad in this decade, which took in Venice, England, Berlin, Morocco, Tunisia and the Low Countries, very few pictures resulted: the exotic setting, like the elevated social milieu, was essentially barren for his art.

Upper-crust patronage also launched him at last as a large-scale decorator of Parisian salons. For the Bernheims (who had surrounded the entrance of their salon with an array of late Renoir nudes) Bonnard completed in 1908 a rather conventional Renoiresque *Les Trois Grâces* (The

75

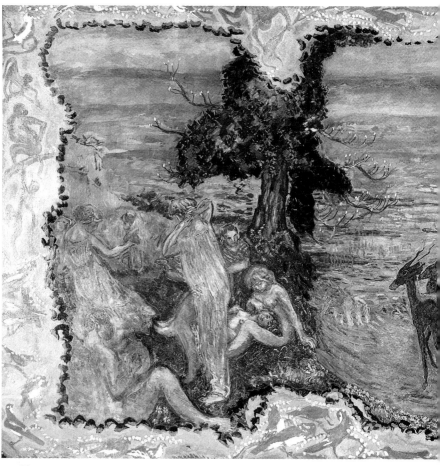

57 *Pleasure*, 1906

Three Graces). Later the same year, Misia (having already divorced Edwards) commissioned a suite of tapestry-like fantasias; the largest, the fourteen-foot *Le Plaisir* (Pleasure), is a Golden Age idyll, incorporating some sixteen nude figures, and a vast seascape beyond. In 1910 he started work for the American heiress Marguerite Chapin (later Princess of Bassiano) on a further *décoration*. *En barque* (In the Boat) is another vast surface, nearly nine feet square. The foreground plunge of the boat creates a kind of dizzy intimacy between us and the children, spilling into our space; while the landscape, although grey in colour and tone, once again suggests Bonnard's nostalgia for the rough hills of his Dauphiné

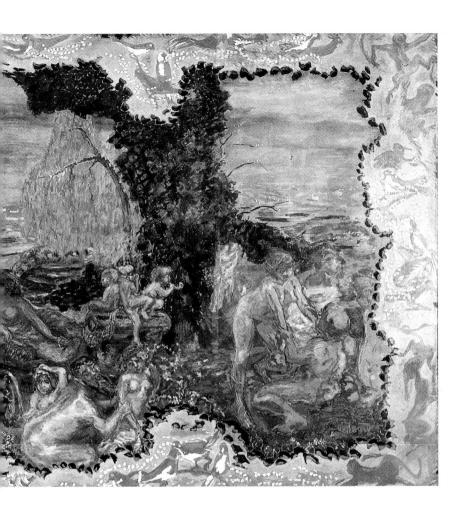

vacations; and more children are faintly visible against the wattle fence of the river-bank.

Between 1908 and 1920 it may be estimated that at least half Bonnard's energies were expended on decorations of this kind, until recently seldom reproduced. Intimist space, vignetted around a close-up figure, was simply not operable at this enormous scale; his solution was usually a foreground frieze, set upon a narrow ledge or stage, with a landscape backdrop behind. These surfaces probably served well as agreeable settings for a crowded salon, but today, stripped of their context, they seem disappointingly vacant, entirely lacking Bonnard's characteristic intensity

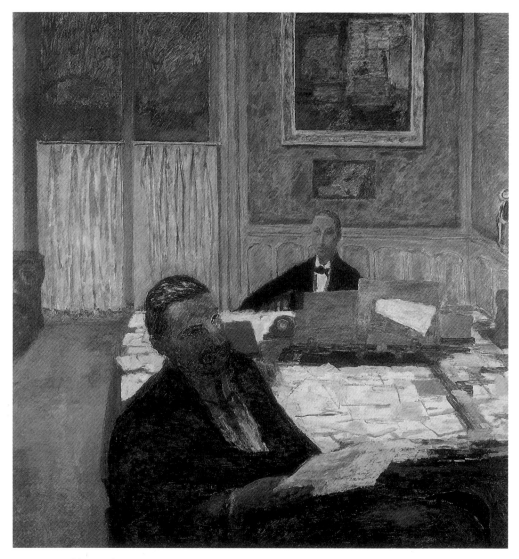

58 *Portrait of the Bernheim-Jeune Brothers, c.* 1920

and compression. And by extending into the twentieth century the vein of Signac's *In the Time of Harmony*, Bonnard risked vacuity of another kind. By 1908 the Golden Age anarchism of the *Revue blanche* was in France a forgotten dream, despised as ivory-tower escapism by the newly emergent revolutionary associations. In the words of one polemicist, 'Syndicalism does not merely promise the workers a terrestrial paradise, it demands they conquer it.' Bonnard, perpetuating the beautiful dream for his bourgeois clients, finds inspiration not in classical sources but in the Rococo and the Ancien Régime – the diffuseness of Watteau's *Embarkation for Cythera*, the overall glitter of Fragonard.

While his mythologies extol a primitive innocence, their modern-day patrons ordered from Bonnard what can only be classed as 'society portraits', among which Misia, as a sort of Madame de Pompadour, strikes a particularly false note. Society portraiture would swallow up Vuillard in a series of very elaborate commissions (those jewelled salons which Claude Roger-Marx characterized as his *féerie bourgeoise*, 'bourgeois fairyland'), and after his one-man show at Bernheim's in 1912, he scarcely exhibited publicly again until 1938. Bonnard, by contrast, chose to distance himself more and more from 'society'. By 1920 he had anyway learnt to subvert even the most recalcitrant subject-matter to his own ends. His portrait of the Bernheim brothers juxtaposes them as blue-black cut-outs across a vast shared desk, with masterly control of rhythm and shape. At the lower edge, in front of Gaston's knee, a gorgeous patch of violet floats on the surface, much like a Monet waterlily, establishing the plane with a marvellous autonomy.

'MY GYPSY CARAVAN'

In the 1900s Bonnard and Marthe spent more of each year outside Paris. Marthe may already have begun to manifest that 'pathological horror' of any kind of social life, that 'desire to escape' witnessed by Thadée Natanson. Bonnard wanted to spare her the social pressures unavoidable in the metropolis, but it seems he too felt drawn to some greater seclusion. Childless and without money worries, they were exceptionally free, and made full use of this liberty. Each year Bonnard would rent a house along the Seine valley for the summer months. Eventually, in 1912, he purchased a modest villa high above the river, opposite Vernon, calling it 'Ma Roulotte' ('My Gypsy Caravan') with all that implies of freedom and travelling light and the elemental.

Something of that spirit appears in his illustrations to *La 628-E8*, an 59 offbeat travel book by an early motorist, his old friend Octave Mirbeau

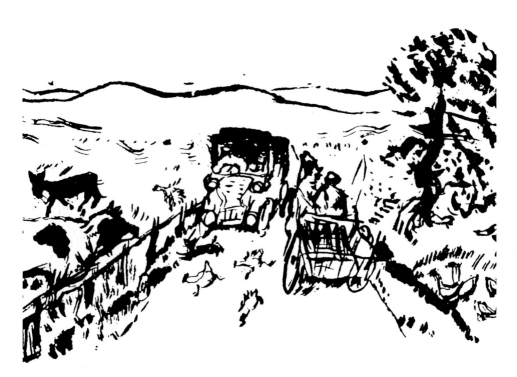

59 Illustration from *La 628-E8* by Octave Mirbeau, 1908 (detail)

(1848–1917). Mirbeau had been close to the Impressionists, and was yet another of the anarchists of the *Revue blanche* circle; his text is provocatively anti-patriotic, anti-clerical and, in one touching episode, pro-Jewish. Bonnard was not one of the party who had made the journey in 1905, but the open-road theme allowed him to bring together some very inclusive imagery: his Low Countries travels with Misia; caricatures of academicians and of the Belgian King; a miners' demonstration and a massacre; as well as animals of every kind. Working very much in the spirit of a Japanese brush-artist, in these emblems Bonnard makes final tribute to the calligraphic bravura he would soon abandon for the much more tentative and delicate pencilled sheets of his mature drawing style. Printmaking and illustration, so dominant in his youth, now yielded to painting as the main focus of his work.

Bonnard inherited Impressionism as a kind of ready-made idiom for the celebration of freedom, for an art of picnics and walks and river-banks. The Nabis' poster-and-patchwork had entailed much filling-in of continuous linear boundaries; by contrast, Impressionist brush work

60 Bonnard, Marthe and Suzanne Bernheim de Villiers, *c.* 1913, photographer unknown

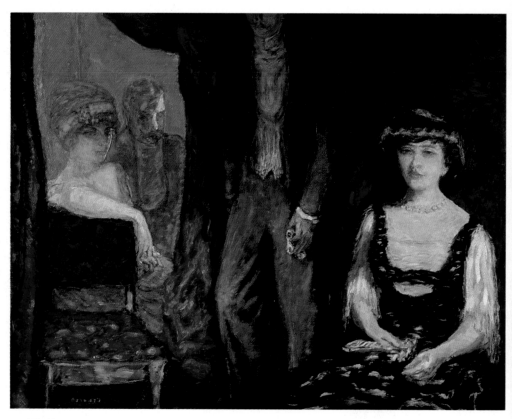

61 *The Box*, 1908

62 *The Box* (detail), 1908

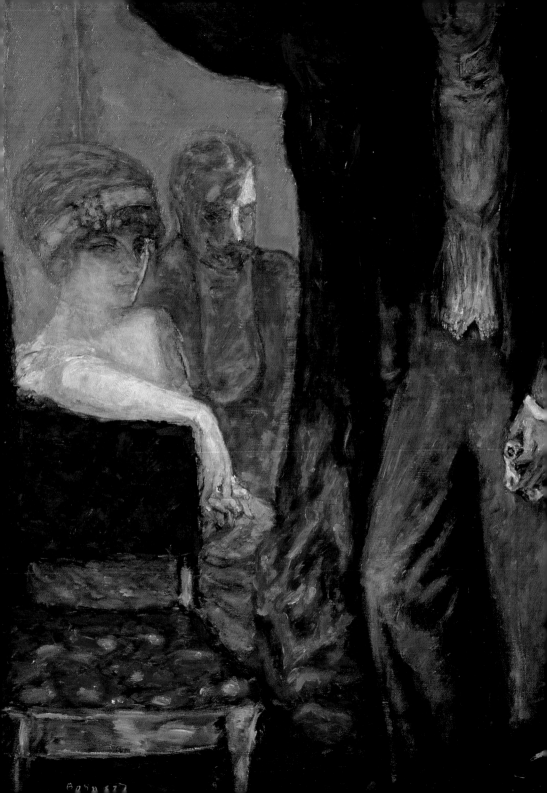

tended towards an overall mesh, made up of small repeated marks. But once Bonnard adopted touch as part of his expressive language, it would become ever more varied: very broad washes floating side by side with raw linear flourishes, scratchings, impasted lumps, and the dabbling of fingers. This new freedom of mark-making assisted him in reaching for a simplicity of vision, often with a child as agent of experience. In

65 *Le Train et les chalandes* (The Train and the Barges, 1909) we are close to the realm of child art. The choo-choo emits horizontal smears of impasted lead-white, as it draws the deep crimson carriages through the striped valley; while the vermilion barges shimmer from the half-hidden river beyond, with their smoke rendered in delicate grey spirals. The little child who watches all this – clutching the paradisal apple – sits in a field of freshest pink.

It seems Bonnard wants to restore a quality of naïvety to perception; to retrieve the wonder of the infant's apprehension of the world. *The Train and the Barges* is underpainted in a transparent blue; and Bonnard has stained the upper area crimson, creating a splendid violet sky suggestive of high summer. But from about 1910, white underpainting becomes almost invariable, resulting in a much higher-toned colour – a response perhaps to the impact of the Midi following his first visit in 1906 and then in 1909. Bonnard himself compared the shock of the southern light to some sudden transformation in *The Arabian Nights*: 'The sea, the bright yellow walls, the areas of reflected light as coloured as those in full sunlight...' At the same time, his affinity to the Impressionists, and especially to their perceptions of light, was strengthened by his growing intimacy with Renoir, and with his near-neighbour in Normandy, Claude Monet.

66 *Ruelle à Vernonnet* (Lane at Vernonnet, 1912–14) is another infant rapture, set in Normandy but rendered with a hot 'southern' palette. Within the Veronese-green foliage, Bonnard inserts ragged patches of deepest black, harking back to the silhouetted shapes of *The Game of Croquet* twenty years earlier. An astonishing chromatic range is drawn upon – turquoise sky, yellow and pink foreground stage; and yet, tonally, the picture is much darker than it may appear in reproduction. The line below the fence, which reads as white, is really a green-grey; the only actual white, the aureole of bare canvas immediately surrounding the child.

64 Colour is no less intense in *Fête sur l'eau* (Regatta), one of a group of exceptionally wild pictures resulting from a visit to Hamburg in 1913. Vuillard and Bonnard travelled together, lured by portrait commissions. In a stay of some weeks, it seems likely that Bonnard would have encountered some recent German art; could he have seen the work of Emil Nolde, whose farouche imagery of Hamburg steamers on the Elbe

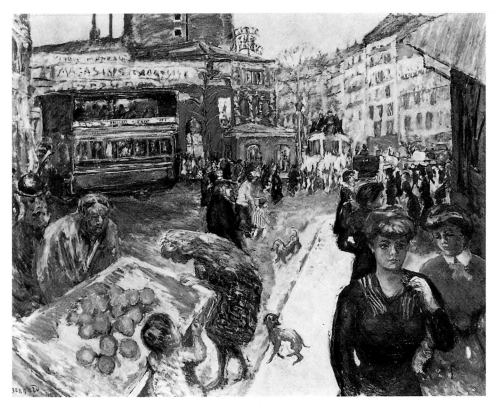

63 *Place Clichy or the Green Tram*, 1906

had triggered, a few years earlier, much of what we now call German Expressionism? Certainly this crowd strikes a new note, as though Bonnard's latent Germanic component, inherited from grandmother Mertzdorff, were suddenly asserting its visceral power. The handling is looser and more vigorous than in any other Bonnard I know; the surface, broken by red and orange flags, yellow flecks on the water, and the flame-like red marks consuming the lower balustrade, communicates a mood of flickering excitement. Rounded hats and heads pile up in the foreground to create an orange-red surge of shadow, while the radiant blue water, cut by the line of dark boats, jumps forward with extraordinary intensity. But the heart of the picture is the profile of the young boy, delicate and touching, in the midst of the crowd. Impressionism's open-air atmospherics are here transposed, through subjectivity and memory, into some more impassioned and human-centred key.

85

64 *Regatta*, 1913

65 *The Train and the Barges*, 1909

66 *The Lane at Vernonnet*, 1912–14

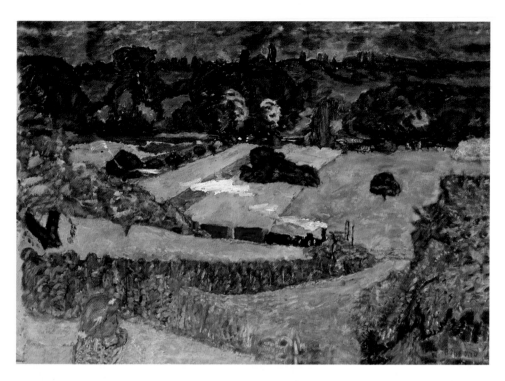

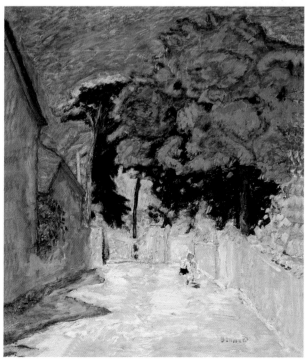

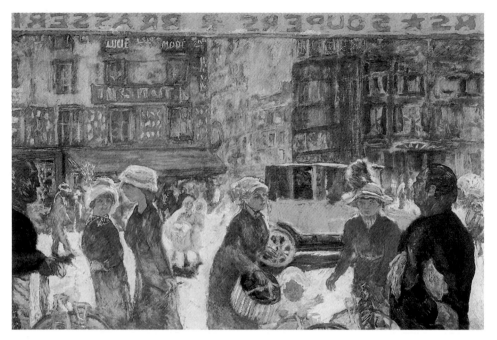

67 *La Place Clichy*, 1912

BONNARD'S MIRROR

A growing polarity develops in these years, between Bonnard's urban identity, still able to relish the passing show, and some more intimate quest, associated with the stillness and silence of the Normandy interiors. *La Place Clichy ou le Tramway vert* (Place Clichy or the Green Tram, 1906) is the most comprehensive of all his Paris scenes, reinventing the crowded spectacle as a vertiginous corridor. We feel the pressure of space as Bonnard's eye moves down it; passing the market barrow on the left, the chic young woman on the right, the yellow awning is wrenched out of 'normal' perspective. Against the all-pervading red – of buildings, women, fruits, and even of the foreground dog – the green tram asserts its unexpected beauty. Beyond, in deep space, a team of white horses hurtles towards us.

But in *La Place Clichy* of six years later, Bonnard distances all that bustle. Sitting at a café table, he has turned his back, to see the street only as a reflection, spread across a plate-glass window. The reverse-lettered

63

88

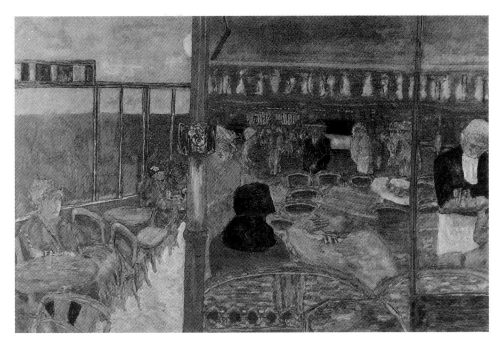

68 *Café 'Au Petit Poucet'*, 1928

awning becomes a decorative border; the animated crowd, a frieze.
Figures are seen *contre-jour*, the two waiters darkest of all under the
awning, the shadowed buildings beyond woven like a tapestry; only the
roadway is bright. The single yellow motor-car, together with the style of
hat, ties the image to the new epoch.

This six-foot canvas was painted for the library of George Besson,
who in 1928, when Bonnard had already been based in the south for
three years, commissioned a companion night-scene of exactly the same
dimensions. We know from correspondence that in Paris Bonnard went
evening after evening to a café on place Clichy, 'Au Petit Poucet', and
made innumerable small sketches. He again uses the mirror, looking
across the café terrace, past another reverse-lettered awning, to the more
distant street, where passing strangers are suddenly lit up as they peer in
at us. But this time the mirrored wall is juxtaposed, with marvellous
invention, to a left-hand segment, looking into the café itself in 'real'
space. It is very much the kind of visual paradox Japanese print-
makers such as Hiroshige delighted in. The divisions of the plane (more

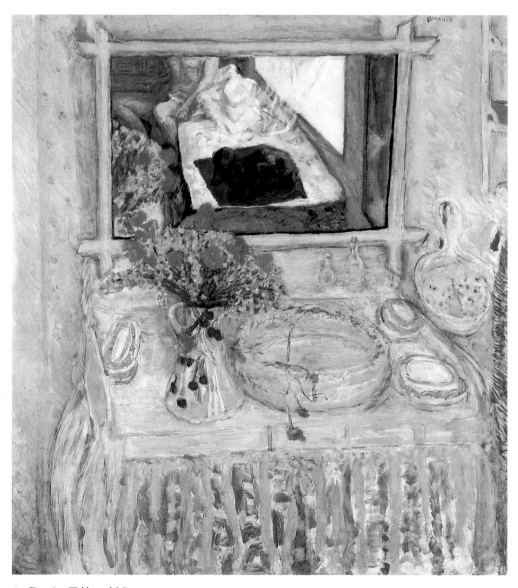

69 *Dressing Table and Mirror*, 1913

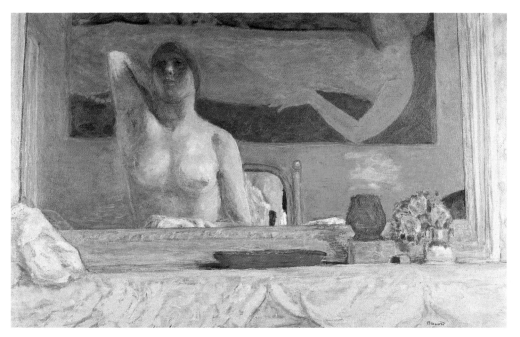

70 *The Mantlepiece*, 1916

complex and bewildering than any Degas) create a kind of parody trip-
tych, with the old bald waiter on the right standing in as a flanking
'saint'. More than Bonnard's earlier street scenes, this grand patchwork of
orange and purplish harmonies affirms the refulgence of modern urban
life in all its electric artifice, just at the moment when he had finally
abandoned Paris.

The mirror made explicit the contradiction in all his treatments of
pictorial space, both opening the wall, and slamming it shut – simultane-
ously extension and closure, deep and flat. As a hinge between the self
and the world the mirror makes both a rift, and a relationship; in
Merleau-Ponty's formulation, 'it transforms myself into another, and
another into the self'. *La Table de toilette au bouquet jaune et rouge* (known
in English as *Dressing Table and Mirror*, 1913) is one of several other close-
ly related images. The filmy, almost bridal whiteness of the foreground

91

still-life, with its delicate wild flowers and feminine appurtenances, is disrupted by the inhabited mirror-space: the shockingly dark sleeping dog, the window, and beyond, a fragmentary naked body, presumably Bonnard himself, sandwiched within the spatial trap.

Le Café (Coffee, 1915) is a beautiful formal conceit. The great slanting plane of gingham check (almost a Bonnard copyright, though painted each time with renewed invention) here fans out to meet the decorative border, which may be interpreted as a mirror frame. The gaze is fixed on Marthe and the dog, and the eye registers a kind of slippage to the right; below, a black oval locks all these orthogonals into place. The indigo rim below saucer and pot, and, above all, the strange blue shadow cast by the chair, indicate artificial light. Reproduction does not show how exquisitely the bare canvas of the table-cloth is set against the rich muddy impasto of the floor. Bonnard has, at a late stage, extended the composition several inches, beyond the lower edge.

70 *La Cheminée* (The Mantelpiece, 1916) has a more complex iconography, and the apparition of this beautiful grave bare-breasted girl seems altogether less 'accidental' than in his other mirror pictures. Her pose is based on a late Antique *Niobe*, while behind her is stretched a very stylized nude, apparently once given to the artist by Maurice Denis. In the midst of the war, Bonnard stayed at Denis's priory at St-Germain-en-Laye, and the two ex-Nabis may be imagined talking through some of the positions which both linked and divided them; between Classical and Primitive, between three-dimensional reality and the flat autonomous space of the painting; dilemmas which are literally 'reflected' in this enigmatic composition.

AN ALTARPIECE TO THE EPHEMERAL

72, 73 *La Salle à manger à la campagne* (Dining Room in the Country, 1913) is the culminating work of Bonnard's early years, and one of his defining masterpieces. The almost seven-foot scale is surprising, much larger than one might expect from reproduction, and larger than such an intimate space would seem to call for. The subject is not immediately evident, its inventory only slowly unpacked to our sight. We are placed this side of a wide expanse of milky, mother-of-pearl table-top, and at first we may think we are in an empty room, dominated by the bold central geometry of door and frame; until we find ourselves in eye contact with the shadowed figure off to the right. She looks in at us from outside the window; eventually we make out also two little kittens, and – perhaps quite some while later – a girl picking flowers in the garden. Yet once we have been

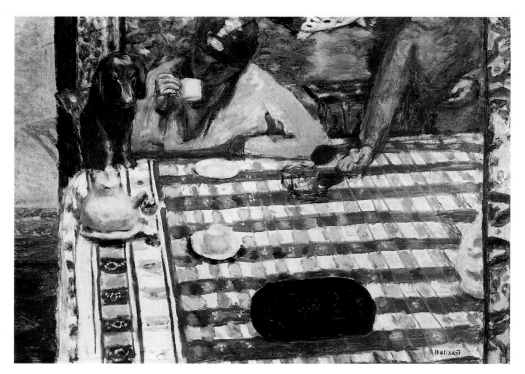

71 *Coffee*, 1915

made to glimpse Marthe, everything is charged with that relationship. The room becomes the vessel of an extraordinary tenderness, its red walls an extension of the red smiling figure. We might see the table as a kind of wheel, turning the successive planes one after the other as it shifts us from inside to outside, from red to green, from solitude to love. We are made to participate in a single enveloping moment of well-being.

When in 1931 Bonnard defined painting as *un arrêt du temps* (a stilling of time) he implied a view of time very different from Impressionist instantaneity – from Monet's serial moments of light. Bonnard could not go, like Monet, in search of his motif; the moment had already flowered, involuntary and unsought. For the *Dining Room in the Country*, the source seems to have been Bonnard's sitting at table, becoming suddenly aware of Marthe's presence; and the painting had to reconstruct the exact circumstances of that perfected moment. I once supposed those deep red walls were some drastically heightened or transposed hue – only to find

93

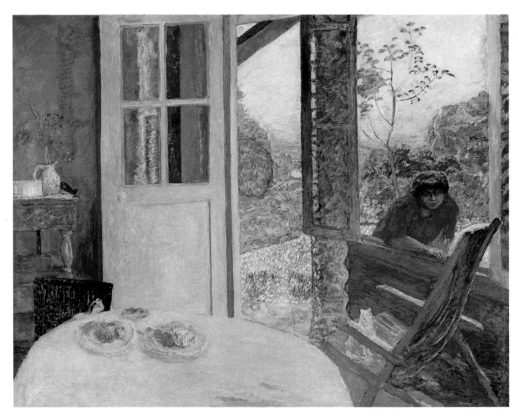

72 *Dining Room in the Country*, 1913

73 *Dining Room in the Country* (detail), 1913

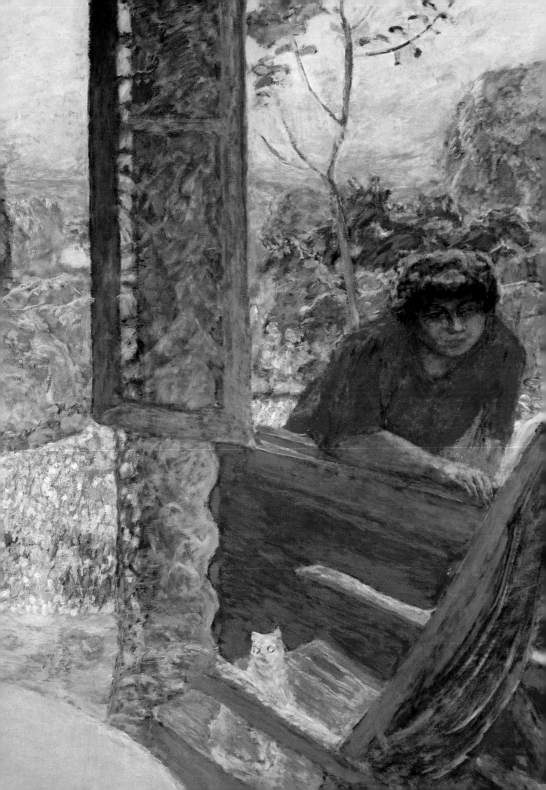

they did actually exist at 'Ma Roulotte'. Bonnard's transports are always tied to the topography of fact.

In Bergson's *Matière et mémoire* (Matter and Memory), published in 1896, memory 'creates anew the present perception; or rather, it doubles this perception by reflecting upon it, its own image...' Bergson's constant emphasis on the self, as 'rebuilding' or 'reassembling' the world in images (he is often seen as anticipating phenomenologists such as Bachelard and Merleau-Ponty), brings him close to the mode of consciousness we find in Bonnard. If the Impressionists had aspired to remove the ego from perception, Bonnard put it back again, registering the place of the specta- tor – Bonnard's own place – with a subjective emphasis new to painting. He employed the approximate qualities of Impressionist mark-making to stress subjectivity; the blur of Impressionism, to suggest the indistinctness of memory. Using Impressionist language for his own ends, for what Proust would call 'the search for lost time', Bonnard was reversing Impressionism, standing it on its head.

In *Dining Room in the Country*, Bonnard had at last achieved the large- scale *décoration* implicit in his Nabi beginnings. To monumentalize the glimpse, to make altarpieces out of the ephemeral – all that came partly out of the Symbolist 1890s, along with the perceptual insights of Bergson. *Dining Room in the Country* announces a new chapter in the tradition of the *grande machine*, that large-scale complex composition which had been the central glory of French painting, from Poussin to Géricault, from Courbet to Seurat. Impressionism has sometimes been seen as a radical break with that kind of set piece, to which its open-air immediacy seemed opposed. But when Cézanne spoke of 'vivifier Poussin sur nature' ('to bring Poussin to life by contact with nature') his example was as useful to Bonnard as to his more obviously Cézannesque contempo- raries. Bonnard too would create his own *machines* out of the material of perception – but perception freighted with the additional cargo of impassioned memory.

A Language for the Heightened Moment

Writing in the mid-1920s, very much under Bonnard's supervision, his nephew, Charles Terrasse, identified the early wartime as 'the years of anguish'. The year 1914 coincided with the onset of a personal crisis typical of mid-life, and at forty-six the painter was shaken by a terrible self-questioning. Looking back at his work, he found an absence of structure – a looseness of composition, as well as a lack of three-dimensional materiality. He set out to overhaul his art.

> I have sent myself back to school. I want to forget all I know. I am trying to learn what I do not know. I am restarting my studies from the beginning, from ABC...And I am on guard against myself, against everything that used to excite me, against the colour which intoxicated me...I was obsessed by colour. Almost without knowing it, I was sacrificing form. But it is absolutely true that form exists, and that it is not possible arbitrarily to reduce or transpose it. So I shall have to study drawing...I draw all the time.

While he never entirely ceased painting (certainly not, as is sometimes claimed, for two years on end) his creative centre did shift for the first time to drawing. Some of the sheets of about 1916 seem exceptionally intense, with a complexity of expressive mark not seen before. *Arbres et Maison* (Trees and House) is made with a raw, almost infantile circular scribble – heavy in the dark looming tree, wilder but much lighter in the sky above. To the left, a cumulus cloud is clearly outlined, so the sky-scribble on the right may not stand for cloud, but as a response to colour (perhaps to a very blue sky); or to a heaviness, to atmospheric substance. It would be several years before he found a fully equivalent way of painting.

The rather larger drawing of a factory (probably Thadée Natanson's munitions factory at Oullins, which Bonnard visited several times during the war) is no less fierce, but with an entirely different rhythm – abrupt and staccato, each emphatic line struck in separately. Made at very high speed, the marks build to a dense congested mesh, converging on the dark rectangle of the entrance. In the painting that followed (one of his

74

76

77

97

74 *Trees and House, c.* 1916

largest) much of this energy is suppressed for a decorative unity. The
slanting lines of the factory roof are lost; the angles of the stacked timber
in the left corner, as well as the hut at the top right, flattened and
'normalized'. Many of the vertical accents have also been removed. The
result is a grand but slightly inert design, which entirely fails to match the
excitement of his first drawn response.

Bonnard's mature drawing emerged from his dilemma as a painter: his
interest in the Impressionist path of 'sensation', but his inability to paint
directly from life. 'By the seduction, the initial conception, the painter
attains to the universal', he explained to Charles Terrasse in the 1920s.

> It is the seduction which determines the choice of motif, and corre-
> sponds exactly to the final painting. If this seduction, this initial
> conception vanishes, all that remains is the motif, the object, which
> invades and dominates the painter. With some artists, Titian for
> example, this seduction is so strong that it never forsakes them, even if
> they remain in contact with the motif for long periods. But I am very

75 *The Factory, c.* 1916

76 Drawing for *The Factory, c.* 1916

weak, and it is difficult for me to keep control in the presence of the object...

His drawing procedure allows him to respond directly to fugitive and momentary sensations, without being enslaved by naturalism. He encounters some fortunate conjunction or chance grouping – it may involve an effect of light or weather, or some more psychological moment of recognition. But it will be, by definition, transitory, and it needs to be recorded very fast; nearly always on a small sheet five or six inches across, in a soft and rather blunt pencil.

'The most important thing', Bonnard explained, 'is to remember what most impressed you, and to note it down as quickly as possible'. Swift drawing had long been one component of French art training. Baudelaire tells of Delacroix, out with his students, and pointing up at a high building. 'If you haven't sufficient skill to make a sketch of that man throwing himself out of that window, in the time it takes him to fall from the fourth floor to the ground, you will never be capable of producing big *machines*.' Bonnard's own paintings, sometimes of twenty square feet or more, are likewise dependent on drawings that are almost instantaneous; and this procedure explains why he declares 'Drawing is sensation, colour is reasoning'. He consciously reverses the academic doctrine he would have learnt as a student at the Beaux-Arts, by which drawing is 'intellectual', and colour 'sensuous'. For Bonnard, on the contrary, drawing is the immediate act; each painting, each area of colour, has then to be a reconstruction of that moment (partly from the drawing, partly from the memories these marks induce); a process of analysis and reinterpretation, across months, sometimes years.

Bonnard's graphic language is therefore a kind of substitute-painting; or, better, painting condensed and abbreviated. By the 1930s, when he made the sequence of water-and-land drawings illustrated at the end of this chapter, he had become extraordinarily adroit at recording every salient item of visual information. An enormous variety of separate marks – dots, ticks, circular scribblings, zig-zags, stripes and emphatic patches – appear in a drawing like *La Baie de Saint-Tropez* (The Bay of Saint-Tropez), tapping out a kind of unsystematized code for colour, atmosphere, effects of light.

In his Nabi beginnings, he had already shown a sharp eye for silhouette. Now he became infallible in the precise registering of his own position in space, so that the framing of each image corresponds exactly to the edge of the perceptual field. He was forced to reconsider the conventions of pictorial space, and especially the way traditional perspective suppresses

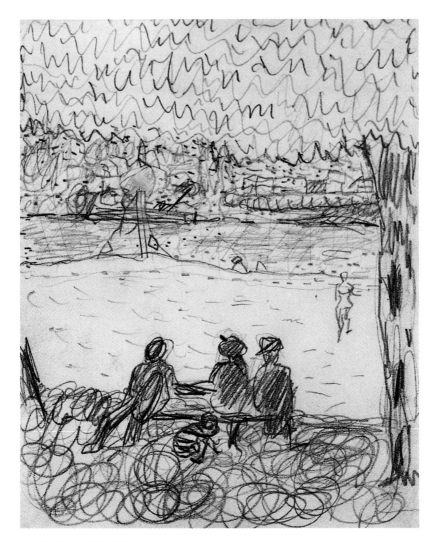

77 *The Bay of Saint-Tropez, c.* 1935

peripheral vision. He seems to have abandoned photography in 1916, exactly at the time his drawing procedures were overhauled; the Kodak was (in Kirk Varnedoe's phrase) 'a little Brunelleschi box', endorsing all the restrictions and fixities of Renaissance one-point perspective.

But Bonnard learnt instead to emphasize the mobility of the human eye, and its capacity to synthesize within a single image a sequence of

different perceptions. In *Matter and Memory*, Bergson had distinguished between two kinds of drawing:

> In the first, we manage by tentative efforts to set down here and there on the paper a certain number of points, and we then connect them together, verifying continually the resemblances between the drawing and the object. This is what is known as 'point-to-point' drawing. But our habitual method is quite different. We draw with a continuous line, having looked at, or thought of, our model…

Bonnard's allegiance is to the latter, everyday or 'informal' method, and against the staring, 'point-to-point' vision central to academic drawing. As Bergson's chief heir, Maurice Merleau-Ponty once put it: 'The world is not in front of us, it is all around us.'

Bonnard's drawing procedure is all about the speed of the intuitive mark, a kind of leap in the dark; and these marks have some of the quality of signs. Writing of Bonnard's friend and contemporary, Henri Matisse (1869–1954), Pierre Schneider has defined the sign as 'a form that has been made buoyant through simplification… condensed by the swiftness of the draughtsman's hand'. The sign calls attention to the act of drawing, whereas a more analytical or descriptive procedure will emphasize the object. Yet Bonnard's marks, however wild, never take on the autonomy of Matisse's; they remain always 'situated', tied to his own presence in the perceptual field. He drew on any available paper – cheque-book stubs, envelopes, scraps, as well as in his little pocket diary – and few drawings were sold or exhibited in his lifetime. It would, however, be wrong to categorize these sheets as preparatory studies – only a small proportion relate to paintings – or to dismiss them as 'slight' or 'sketchy'. They are the basis, the raw material of his greatest art, but they also often embody in themselves an extraordinary candour and transparency, of an exalted and exemplary kind. These modest little sheets force us to redefine our criteria for twentieth-century drawing. Beside Bonnard's 'disinterested' responses – each registering the exact configuration of each excited moment of perception – the drawings of his contemporaries can often appear rhetorical, stylized, virtuosic.

IN THE GRAND MANNER

Vernonnet is the next village to Giverny along the Seine, an easy walk, and Bonnard and Monet began to exchange visits before the First World War. After the death of his wife in 1911, Monet (1840–1926) worked in a kind of frenzy, let loose in his late seventies in a series of huge purpose-

78 Claude Monet in his studio with *Morning* for the Orangerie, Paris, *c.* 1924–25

built studios, with infinite supplies of paint and canvas. His *Waterlilies* can be as much as thirty-six feet in length; they exclude all anecdote, all 'composition', all spatial subjectivity. A true 'floating world' is embodied.

These astonishingly diffuse canvases may have influenced Bonnard in his own large-scale decorations. Late in life, he advised a young painter: 'Go in for large dimensions, they will show up your merits and your faults more clearly.' Throughout his forties, he continued to work on a mural scale, pursuing an ideal landscape whose imagery pulled in the opposite direction from his perceptual drawing. When he wrote later to George Besson 'I float between Intimism and Decoration', he was pointing to a fundamental division in his art, whose tensions could be further defined: the ideal, the Mediterranean, the diffuse, as against the everyday, the northern, the compressed.

In 1911 he completed a vast triptych, *Méditerranée* (The Mediterranean), for his Russian patron Ivan Morosov, and a year later, the eleven-foot

79 *Early Spring in the Village*, 1912

Premier printemps au village (Early Spring in the Village). Like many of his decorations it combines pastoral convention – the old goatherd by the side of the road – with contemporary bourgeois life: the mother who takes her little girl's hand as they climb. But all these figures are dwarfed to mere staffage beside an immense clump of varicoloured foliage – a disconcertingly obvious space-filler. *L'Eté* (Summer) was commissioned in 1917 by his Swiss patrons, the Hahnlosers. At eleven feet it was, the artist warned, 'more than double the size I had in mind at the outset – and therefore I have had to look for subjects more decorative than expressive'. There are genuinely poetic passages, such as the pale sun reflected in the pool, yet the general impact is, once again, of a vast sprawl of indeterminate leafage, whose 'greenery-yallery' seems to hark back to the most vacuous of 1890s dreamworlds.

80 *Summer*, 1917

Bonnard was still haunted by those Golden Age yearnings, those 'utopian moments', which he shared with Roussel, with the sculptor Aristide Maillol (who made his own suite of illustrations to *Daphnis and Chloe*), and even with the Matisse of *The Dance*. Mallarmé's *L'Après-midi d'un faune* would dazzle Modernist Paris when danced in Debussy's setting by Nijinsky in 1913. (Proust was at the première, in Misia's box, with Rodin and Renoir also in attendance.) In French culture, Arcadia still stood for a time before society destroyed human liberty – a nostalgia, and an aspiration, that would become all the more poignant in the midst of war. From 1916 to 1920, Bonnard worked on four decorations, commissioned by the Bernheims: *La Symphonie pastorale* (The Pastoral Symphony), *Le Paradis terrestre* (The Earthly Paradise), *Méditerranée* (The Mediterranean), but also, more unexpectedly, *Cité moderne* (Modern

105

City) – a scene set on a suburban bridge above the Seine. A tug-boat passes below, its billowing smoke rhyming with the great swags of evening cloud; from stage left, a group of young women are moving from a news-stand, towards the dark, half-naked figure of the manual worker. The distant factory chimneys identify this as Asnières, where Seurat had set his *Baignade* (Bathers) almost thirty years earlier. (It was among Bonnard's favourite paintings, and at one time was owned by Fénéon; a postcard of it was pinned to the studio wall in his final years.)

Like the Bernheim pictures, *L'Enlèvement d'Europe* (The Abduction of Europa, 1919) is at a more manageable scale, and is probably the most convincing of all Bonnard's mythologies. The foreground nude figures have some of the faux-naïf awkwardness of the sleeping children in *Summer.* But the great white bull is a marvellous invention, reading at

81 *Modern City*, 1916–20

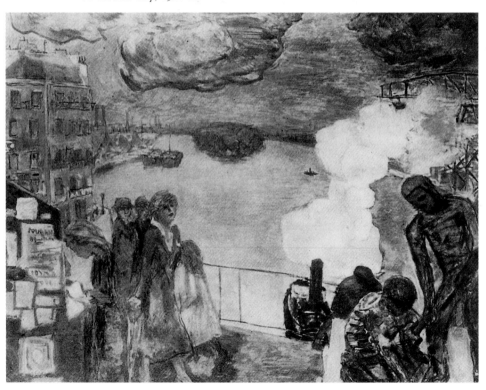

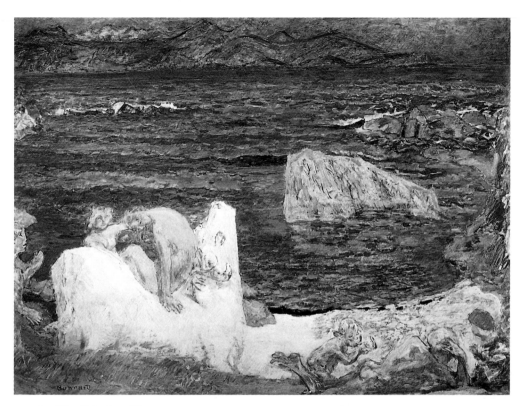

82 *The Abduction of Europa,* 1919

first as a kind of iceberg, in the midst of the hot sea – whose incredibly deep and radiant blue, sharpened by two streaks of black, transforms the brown of rock and sky into gold. This is essentially an actual landscape, the southern massif of the Esterel, which Bonnard had painted shortly before. The choice of theme may allegorize the fate of Europe after the war; but the picture is also a homage to Bonnard's favourite painter, Titian – to the great *Europa* now in Boston – and reflects a burgeoning love for all that was 'Mediterranean'.

By 1919, almost all European painting seemed engaged in that same romance. The tendency dubbed by Jean Cocteau 'The Return to Order' had many variations: the parodic neo-Classicism of Picasso or the more earnest neo-Giottesque of Carlo Carrà in Italy, where nostalgia for *Romanitas* was soon harnessed to fascism. Elsewhere also, the new Classicism has usually been viewed as reactionary – as a belated attempt to piece

107

together what had long since become irrevocably fragmented. After 1920, Bonnard painted only one further large-scale decoration, the enormous wall of the Palais Chaillot for the International Exhibition of 1937. *La Pastorale* (Pastoral) covered almost two hundred square feet, but it was by far the least successful of all Bonnard's mythologies – sentimental, faux-naïf, and almost entirely illegible. He recognized his defeat. 'The only chance I have ever had to work on such a large surface, and I failed to make good use of it, as usual.' His Age of Gold would eventually find embodiment, not in pastoral allegory, but in his humdrum everyday life, above the actual Mediterranean, in the midst of a second war.

'A TERRIBLE DISCOURAGEMENT'

It is often said of Bonnard that the two world wars leave no trace in his art. That is not literally true: in 1916 he journeyed with Vuillard to the battlefields of the Somme, depicting that ruined world in a sad little picture on his return. (The picture known as *L'Armistice* – a wild flurry of excited crowds and flag-waving – has been redated to 1916, and probably shows the Fourteenth of July celebrations of that year.) More generally, the war, in which France suffered well over one million dead, and three million wounded, may have been one factor in opening his art to a new sense of the tragic.

Bonnard continued to be based with Marthe in Normandy, but he had owned a car since 1911, and at least a month each year was spent along the Côte d'Azur – Saint-Tropez, Cannes (the first four months of 1917) and Antibes. Bonnard would stow a roll of canvases on the roof, in various stages of completion; many pictures would have been worked on in several different locations. Paris remained a draw (for a month or two, usually in winter) and most years they would also spend weeks on end confined, for the sake of Marthe's health, in a long sequence of traditional spa-towns: Uriage-les-Bains near Grenoble, Luxenil-les-Bains near Colmar, Saint-Gervais-les-Bains near Annecy, Arcachon near Bordeaux. The map of all these journeys implies many whole days spent on the road, and they stayed usually in third-rate hotels. Their thrift bordered on stinginess; as Annette Vaillant recalls, 'Shut in together in their narrow vagabond existence, they shared a fondness for discomfort.'

91, 92 *Le Bol de lait* (The Bowl of Milk) was begun in Antibes in 1919, at about the time Bonnard's new drawing procedures began to pay off. Standing before it at least a hundred times at the Tate Gallery, I had seen the picture as a nocturnal (or early morning?) retelling of *Dining Room in the Country*; a moment of domestic revelation, with Bonnard suddenly

108

83 *The Armistice, 1916*

glimpsing Marthe as she prepares a saucer for the cat. But the nine
preparatory drawings refute any such simple interpretation. They reveal 85
not one, but two figures – a woman and a young girl – engaged in some
activity with a basket. There is no cat. Whether she is Marthe or not, the
eventual girl is certainly our emotional focus; and yet she is placed far to
the periphery of vision, her pink gown almost lost in shadowy orange
warmth. The sharply falling table throws up its vivid still-life, and regis-
ters our position, so far to the left as to be off the picture altogether. This
potential wrench of space is stabilized by the flat design, centred on the
disc of the bowl itself, whose radiance, much enlarged in the course of
painting, reads almost as a light source. The right edge of the window falls
along the centre-line, dividing the picture in half, and is taken up again in
the vertical tail of the phantasmal cat, while the strongest accent of all is
in the shadow-stripe across the table. As so often in Bonnard, colours that
appear unified at a distance turn out to be complex and broken closer at
hand. The table is an unnameable scumbling of purple over green, just
as the 'milk' is not white. (It is far less bright than the thickly impasted

85 Drawing for *The Bowl of Milk*, 1919

patch on the vessel to its left.) The Mediterranean sparkles blue at the top, but between each balustrade, mutates to crimson. All this 'structure' and 'formal play' exists also as a mechanism, by which light has been made to break in upon the room's frowsy darkness, with the transfiguring shock of a metaphysical force. With her sightless eyes and grave hieratic stance, the girl becomes a priestess, assisted in her mysteries by her feline familiar. The everyday has been transmuted to the archetypal.

Marthe had become a difficult partner in the war years, discouraging even his closest intimates from visiting, and, according to Thadée Natanson, 'alarming everyone around her (and herself) about her health'. In the middle of the war, Marthe and Pierre were staying with him at Oullins; one morning at dawn, Bonnard came downstairs, haggard after a night beside Marthe, who'd suffered another collapse. Natanson recognized in his old friend 'a terrible discouragement...the voice of despair'. Bonnard is known to have had at least two serious love-affairs with much younger women who modelled for him: with Lucienne Dupuy de Frenelle, who appears in several pictures of 1915–16, and who is probably the haunting figure of *The Mantelpiece*; and, perhaps beginning around 1917, with

84 Bonnard and Marthe at Vernonnet, *c.* 1920. Photographer unknown

86 *Renée Monchaty*, 1921

87 *Young Women in the Garden*, 1921–23 (reworked 1945–47)

88 *Decoration at Vernon*, 1920–39

Renée Monchaty. Much of the story still remains shadowy, but the out-line can now be given as follows. Renée, known as Chaty, was, according to Sacha Newman, 'a statuesque blonde who fulfilled Bonnard's vision of more monumentally classical forms'. Bonnard was now in his fifties, and Renée, an aspiring young artist, still in her early twenties. In 1921, they spent two weeks together in Rome, where they met her parents, and obtained their permission to marry. But in 1923, when Bonnard found himself unable after all to abandon Marthe, Renée committed suicide. The circumstances are unclear; one account told of Bonnard himself discovering Renée in Rome, drowned in her bath; our view of his final Bath pictures could hardly go unaltered. But it now seems established that she (after, according to Hahnloser, 'filling her bed with white lilacs') shot herself with a revolver.

Marthe is known to have insisted Bonnard destroy the pictures record-ing his involvement with Renée, but one at least survives. *Jeunes Femmes au jardin* (Young Women in the Garden) seems centred on the conjunction of fruit and golden-haired girl, until we recognize Marthe's cornered,

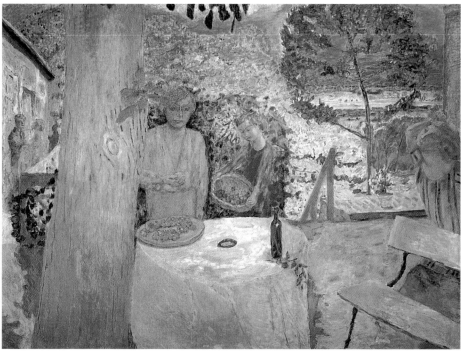

unsmiling profile; the structure extending between them, presumably a garden seat, could as well be an instrument of torture. Begun in 1921, the picture was reworked a quarter-century later, after Marthe's death, and shortly before Bonnard's own; he added the great swathe of yellow, as though to confer on the dead girl all the redemptive value gold came to signify in his final vision. *Piazza del Popolo* comes out of a drawing made in Rome, and may embody another allegory of choice, with Renée on the left, and Marthe the green-veiled woman cut off on the right; between, a third figure holds aloft the weighing scales.

88 *Décor à Vernon* (Decoration at Vernon) also seems to incorporate some half-buried narrative. In 1918, Bonnard had completed the first of two very large-scale views from the terrace, looking down on the Seine. (The version of 1928, illustrated here, would be the more intense.) Now, in

89 *Piazza del Popolo*, 1922

90 *The Terrace at Vernon*, 1928

1920, the same vista is the setting for an enigmatic staging. In the saturated evening light, Marthe stands behind a table, holding an apple plucked from the bowl, eyes downcast but splendid in her orange-gold: a goddess, Pomona or Juno. A young girl attendant brings a basket of plums, as if in homage. But from the right, there enters another figure – a golden girl with arm raised, as if to strike Marthe. (The Antique source of her gesture, in the Louvre, shows a Roman legionary slaughtering a Gaul; here, she wields not a sword, but a tennis racket.) And it has been suggested that Marthe feels at risk also from the small figures to the left, perhaps chattering or gossiping about her. The artist continued to work for the next twenty years on this haunting composition, whose most compelling element is perhaps the foreground tree, a wide, flattened pinkish-violet band passing vertically across the entire surface. This fleshy trunk seems to stand as surrogate for Bonnard's own presence in the scene: as covert observer, as stretched integument.

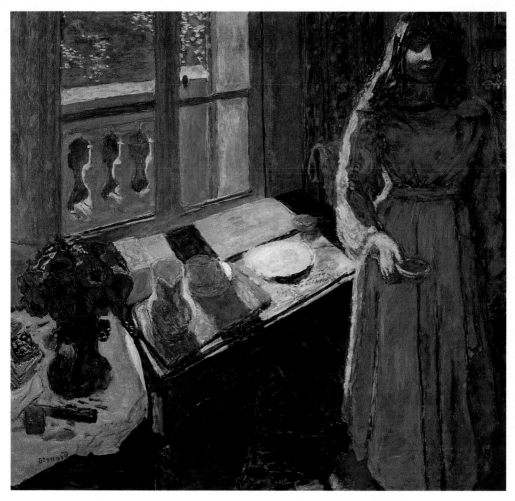

91 *The Bowl of Milk*, 1919

92 *The Bowl of Milk* (detail), 1919

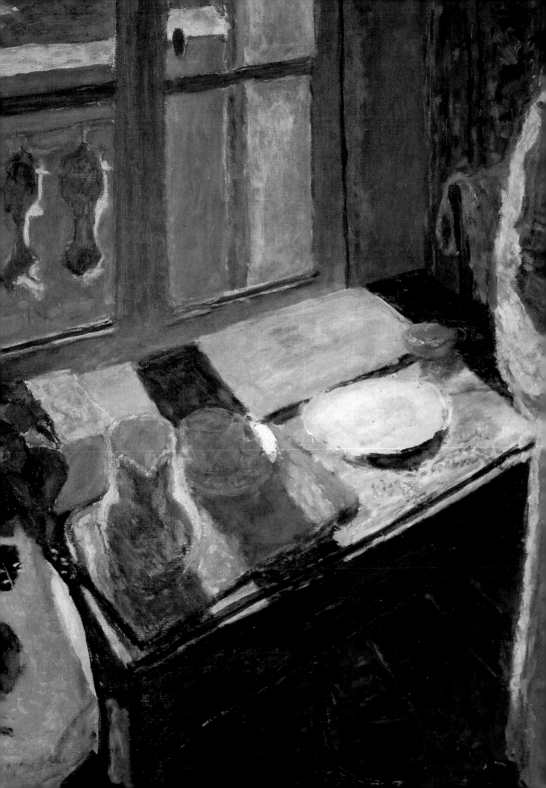

In 1912, Thadée Natanson had described Bonnard as tall but stooped, shy and shortsighted, waving his arms about with 'almost random gestures'. Around 1920 his art takes on a new intensity, a power of colour and strength of form (which may correspond to the affair with Renée Monchaty), and he paints *Autoportrait à la barbe* (Self-Portrait with Beard), a kind of sunburnt Adam, or primitive hunter, hirsute against what looks like a forest fire. The gaze is swift and penetrating, and not in the least myopic. The little picture known as *Conversation dans le parc* (Conversation in the Park) has a joyous immediacy of colour, clashing and sizzling around the vermilion-orange slab of the central dress. The black-suited male is contrasted to the three radiant women, but between Marthe (second from the left) and the young girl on the right, Bonnard creates no obvious tension. (We are in the era of the universal and unisex floppy hat – that beach-hat which seemed, to the photographer Alexander Lieberman, so redolent of Bonnard's quest for informality and ease.) The hot intensity of very bright sunlight may suggest the Midi, rather than Normandy.

Signac et ses amis en barque (Signac and His Friends Sailing) was begun early in 1914, when Bonnard returned from a visit to Saint-Tropez, but the picture's gestation spanned the entire difficult decade to 1924. Signac is the floppy-hatted helmsman at the centre; but in this most elemental of images, the figures are only foil to the tremendous clash of sea and pivoted sail, as the great wedge of the boat rushes forward. The sail's huge expanse of creamiest white fills one quarter of the picture's surface, whiteness asserted almost as a principle, set against some of the deepest blues in all art – crimson/brown/blue darkness all around them, and streaked blue billows pushing back to the purplish horizon. We might guess at some of the adjustments made over all the years it remained in the studio: widening the sail at top right, breaking the horizon (probably with another boat) at the left, rimming Signac with blue, and the mast and top edge with a greener blue. The result is a wonderfully achieved formal mastery, where every descriptive element is also a structural one: the lines of the ropes, the two dead birds on deck, the jigging wild shapes in the water, and the pale green of the island, touched with gold – all are raised to a symbolic intensity.

In 1924 Bonnard was asked by the Hahnlosers to make a kind of group portrait, of the Swiss family afloat in their beloved yacht in the south of France, for their house in Winterthur, where they still spent most of the year. Coming so soon after the Signac picture, it seems

93 Bonnard and his Ford, 1923. Photograph by Jacques Salomon

94 *The Sailing Excursion*, 1924–25

a milder, smaller pendant, almost a spin-off. Yet this too involved great difficulties. Bonnard had already exhibited the picture at Bernheim's, when he had misgivings, and insisted on reworking it. 'Seldom have I bungled anything so completely', he explained to Mrs Hahnloser. 'All one sees is the white of the sail.' When he'd completed his modifications (above all a darkening of the blue of the sea) the sail appeared to have shrunk, though only the colours had changed. 'The impact of colour

95 *Signac and His Friends Sailing*, 1914–24

alters proportions completely. This was a surprise and a lesson to me.'

Once Bonnard became settled in the Midi, the sea in all its changing moods, and all the varieties of boat and sail, would become the subject of hundreds of drawings; but not, significantly, of many paintings. Even the Hahnloser picture is less elemental than human; one relishes the wit of the daughter's foreground profile (a meandering line that could be the trail of an insect). At the Zurich Kunsthaus, the Signac boat now

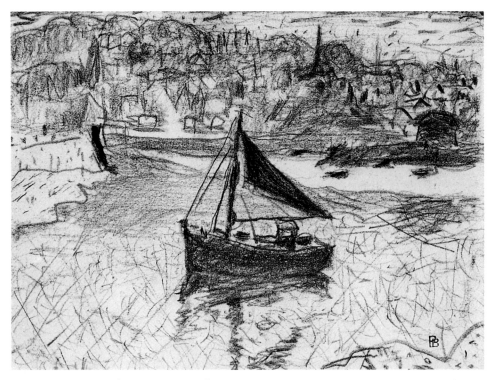

96 *Fishing Boat at Deauville, c.* 1935

hangs in sight of a Monet *Waterlilies* painted about the same time, and roughly four times the scale; reluctantly, I found myself recognizing that the Bonnard looked a little tame beside it. As elemental art, Monet is unrivalled. But Bonnard's art is essentially human-centred, and his supreme achievements after 1925 are mostly interiors, their waters confined to the bathroom.

WORKING AND REWORKING

Bonnard's working practices seem to have crystallized in the 1920s, remaining more or less unchanged for the remainder of his life. One may summarize his technical procedures by collating eye-witness accounts from several different sources.

The starting-point of almost every later painting was a moment of seeing; each composition was to a large extent 'given', arrived at

intuitively in the act of making a small pencil drawing, in the five or fifteen minutes he spent on the spot. Then, sometimes immediately, sometimes only after a gap of several years, he made a decision about scale – but not about exact format – and began a painting. His practice was to cut and pin to the wall a length from a roll of ready-primed canvas, often beginning several pictures within the same large piece and of totally different subjects – a nude, an interior, a still-life – all fitted in side by side. It was a procedure that emphasized the artificial and non-illusionistic aspect of painting, especially when (as some contemporary photographs confirm) the canvas area was surrounded by the violently flowered wallpaper of some rented room. He found working within the standard stretcher formats 'intolerable':

> That's why you don't see any stretcher. I like to work always on a piece of unstretched canvas larger than the final image. This gives me room

97 *Beach at Low Tide, Arcachon, c.* 1930

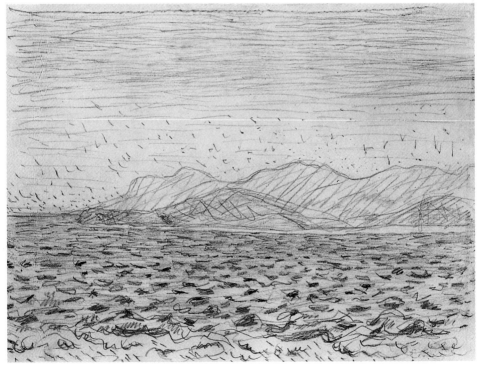

for alteration...For each landscape you need a particular ratio of sky to land, of water to foliage, and it is not always possible to judge the dose right from the start.

Here is Charles Terrasse's account, from the mid-1920s:

He sometimes used a hotel room as a studio, and would tack a piece of canvas on the wall and begin work, singing. First he would draw in charcoal the basic lines of each composition, working from a quick sketch...Then, little by little, the painting took shape – but never quickly.

From that point on, his procedures were geared partly to keeping the surface fresh and informal. As he told a fellow-artist, 'I like a canvas not to look wearied by the brush.' One hears variously, that he used two palettes (one cold, one warm); that he mixed each colour on a separate plate; or – as is confirmed in several photographs – that he allowed layer upon layer of crusty paint to build up on his palette, thereby building in an element of chance 'impurity'. The reality must be that he had several different ways of working, and we need to be wary of any too definite assertion.

In the early 1920s a Mexican painter, Angel Zarraga, met Bonnard when he was working in a hotel room at Cap d'Antibes.

During my first visit, all the canvases were white. The whole room radiated from them. When I came back a few days later, I saw on every one of them a few colourful accents whose pictorial meaning was not at all recognizable...He simply walks back and forth between the white surfaces, waits for an idea, sets here a tone, there a brush stroke, puts several streaks on a third canvas. After a little while...he lays down his brush, calls his dog, who is always near, and goes for a walk with him on the beach. He chats for fifteen minutes or a half-hour with acquaintances he meets and then abruptly but gently he breaks off the conversation and returns quickly to his room...Weeks, even months, pass in this way.

Félix Fénéon records a visit to Le Cannet, probably in the late 1930s.

With four drawing-pins he had tacked a canvas, lightly tinted with ochre, to the dining-room wall. During the first few days he would glance from time to time, as he painted, at a sketch on a piece of paper twice the size of one's hand, on which he had made notes in oil, pencil

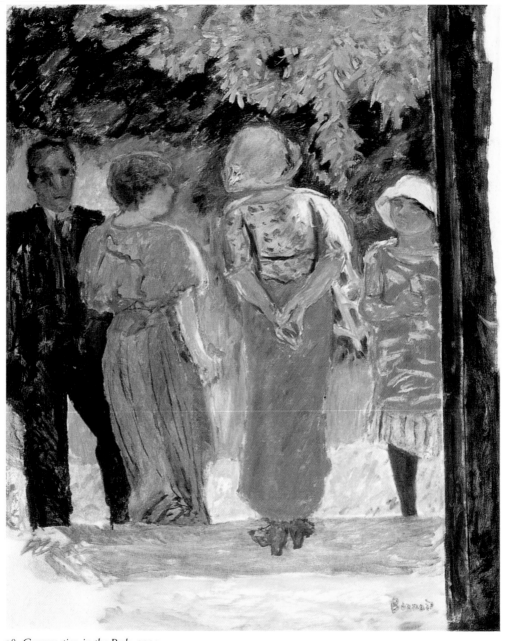

98 *Conversation in the Park, 1922*

and ink of the dominant colours of each little section of the motif. At first I could not identify the subject… On the eighth day I was astonished to be able to recognize a landscape in which a house appeared in the distance, and a young woman on a path, with a child and two dogs beside her. From that moment Bonnard no longer referred to his sketch. Occasionally he would place a dab of colour with his finger, then another next to the first. On about the fifteenth day I asked him how long he thought it would take him to finish his landscape. Bonnard replied: 'I finished it this morning'.

Few works were completed so easily, and the process was often one of subtraction rather than addition; he worked he said 'with brush in one hand, a rag in the other'. According to Charles Terrasse, 'He would customarily put aside a picture when it was nearly finished. After weeks or months, he would take it up again, seeing it with a fresh eye, finding a definitive solution, modifying, accentuating…' Eventually, the canvas would be cut out and stretched, and perhaps framed. But then there was a procedure known to Rouault and other fellow-painters as 'Bonnarding'. 'Sometimes, having mixed one of his burning hues… and applied it to the work in progress, he would wander around the house from canvas to canvas, finding little places where he could insert what he had left over.' Bonnard was also known to retouch his work even after it had left his possession: 'I always carry in my pocket a little box with some colours ready in it. When I come across one of my canvases that displeases me, out comes my little box, and I fix it.' In the most famous yarn of all, the artist once persuaded Vuillard to distract a guard at the Musée Luxembourg, while he surreptitiously reworked a painting that had been hanging there for several years. When we see the freshness and apparent spontaneity of Bonnard's late works, it is difficult to imagine the extent to which each is an accretion of endless separate reconsiderations. As Bonnard put it at the very end of his life, 'In art, reactions are the only things that count.'

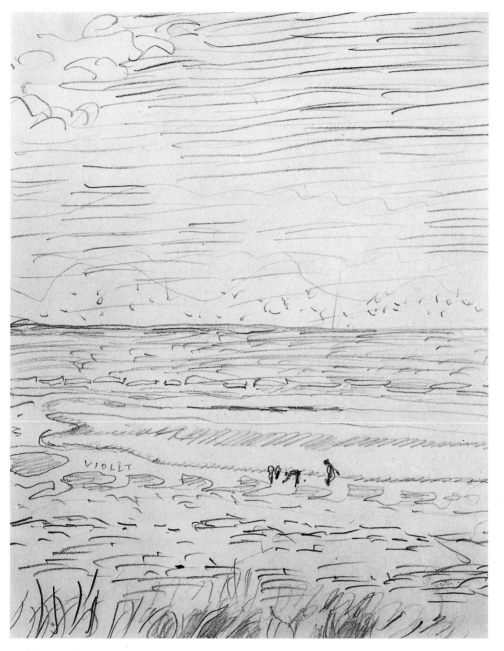

VIOLET

99 *The Bay of Cannes, c.* 1938

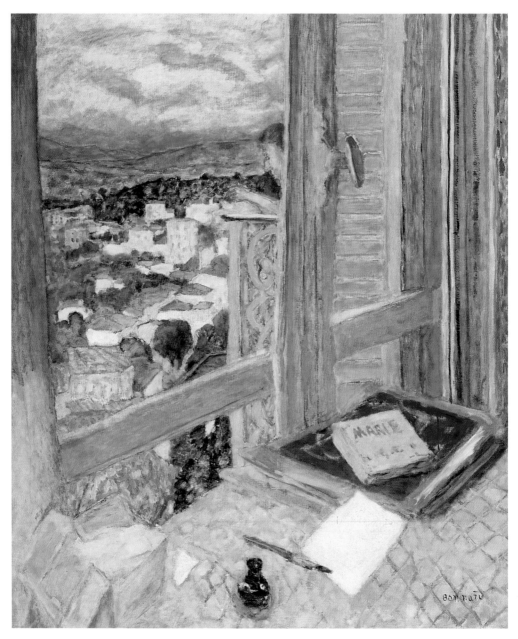

100 *The Window*, 1925

The Life with Marthe

The full importance of Marthe in Bonnard's work has only recently been recognized; when Charles Terrasse's monograph was published in 1927, she remained altogether unmentioned. Yet after 1923 his art becomes 'about' Marthe, centred in this single person, to a degree unprecedented in any earlier painter. Marthe has come to be seen as in some sense the driving force of his art; in the words of the painter Sargy Mann, 'I believe that it was his desire to draw and paint her, more than anything else, that brought about the development of his style, from its brilliant decorative beginnings, to the formal strength and realism of its maturity.' She was by the 1920s a 'touchy elf', whose speech was 'weirdly savage and harsh', who dressed eccentrically, who hopped about on very high heels like some bright-plumaged bird; and Bonnard's depiction of her incorporated elements of comedy, of affectionate absurdity.

In 1925 after thirty-two years together, Bonnard married Marthe at last; they had been spending more and more of each year together in the South, and his purchase of the villa 'Le Bosquet' at Le Cannet the following year represented a further conclusive commitment to her. But their relationship was now one of confinement. She has been described (by Nicholas Watkins) as his 'muse and gaoler'. Thadée Natanson recalls Bonnard slipping out 'to walk the dog', then joining friends surreptitiously in a restaurant, appearing before them carrying his canine accomplice in his arms. She was described as suffering from a 'persecution complex', and she disliked other artists visiting Bonnard in his studio, fearing they would 'steal his tricks'. The Hahnlosers referred to her as 'Marthe the Demon'; Annette Vaillant characterized her as 'an uneasy, tormenting sprite'.

Marthe's health-worries became ever more dominating, though their precise nature remains, like so much else about her, tantalizingly unclear. Various dietary régimes were prescribed; we hear of 'supplements of sardines mashed in cod-liver oil' – to combat anaemia – and of the couple 'eating very raw red steaks to fortify Marthe'. At some time early in the century she had adopted a pattern of spending several hours each day in the bathroom. This has usually been attributed to some kind of cleansing

mania and has been an important constituent in the overwhelmingly negative picture of Marthe that has come down to us. To quote John Berger: 'a tragically neurasthenic woman; a frightened recluse, beside herself, and with a constant obsession about washing and bathing'. Yet, as Sarah Whitfield has shown, Marthe suffered, and would eventually die from, tubercular laryngitis, for which in France a hydropathic régime was a frequent prescription, and this typically entailed several immersions each day. Probably hydropathy also explains the Bonnards' continuing visits to various French spa-towns. Marthe may have been less mad, and more ill, than we have supposed.

100 *La Fenêtre* (The Window) is one of several pictures of the mid-1920s that might be described as coded messages from prison. It seems at first a rather innocuous, almost vacant image, much taken up with the formal interaction of vertical and horizontal, of window frame and shutter, of brown and green – the patterned geometry that compresses our plunge outwards into the Midi landscape. Writing at the window (not of 'Le Bosquet', but of an earlier rented villa) Bonnard has looked up, to glimpse momentarily the profile and single arm of Marthe as she appears on the apple-green balcony. It could be a moment of loving recognition, a sighting of the muse. But Bonnard has placed on the desk *Marie*, the novel he had illustrated and for which the young Marthe had posed early in their life together; its theme, we may recall, was of an upper-class man who returns to his lower-class lover only when she becomes ill.

 The Monchaty affair must have been a terrible experience for Marthe, and in the portrait of 1925 she still comes across grim and devastated; she often referred to herself as 'ravaged'. She had been galvanized in the early 1920s, into taking painting lessons, and in 1924 she had exhibited in Paris under the name 'Marthe Solange'. Thadée Natanson commented: 'She resolved to paint in the same way as, or in opposition to, another person in their entourage by whom she felt threatened.' This was presumably Renée Monchaty. Annette Vaillant, who knew Pierre and Marthe at Le Cannet, wrote: 'He looked after her, feared her, put up with her; her identity almost merged with his in the constant anxiety she caused him.' In the aftermath of Monchaty's suicide, Bonnard's involvement with Marthe seems to have been rekindled in a new way – as a kind of convergence, almost an infection, by which the artist entered into her experience, centred especially on her life in the bathroom.

102 *Baignoire* (The Bath), probably begun at 'Ma Roulotte' in 1925, has been interpreted by Nicholas Watkins as witnessing the bleakness of Bonnard's vision at the moment of marriage. 'Marthe is stretched out like a corpse in the stillness of a watery grave…uncompromisingly rigid and

101 *Portrait of Marthe*, 1925

anaemic in colour, it is a cold painting that speaks of uncomfortable events, troubled dreams and blighted hopes.' Certainly there is something disagreeable about her purplish mottled head, so oddly separate from the underwater body. But I take this picture also to be the beginning of Bonnard's striving to 'become' Marthe, even in her numb reverie.

In Gabriel Josipovici's novel *Contre-Jour*, the bathroom is a place of refuge for Marthe, where she can 'recover her composure'. She lies with her eyes closed, imagining herself in the garden: 'I step forward to smell

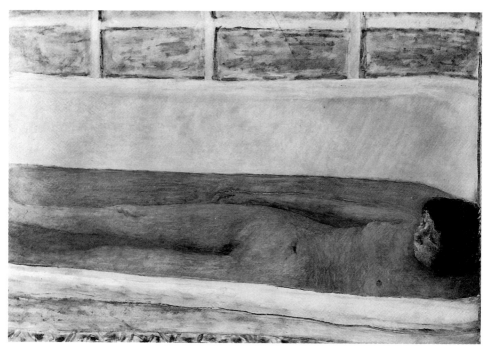

102 *The Bath*, 1925

a flower, and bang my knee against the inside of the bath.' But the bathroom is also where Bonnard settles down 'with pencil and paper in one of the chairs in the corner', where Marthe feels herself constantly 'put under observation': 'It is intolerable to be looked at like that, dispassionately, relentlessly day after day...the intensity of his gaze, its impersonality'. Josipovici explores the confusion of identity often evident in the bathroom pictures; their lyrical intensity, Bonnard's blaze of exalted colour and numinous light, inextricable from Marthe's fevered imaginings.

THE SOUL OF AN INTERIOR

The villa 'Le Bosquet' has been described as 'a type of modest chalet built by speculators for the retired' and it was at the time of Bonnard's purchase a somewhat flimsy and characterless house, redeemed chiefly by its position in the landscape, high above the Mediterranean. Several improvements were made, notably a tiled bathroom, and they finally

took possession in 1927. But they still kept on the Normandy house (until 1938), as well as the Paris apartment and studio. As the artist explained in 1933 to Pierre Courthion,

> I don't spend much more than two months in the year in Paris. I come back in order to keep in touch, to compare my paintings with other paintings. In Paris I am a critic, I can't work there: too much noise, too many distractions. I know that many painters get used to that life. For myself, it was always difficult.

Over the next twenty years, he would complete at least 150 works set inside 'Le Bosquet', and it is possible to explore the house as if through Bonnard's eyes, its spaces unfolding as in a film. In 1904, Julius Meier-Graefe had written of Vuillard: 'No artist has ever so suggested the soul of an interior – the sense of habitation.' In the closed world of 'Le Bosquet', Bonnard fulfils the Intimist project. The phantasmal Marthe, a year before her death in 1942, is glimpsed in a beautiful watercolour, *Le Radiateur* 104 (The Radiator), as she glides through the bathroom door into the small sitting-room, carrying a tiny cup; and the same room is evoked again, this time transformed by electric light, in a marvellously atmospheric little pencil drawing.

103 *Interior of the Small Sitting Room at Night, c.* 1940

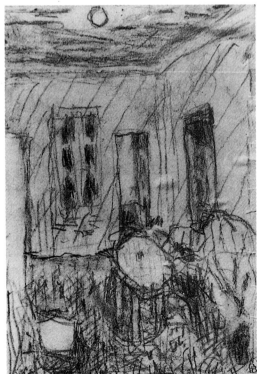

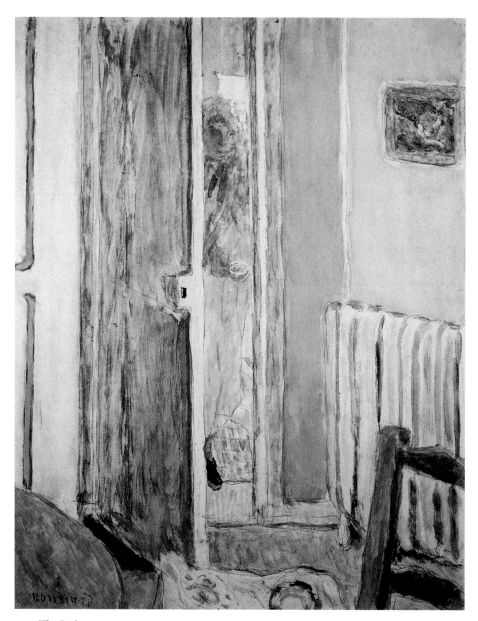

104 *The Radiator, c.* 1941

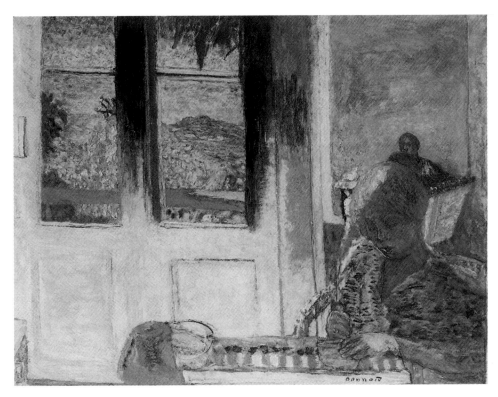

105 *The French Window*, 1929

Of the dining room, there are almost sixty paintings. *La Porte-Fenêtre* (The French Window) is a divided image. On the left, we pass through the window into the world beyond, down to the blue sea; on the right, we see Marthe close to us, preoccupied, set apparently against a blank wall. Yet on closer inspection, this yellow area is revealed as a mirror (another deep space, but this time closed off) and we recognize above Marthe's head the tiny distanced presence of Bonnard himself. The juxtaposition of blue landscape – seen only through the black bars of the window frame – and yellow mirrored room, creates an extraordinarily explicit sense of interior and exterior, as parallel but separate, and possibly opposed, zones. Writing about a picture like *The French Window*, one can create, all too easily, a psychodrama. Nevertheless, some acknowledgement that Bonnard's late interiors are more than topography – that they

135

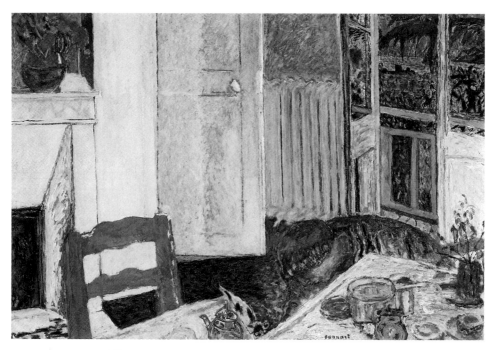

106 *White Interior*, 1932

witness rare and psychologically charged moments – seems essential if we are to give these images due weight and significance.

Bonnard wanted, he said, to 'show what one sees on first entering a room, what the eye takes in at one glance; one sees everything, and at the same time nothing'. In *Intérieur blanc* (White Interior), the French windows are now open to the balcony, and the colour is so arranged in its white and gold as to create at first the feel of an empty room. Marthe, bending at the table as she feeds the cat, is made nearly invisible, merged with the reddish plane of the floor, and displaced by the orange chair, so naïvely silhouetted but so commandingly present (and reminiscent of the foreground chair in Renoir's *Moulin de la Galette*). *White Interior* is extreme in its spatial flattening. The foreground mantelpiece should, after all, be at right angles to the radiator, yet both are rendered in the same plane, as is the door between. This door is itself divided, between a dark yellowish grey, and a lighter and colder off-white; while beside the mantelpiece, and again on the far right, a still brighter lead white is thickly

impasted. Bonnard does not hesitate 'to take', as he put it, 'all possible liberties of line, form, proportions, colours, to make feeling intelligible and clearly visible'. In his own repeated declaration, 'il faut mentir' – one has to lie. Here, Marthe herself and the foreground still-life are very much smaller than they would 'really' be, and the little teapot appears almost absurd beside the enormous, more than life-size, chair.

As he moved about the house, Bonnard's heightened moments – or ecstasies – were often set off by chance groupings of objects. In *La Moulin à café* (The Coffee Grinder), the dark vessels are embedded in the golden substance that surrounds them; to the left, the pale yellow wall fuses seamlessly with the unnameable round object below. If Chardin depicted the dense materiality of things, Bonnard in his still-lifes tends to dissolve them. In the very long-format picture now in Basel, many of the forms are enigmatic and the sense is of a sequence of riddles, reinforced by the half-occluded book which gives the painting its title VENUS DE [CYR]ENE,

107 *The Coffee Grinder,* 1930

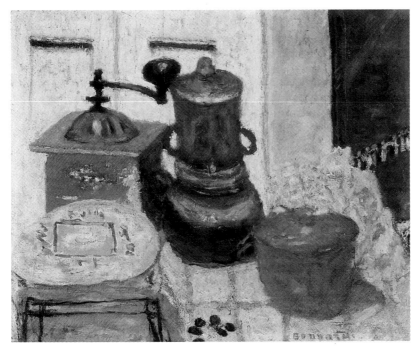

and two further even less legible inscriptions. We seem close to the word-play of 'hermetic' cubism, or to those arcane words inscribed within several Beckmann still-lifes of similar date.

But Bonnard's greatest still-lifes are those loaded tables, nearly always presented to our gaze in association with Marthe and as part of a complex domestic setting. In *La Table* (The Table, 1925), it is at first the great white cloth, the apron-stage, with its array of fruits, plates, baskets which almost hypnotically compels our attention. Marthe seems no more than a small background figure preparing food for the dog. Then, as our eye wanders from object to object – clusters of apricots, a bowl of dark berries – each one is revealed as strangely discarnate; it is Marthe who remains, as in *The Window*, the determining presence. This marvellous still-life is almost a decoy, each of its incidents a device for slowing us down, for suggesting the accretion of separate perceptions into one essential moment of seeing. It is, writes David Sylvester, 'more like the process of recalling than it is like the process of looking at something which is actually there'. What Bonnard cherishes is not so much the still-life as its association with Marthe, and with a moment stilled and perfected.

The Table probably shows the dining-room at 'Ma Roulotte'. Five years later, while staying in a rented villa at Arcachon, Bonnard embarked on the five-foot high *Salle à manger sur le jardin* (usually known in English as Breakfast Room), with its glorious foreground still-life, and recession into the leafy distance beyond. The inside/outside tensions he had

108 · *Still-Life with Bouquet*, 1930

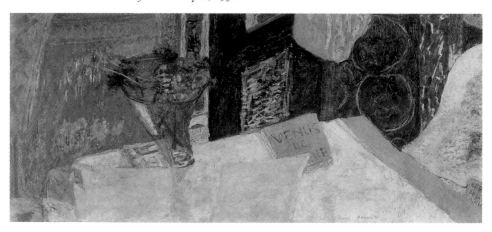

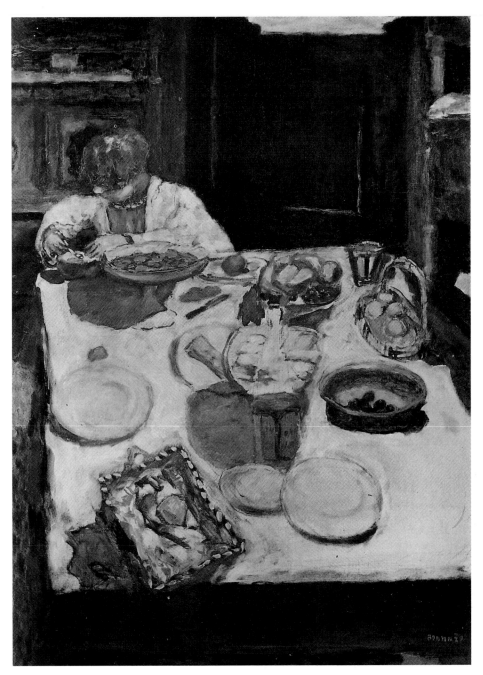

109 *The Table*, 1925

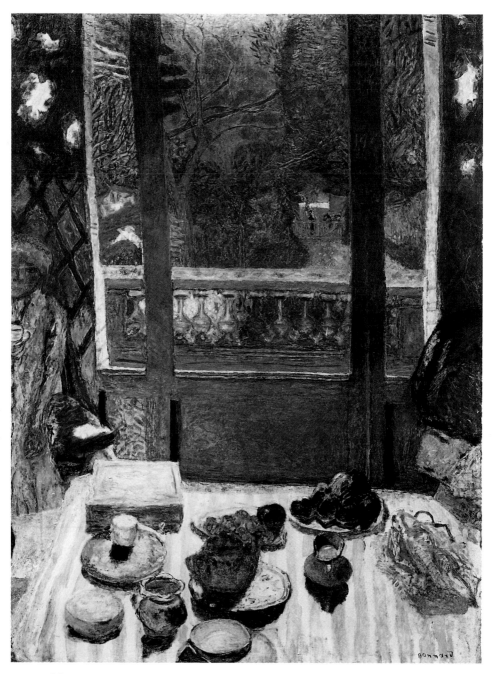

110 *Breakfast Room, c.* 1930–31

recently explored in *The French Window* are taken up again. There also, he had drastically darkened the vertical window struts, forcing the eye to pass beyond them into deep space, and here the Indian yellow wall is suddenly before our eyes transformed to a dark greenish-grey. Such effects might come under the category Bonnard called 'distortion for visibility's sake'; and these shifts and sequences also register the penumbra of vision, mimicking the iris as it expands and contracts in its passage around a room, often uncertain what it is seeing. Thus the form on the right, near to us, remains altogether enigmatic – variously identified as a shoulder and arm, a human profile, or a dog's. But the nub of the picture is the tiny cropped half-figure of Marthe, who stands on the left periphery, cup in hand, staring intently – perhaps with hostility – out at us. This woman, backed against the pink latticed wall, seems like some terrible diminished counterpart to the girl of *The Bowl of Milk* a decade before. In picture after picture, Marthe is now seen out of the corner of the eye, felt at the margins of consciousness.

'THE MAN FREED FROM THE ORDER OF TIME'

An art whose basis is the heightened moment has very different frontiers from an art of representation. Bonnard associated the first conception of each picture with a sudden involuntary heightening of experience: 'The emotion surges up: the shock is instantaneous, often unforeseen'. A note of 1936 reads: 'Consciousness. The shock of feeling and of memory.' The word 'epiphany' may carry overtones too specifically Christian to be appropriate for Bonnard. Its dictionary definitions include 'an appearing'; 'a showing'; 'any moment of great or sudden revelation'. 'Ecstasy' may be better, conveying more of the sense of movement; it is a 'standing out', or 'displacement'. Certainly Bonnard's paintings often communicate experiences that could be paralleled in the literature of mysticism. (I think of the glow of light on a pewter jug that triggered Jacob Boehme's ecstasy, or Thomas Traherne's retrieval of infant rapture.) Such moments entail a double motion: outwards, towards the scene or object, which one suddenly perceives as if for the first time; yet also inward, in a 'coming to oneself', a rediscovery of the fullness of being.

It is this paradox, of losing and *thereby* finding the self, that aligns Bonnard's vision with that of his near contemporary Marcel Proust (1871–1922) in his vast novel *A la Recherche du temps perdu* (a title virtually untranslatable into English; published as *Remembrance of Things Past*, but literally 'In Search of Lost Time'). Proust had been a schoolfellow of Denis at the Lycée Condorcet, and intersected with Bonnard at many

points in his life. We know that the artist read *A la Recherche* probably before 1925, and reread it after 1940. Proust's artist-character Elstir may contain a component of Bonnard (he may be Monsieur Biche, 'Mr Bitchy', at Madame Verdurin's *petit cénacle*, or little group), but the real identity is with the narrator, 'Marcel'; just as Proust writes the book of himself, so Bonnard will paint the picture of himself. Bonnard's self, like Marcel's, is not that fixed and continuous character of our usual social being. What he has to record is a sudden stabbing involuntary vision of things, and of his place among them. Jean Clair writes of Bonnard being 'giddy in the astonishment of the relived moment'. He is a myopic spectator, moving through a 'floating world', until arrested by a sudden focus. (The transition from blur to focus is essential to his painterly language.) At such a moment, according to Marcel,

> our true self which seemed – had perhaps for long years seemed – to be dead but was not altogether dead, is awakened and reanimated by the celestial nourishment that is brought to it. A minute freed from the order of time has recreated in us, to feel it, the man freed from the order of time.

In the 1890s Bonnard had been separated from some of his Symbolist colleagues by his secularity, and his pictures remain solidly grounded in fact: in how many layers of wood surround a window frame, in how a rectangle is divided, in how the eye sees. Bonnard transfers the terms of a Symbolist quest (the storing-up of aesthetic moments) to the harsher world of Modernism; renewing it, and in a sense redeeming it. That seems to me true of Proust and Yeats and John Cowper Powys as much as of Bonnard; after 1914, they all explore the epiphany through the medium of the self. I would like to place beside such Bonnard interiors as *Dining Room in the Country*, some lines from Yeats's 'Vacillation', published in 1932:

> My fiftieth year had come and gone,
> I sat a solitary man,
> In a crowded London shop,
> An open book and empty cup
> On the marble table top.
>
> While on the shop and street I gazed
> My body of a sudden blazed;
> And twenty minutes more or less
> It seemed, so great my happiness,
> That I was blessèd and could bless.

Freud downgraded ecstasy, writing it off, along with daydreaming, as an aberration – as atavistic forms of mental life, and regressions to 'primary process' thinking. But Bonnard's first-person art could be seen as a sustained argument for the validity of such modes of being, often in association with Marthe. Her bathroom at 'Le Bosquet' was for Bonnard what the famous 'cork-lined room' was to Proust: a place of incarceration, and the alchemical chamber in which the base metal of the everyday was transformed to gold.

Much of Marthe's day would have been lived in the bathroom, and Bonnard may have seen her more often naked than clothed. Her body was not that of a classical or majestic nude; her nakedness always implied vulnerability. In *Nu à la baignoire* (Nude in the Bathroom), Marthe props herself on the rim of the bath, and the world dissolves around her, or she into the world. Her figure is drawn with extraordinary fragility, especially the little right arm, tentative and almost crippled; it is, I think, holding one end of a towel, but the gesture comes across rather as Marthe's shading her eyes from the dazzling void of whiteness that invades her. Some of these effects of dissolution – the way the black and white tiles below the bath overlay her ankle, the merging of the bath into wall, of arm into shutter – might suggest an unfinished state, but the picture hung prominently in his one-man exhibition at Bernheim's in 1933.

In *La Toilette* (also known as *Nude in the Bathroom*), begun in 1932, Marthe leans forward, teetering on high heels, balancing herself with one hand on the basin; she seems to be dipping her toe in liquid gold. (This object below appears at first to be a round basin, but is in fact a footstool.) Her body has been weirdly reconstituted, as an unfamiliar shape with a single white breast, dominated by the very straight columnar leg, and embedded within a space rendered all over as shimmering coruscating patchwork. The bathroom at 'Le Bosquet' had light coming in from at least two directions, and the reflective tiles on wall and floor offered Bonnard total liberty for colour invention, for bounce and refraction; tiles that were pale grey on one side of the figure could become dark blue shot with crimson (lit by a sudden blaze of white) on the other.

The sheer complexity of these patterned intersecting planes baffles analysis, and is obviously the result of endless adjustment. 'I try to give the pictures more layers, more unity', he wrote. 'There must not be any holes.' While most of his contemporaries were pushing towards simplification, Bonnard's art retained an 1890s elaborateness and sumptuousness

112

111

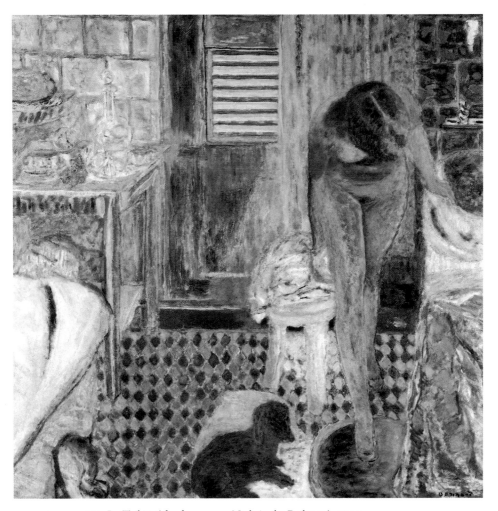

111 *La Toilette* (also known as *Nude in the Bathroom*), 1932

of surface, allowing him to create the slow contraction and expansion of a space of reverie, of a moment held. In his novel *Contre-Jour* Josipovici makes him say, 'I want my people to be bathed in time as the Impressionists bathed them in light'. In *La Toilette*, where the alarm-clock stays forever at five o'clock in the afternoon, we see at her feet a comical red dog, basking in a patch of thick lead-white sunshine – her faithful hound. Later, its dark squirming silhouette, sitting up and begging for

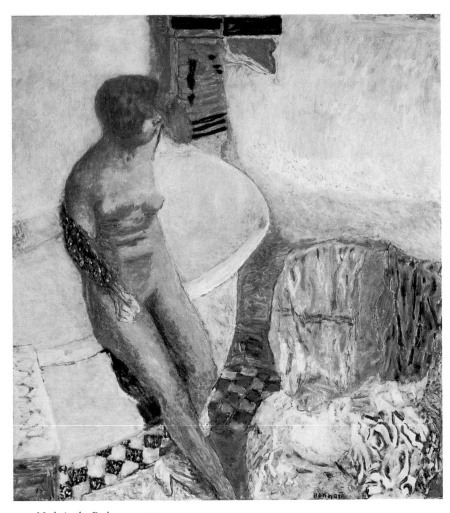

112 *Nude in the Bathroom*, 1931

attention with quivering nose in air, while Marthe reaches for a towel, will dominate the beautiful and subaqueous *Marthe au chien* (Marthe with Dog) completed the year before her death. 113

A drawing from his pocket diary of 1939 glimpses Marthe through the bathroom door, bent nude at the basin; this vignette becomes one of several components in the complex structure of *Intérieur au Cannet* (Interior at Le Cannet), where the mirror and the balcony to the right 115

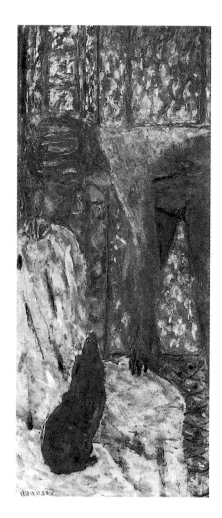

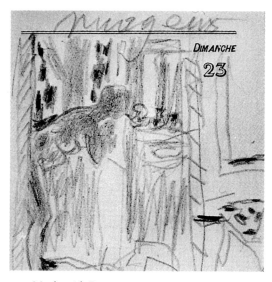

113 *Marthe with Dog*, 1941

114 Drawing from Bonnard's pocket diary, 1939

115 *Interior at Le Cannet, c.* 1939

create a sequence of spatial conundrums and uncertainties. This is in fact the same door already seen in *The Radiator*, though the topography is here transformed out of all recognition. The dominant sense is of a calm pale lavender and golden surface, suddenly cleft asunder by the dark stripe of bathroom as we press forward into it – with Marthe and the bidet jutting crimson from either side.

116 In 1931 *Grand Nu au miroir* (Nude in Front of the Mirror) had already been set in the same corner. Marthe, at almost life size, stands wearing only her high heels, one side silhouetted darkly in a grave stillness, the other broken into by light. The mirror is empty, but it is as though the

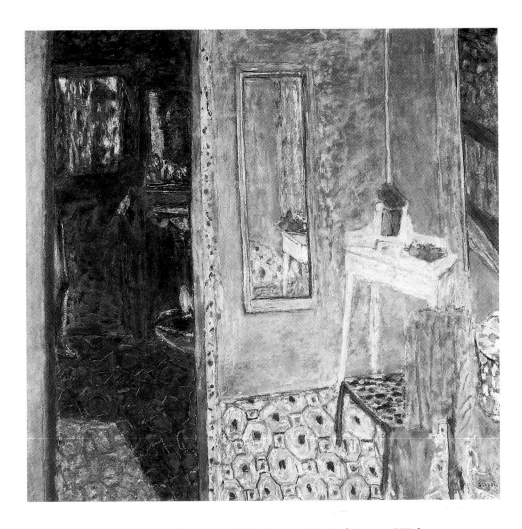

golden radiance emanates from it, and Marthe is a kind of Danae. (With its watery mother-of-pearl reflective surfaces, it seems fateful that this most 'Venetian' of all Bonnard's pictures should end up at Ca' Pesaro.) At a late stage, he has enlarged the picture by about three inches along the right edge. In a related, probably subsequent, pencil drawing, exceptionally various in its tonal patterning, her stance is more animated; she may be pulling on a chemise, or applying make-up, but she looks very much the bob-haired girl of her era. And her legs are now overlapped by an area of foreground scribble, which seems even more emphatic in a further variant, with her head moodily darkened in watercolour.

147

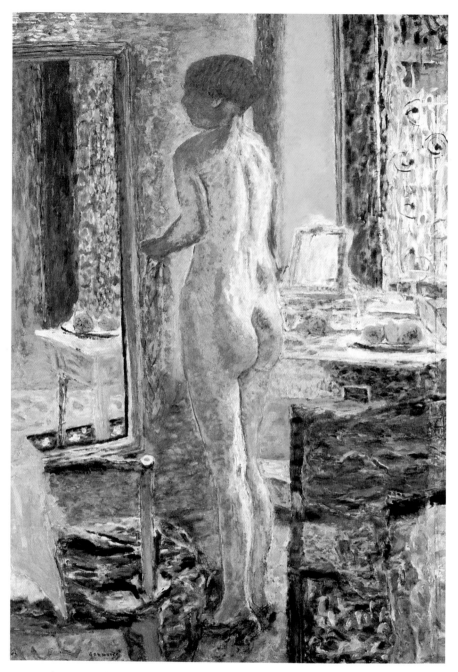

116 *Nude in Front of the Mirror*, 1933

117 *Large Yellow Nude*, 1938–40

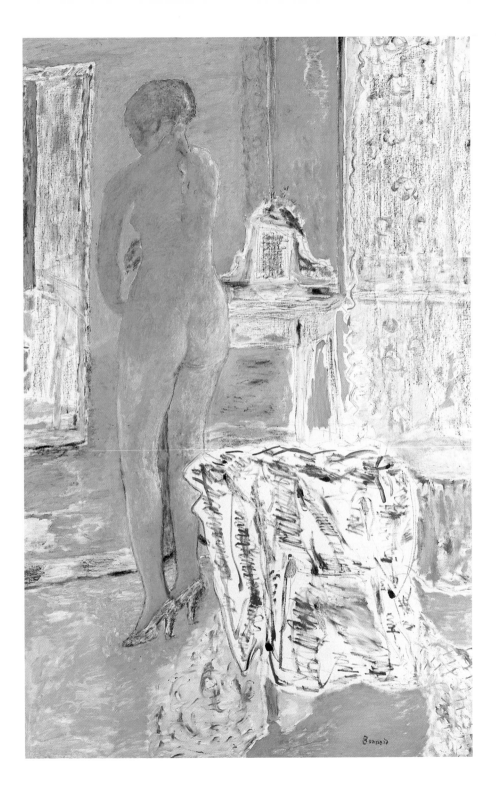

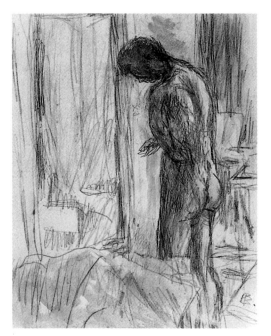
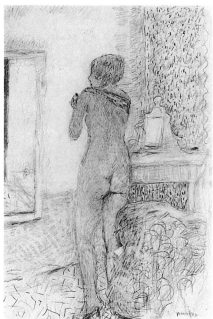

118 *Nude in Front of a Mirror, c.* 1936

119 *Nude in Front of a Mirror, c.* 1933

All these elements are brought together in a completely unexpected way in the final, and the largest, image in this sequence, *Le Grand Nu* 117 *jaune* (Large Yellow Nude). Yellow has now taken over, and the handling is bold, summary and almost off-hand – a kind of drawing/painting we might associate with late Munch, for example. Marthe is now a near-caricatural figure, as yellow as a canary, tapering down to her blue high heels. She is placed further from us, and once again overlapped by an indeterminate foreground presence, usually described as a patterned bathwrap flung over a chair. But the American painter Eric Fischl has suggested an alternative reading – a cloth (perhaps a bloodied sanitary towel?) held forward to our gaze by the artist's two hands. After an initial shock of disbelief, the presence of Bonnard himself in this late picture seems an entirely convincing interpretation, and one that is reinforced in the sequence of paintings to be explored in the next chapter.

Energetic and active well into his seventies, Bonnard would set out soon after daybreak on a strenuous walk down the steep path into the rocky hillside surrounding his house. In a poignant little emblematic drawing, he portrays himself standing hunched over his stick, surveying the Mediterranean below. This daily ritual facilitated the onset of those states of being he most valued, and which made his landscapes (to borrow a title from Rousseau) the 'Reveries of a Solitary Walker'.

When he first settled in the Midi, he carried with him those slightly conventional notions of pastorale imbibed from his youthful reading, and echoes of *Daphnis and Chloe*, as of Claude's *Campagna*, are still evident in his first great tribute to the South, the eight-foot *Paysage du Cannet* (Landscape at Le Cannet) of 1928. The artist himself is sprawled in the right foreground, at one with the beasts in this earthly paradise, while a bright red calf comes to greet him from the left. Between, there opens the tremendous inland vista, and the flat blue expanse of the mountain, all surmounted and knit together by the orange sky. Below the crooked

121

120 *Self-Portrait at Le Cannet,*
c. 1939–42

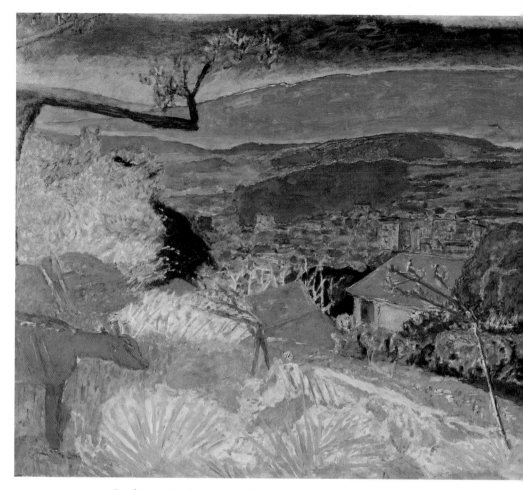

121 *Landscape at Le Cannet, c. 1928*

bough on the left, a patch of deepest prussian blue, is made to sing out with a flaming intensity. Like the author of the twenty-third psalm, Bonnard tells of his being made to lie down in green (and orange) pastures, of his soul being restored.

In 1930 Bonnard found himself temporarily hospitalized. Unable to paint on a large scale, he took up watercolour for the first time in thirty years. But he disliked its transparency: 'The technique of watercolour irritates me: one tries to make the white paper create the effect of light one is trying to achieve. That's illogical, to my way of thinking.' Opaque

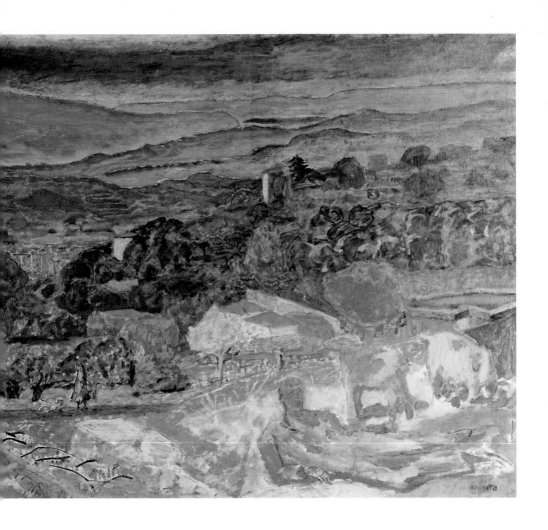

gouache or body-colour would prove a more sympathetic medium,
allowing him to make more radical changes. The delicate *Self-Portrait* of
1930 (see chapter 6) combines both transparent and opaque. The new
medium may have contributed to his altered handling of oil; his paint
surface, relatively solid and seamless in the 1920s, becomes after 1930
altogether more broken. In such pictures as *Descente au Cannet* (Descent 122
to Le Cannet) and *Jardin au petit pont* (Garden with a Small Bridge), some 123
areas are left as blank canvas, and patches of transparent colour float as
hard-edged shapes. These shapes seem airborne, aerated (quite different

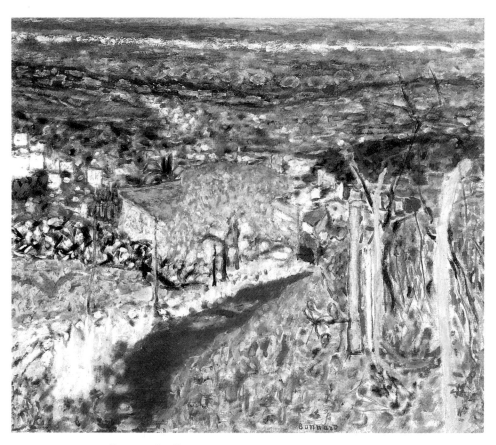

122 *Descent to Le Cannet*, 1943

from the more designed flatness of Matisse), and the marks are more sep-
arate than before, wilder and more unpredictable. As Bonnard explains in
a recasting of Denis's Nabi definition: 'The picture is a series of blotches
which are joined together and finally come to form the object, the fin-
ished piece, over which the eye must be able to wander completely
unhindered.'

When after 1930 landscape becomes a more important part of his
activity, he begins to see Le Cannet more freshly – to accept the actual
terrain for what it is – and Arcadia is exchanged for modern life. The
124 white telegraph pole is the crucial note of *La Route rose* (The Pink
Road), and the almost windowless house it cuts across is unidealized. But

the deep rose and orange foreground expanse speckled with black, and the weird mingling of yellow and green and pink blotches in the sky, communicate a visionary intensity, approaching the altered states of the hallucinogenic. This visionary quality may have first entered his art in response to the intense heat and dazzle of the South, until Bonnard came to see all landscape in terms of an evenly shimmering fabric, made up of colours very equal in tone and saturation, placed side by side. In his studio at 'Le Bosquet' (to the right on the wall illustrated at the begin- 6 ning of this book) he pinned several silvered sweet wrappers. It seems likely these patterned surfaces acted as exemplar and analogue to the blobbed, zoned surfaces of his late landscapes, their jewelled points of light strung out in all directions. As in Gerard Manley Hopkins's

123 *Garden with Small Bridge*, 1937

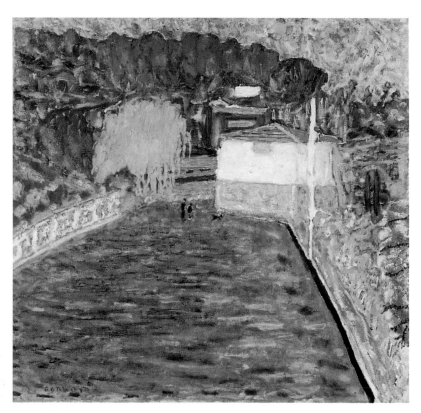

124 *The Pink Road*, 1934

ecstatic vision of 'Pied Beauty', Bonnard's later landscapes are 'plotted and pieced', with 'skies of couple-colour', a world of 'dappled things'.

The large *Paysage de Normandie* (Normandy Landscape) was transformed across a five-year period. Greener than any Midi counterpart, it nevertheless shares the same febrile response; the great tree seems to be sucked upwards, in a rhythm˜as apocalyptic as that of Altdorfer or Van Gogh. (In 1933 he spoke of Van Gogh as 'a great artist I admire'.) *Paysage d'automne* (Autumn Landscape) is again set in Normandy, close to 'Ma Roulotte'; it is painted on board, far more thickly and densely than Bonnard would ever cover a canvas. This exceptionally flattened and formalized surface recalls the Nabi patchworks of the early 1890s, and was made as a preparation or 'cartoon' for a tapestry – never woven, but in its threaded white and gold, easily imagined.

156

125 *Normandy Landscape*, 1926–30

126 *Autumn Landscape*, 1932

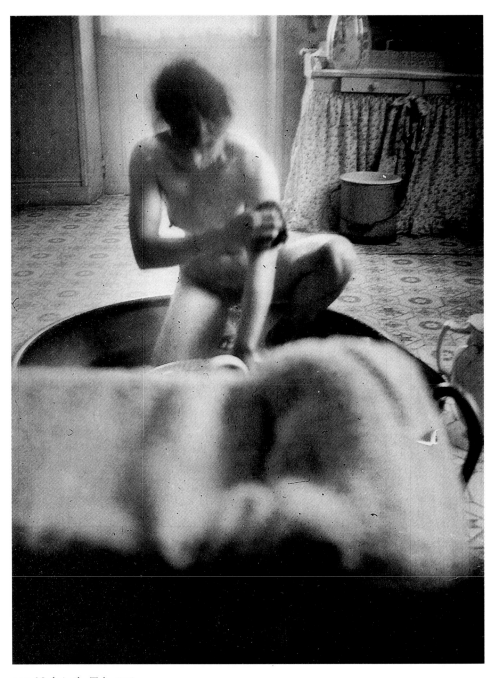

127 *Nude in the Tub,* 1908

A New Space for the Self

In a marvellous photograph of 1908, the entire lower half asserts Bonnard's own presence, from the band of darkness at the base, rising to what may be his own blurred hands. This looming foreground self is dramatically juxtaposed to the diminished and vulnerable nude woman, thrown up by the steeply tilted plane of the patterned floor. Marthe half kneels as she sponges herself within the tub's dark circuit, head lowered, and one nipple sharply silhouetted against a bright patch of light.

Photographs of this kind may have led Bonnard to his practise of including the self within his later sequence of bathroom paintings. Certainly from 1920 he is pioneering a radically new kind of spatial representation – a space quite different from any systematic perspective (the Albertian window or stage-set) as well as from empirical naturalism. The presence of the self charges everything with subjectivity, with emotional ambiguity and psychological complexity.

Bonnard made explicit, more than any artist before, that space extends between the self and the world. He was acutely attentive, especially in later life, to the mechanics of seeing. A note of 1 February 1934 reads: 'Painting, or the transcription of the adventures of the optic nerve.' These 'adventures' increasingly set in question the received conventions by which earlier artists had conveyed our experience of space. Phenomena that had long been observed in the literature of perception (such as the 'curved' lines at the junction of wall and ceiling, or the darkening and striation that occur on the periphery of the visual field) began to appear in painting after painting.

Artists have traditionally limited representation to the sharp-focused central area of the visual field. Yet the totality of our gaze is much wider; if the focused area is 90 degrees, peripheral vision extends it to at least twice that. And since our everyday viewing is not a steady gaze, but a mobile scanning, the kind of seeing we normally experience will be nearer to 250 degrees. Kepler complained that, by linear perspective, painters had been 'educated into blindness'. Bonnard set himself to unlearn the kinds of seeing associated with one-point perspective, with the fixed stare of the art school life-room. 'The eye of the painter gives to

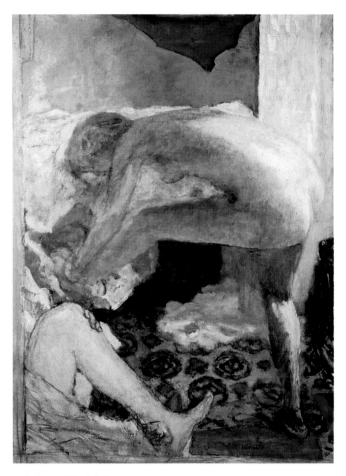

128 *Large Blue Nude*, 1924

objects a human value and reproduces things as the human eye sees them. And this vision is mutable, and this vision is mobile...' His art could not operate within the vestigial spatial formula inherited by most twentieth-century painters: that shallow shelf, or simplified vertical/horizontal grid, which was the legacy of Poussin and David, via Cézanne and Cubism. In the previously uncharted territory of peripheral vision Bonnard discovered strange flattenings, wobbles, shifts of angle as well as of colour, and darkenings of tone, penumbral adventures and metamorphoses which liberated him from visual convention. It was as though the

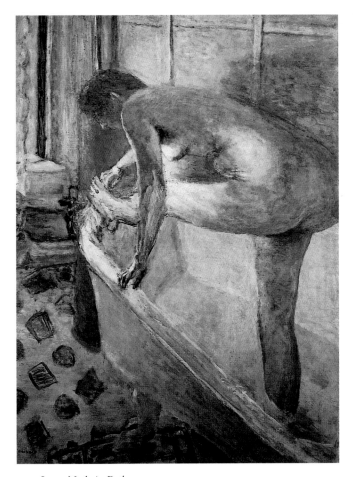

129 *Large Nude in Bath*, 1924

central area of fact were surrounded by much less predictable, almost fab-ulous, margins; where imagination and reverie and memory could be asserted as a heightened reality, in 'impossible' intensities of colour.

He learnt to register in his art an intense consciousness of spatiality – of the vertiginous gulf that appears at a table's edge, of diagonal thrusts deep into space, of the various atmospheric effects that emphasize the wrench between near and far – while yet keeping his Nabi faith with the flatness of the picture-surface. Something of the complexity of Bonnard's seeing comes across in his conversation with Charles Terrasse in 1927:

I stand in a corner of the room, near to this table bathed in sunlight. The eye sees distant masses as having an almost linear aspect, without relief, without depth. But near objects rise up towards it. The sides trail away. And these shifts are sometimes rectilinear – for what is distant; sometimes curved – for planes that are near. The vision of distant things is a flat vision. It is the near planes which give the idea of the cosmos as the human eye sees it, of a universe that is rolling, or convex, or concave...

An extreme tension develops in the early 1920s between this almost anarchic plurality of space, and the sonorities of flat decorative colour. The effect is often of a sudden compression, rather like a zoom lens, yanking the eye into space, bringing the distant close. Bonnard's art, centred on the exceptional moment – on moments that detach themselves from the flow of ordinary living – now found weird structures to convey some of the shock of each epiphany: a heightened space to signal a heightened state.

'LET IT BE FELT THAT THE PAINTER WAS THERE'

When Bonnard in so many of his bathroom pictures signals his own presence within the image, he marks out a special region of experience which still awaits definition. These images locate the spectator within Bonnard's own space; we are made to stand where he stood, to move as he moved. We are all familiar with the experience of seeing a part of one-self intrude into the visual field: the tip of one's own nose, the edge of one's own spectacles, a knee or a hand. Our snapshots may be 'spoiled' by this. But Bonnard saw a possibility there. Degas had once declared: 'Bonnard cherishes the accidental', and on this 'accident' he would base some of his most monumental pictures.

Although both the compositional drawings illustrated here seem already complete and full of meaning, it seems neither was developed into a painting. In the spirited drawing of 1919, Bonnard's leg overlaps the standing Marthe; it was first drawn in pencil, then – perhaps some while after – overlaid with pen and ink. The second drawing revisits the territory of *Man and Woman* thirty years earlier. Bonnard catches sight of himself, with Marthe behind, and out of the chance conjunction of two mirrors a complex polarization emerges. She stands naked at her mirror, brightly illuminated, but turned away, totally self-absorbed; he is slumped in his corner, heavily clothed, in shadow, enclosed in the mirror that encompasses them both. Looking in at her, he looks out at us.

130 *Nude with Bonnard's Leg,* 1919

131 *Nude, Back View with Self-Portrait,* 1930

The two large bathroom paintings of 1924 demand to be seen together. I suspect both started out from the same drawing – the same bending figure, placed within two canvases of similar scale – and he may well have worked on them side by side, perhaps even on the same roll. In *Le Grand Nu bleu* (Large Blue Nude), Bonnard's pale leg obtrudes, but the left and lower edge are also bordered with a pencil-ruled strip (a mirror-surround, a door, or simply a compositional device?). The image resolves itself into a relationship; Bonnard sits, holding his knee, gazing at the object of his contemplation – not so much Marthe, as the dazzlingly illuminated patch on her back, isolated from the rest of her body, and rendered in thick impasto. The shadowy blue and purple surrounding this radiant form evokes an underwater world, and Marthe, reaching into darkness, seems more remote than ever.

128

132 Drawing for *Getting Out of the Bath, c.* 1926

129 The companion picture may seem at first less atmospheric, and with-
out the dramatic lighting her pose is totally altered, made more diffuse.
Bonnard's presence is now registered more obliquely in the powerful
enlargement of buttock and back at the right margin, and the sharp con-
traction of the bath as it descends; he is close to, almost fused with, the
dark vertical of her leg. Strange disjunctions build between the green of
the water pushing off to the right, and the plane of the floor, patterned in
absolute flatness; they are like continental plates drifting apart.

Behind both these pictures there certainly lies Degas, tracing and
retracing the poses of his bathing models. But Degas's art is formal, his
women anonymous, his standpoint, if not (as is sometimes argued)
voyeuristic, at least removed. Bonnard transforms Degas into tenderness,
into a new intimacy and participation; we are made to witness a relation-
ship not between artist and model, but between Pierre and Marthe. The
nude, in both Degas and Bonnard, is rendered outside the conventions of
female beauty, and often without much sexual charge. But where Degas
134 retains some of the thrust of realism, of stripping illusion from the body
(so that his bathtub women have often been perceived in terms of ani-
mals cleansing themselves) Bonnard's art performs a kind of 'reillusion-
ing', by which Marthe's body is affirmed as a vessel of human emotion,
holding its full measure of psychological and contemplative significance.

164

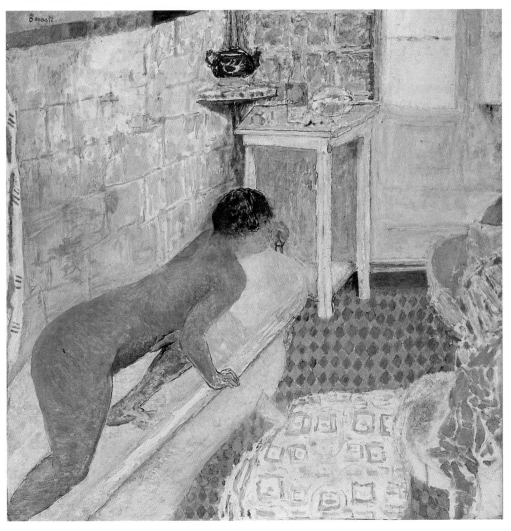

133 *Getting Out of the Bath*, 1926–30

'Let it be felt that the painter was there', Bonnard would write in the 1930s. Many of the bathroom pictures have at their margin an area of undefined forms, which may be read as a chair draped with patterned towels and gowns, but which may also indicate the presence of the artist, edging into the scene. In *La Mule verte* (The Green Slipper), we slide vertiginously down from the jumble on the left, and the leg detaches itself against the space with a transfixing solidity and presence. In his preliminary drawing for *La Sortie de la baignoire* (Getting Out of the Bath), the spectator's presence seems to billow up from the lower right, and the rim of the bath abruptly changes direction. In the painting, the rim has stabilized, but now it is the base of the bath which expands, while on the right, a vertical patchwork, like a patterned totem pole, establishes where Bonnard is standing. As for Marthe, she is probably not 'getting out' at all, but reaching for the tap; and in the painting (which may be unfinished) she becomes some tawny and feral creature, moving almost frighteningly on the edge of vision.

132, 133

In another, possibly unfinished, but exceptionally beautiful and meditative picture, we find ourselves actually *in* the bath. The artist sees his own foot emerging beyond the narrow band of water, and his eye adventures outwards. The bathroom, emptied of Marthe, still feels charged with the sense of his own existence. We might expect the window to recede upwards (as it certainly would in a photograph) but it expands, becoming a great door into blue space. Above, a patch of ceiling glows like fire.

136

134 Edgar Degas,
Woman at her Bath, c. 1895

166

135 *The Green*
Slipper, 1925

Marthe and Bonnard are again united in a final bathroom scene, prob- 137
ably completed shortly before her death. Of Marthe, we see only her
purple legs, suspended upside down from the lower corner. Along the
centre of the canvas, the pale rim of the bath rises vertically, like a white
column; implicitly, the spectator stands directly above. Yet Bonnard has
inserted himself as a small distant figure in dressing-gown and slippers –
according to David Sylvester, he holds a palette – and cut off at chest
level, as Marthe is at the hips. They could be seen as polarized and
reversed opposites, though with Marthe as by far the larger component.
Or should one say, rather, that out of these two headless fragmentary
persons, a whole can somehow be made?

136 *In the Bathroom, c.* 1940

137 *Bonnard with Marthe in the Bathroom,* 1938–41

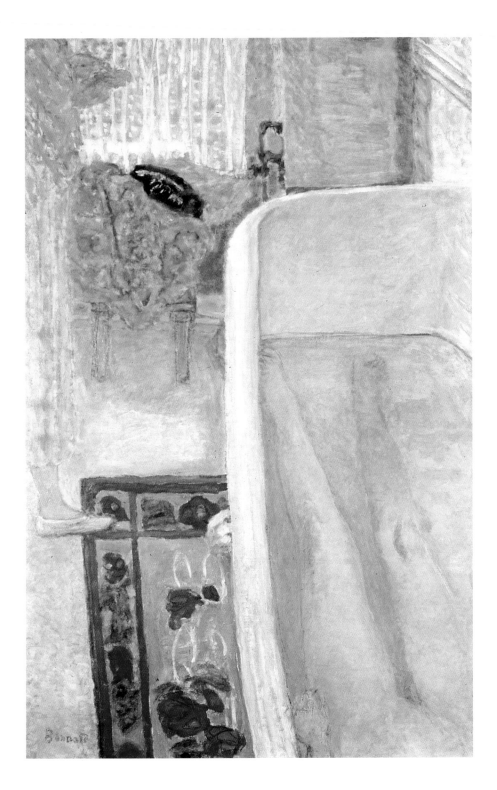

In all these bathroom images, the essential subject is the exchange between self and other: sometimes a merging, the breaking of the barriers between them; sometimes the sense of a rift, of their separation. Such elusive areas of feeling may be better expressed in images than in words. Merleau-Ponty, in *The Visible and the Invisible*, touches on the presence of the self in our seeing: 'As soon as I see, it is inevitable that vision is doubled with a complementary vision. Myself seen from without, such as another would see me, installed in the midst of the visible...' And through this objectified or 'doubled' self, Bonnard articulates a new relation between the viewer and the world.

THE DISAPPEARING SELF

Bonnard's late self-portraits, most of them glimpsed in the bathroom mirror, unfold a parallel sequence. But here the emotional timbre shifts from reverie, to something approaching tragedy. These are among the most poignant self-portraits in the entire tradition of Western painting. They are linked, formally, by their use of *contre-jour*, Bonnard's rendering the self in shadow; and he draws out of the head an extraordinary intensity of colour, a nocturnal or dreamlike range of hue unavailable to daylight flesh. Peering, like Bonnard, into the darkness, we discover unexpected resonances.

139 Of all these dark selves, perhaps the most disquieting is *Le Boxeur* (The Boxer). At some time before 1930 the artist renounced the beard of his bohemian years, and adopted an unflattering little moustache, assuming his final persona as a kind of shrivelled *petit bourgeois* or retired functionary – the Bonnard we know from the photographs of Cartier-Bresson and Brassaï. Here he has caught sight of himself squaring up to the bathroom mirror with puny fists, in play, or in impotence. From the battered pulp of the head – a red lump of raw meat, set atop the naked torso – there emanates a terrible pathos, eyes lowered in shame, in defeat. And yet, the picture triumphs after all; a kind of tragic-comic clowning is transformed, by the exquisite violet line along the shoulder, by the magically shimmering yellow-and-blue field in which the figure is embedded, into an image of unforeseen beauty.

140 The watercolour portrait is more contemplative. An exceptionally large but delicate pencil drawing has been overlaid in transparent washes, unifying the head in a dark golden tone, and rendering the hand a powerful crimson. The pale ochre behind becomes a little more opaque in the stripes of the dressing-gown. But to this predominant gold, Bonnard has added at crucial places – behind the head, under the chin, at the eye and

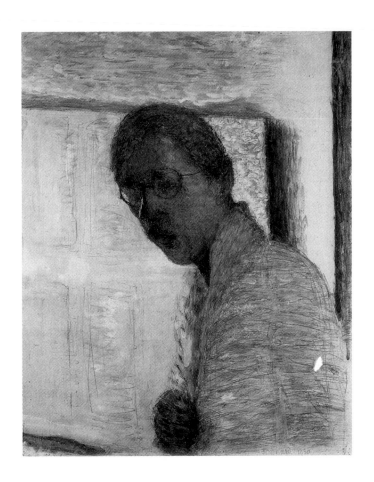

138 *Self-Portrait*, 1930

along the line of the nose – a broken impasto of white gouache, whose solidity sets off the head's insubstantiality. The conjunction of gold and white has served the colourist, ever since Duccio, to signal the evanescent, to create a disappearance. Here it dissolves an extraordinarily frail image, and we only barely read the artist's myopic, almost blind gaze.

Both colour and tonal contrast are pitched to unparalleled intensity in the 1940 self-portrait. Under electric light, the bathroom shelf in the foreground presents a dazzling treasure – ruby hair-brush, golden bottle, emerald stopper – while the wall reflected behind is a fiery Indian yellow, streaked with orange and pale green. In another 'disappearance', Bonnard's white shoulders recede into the gold, except for a bright blue shadow. We are left with the two crimson and mauve hands – I suspect, in his first glimpse, he may have been washing his brushes – and rising from

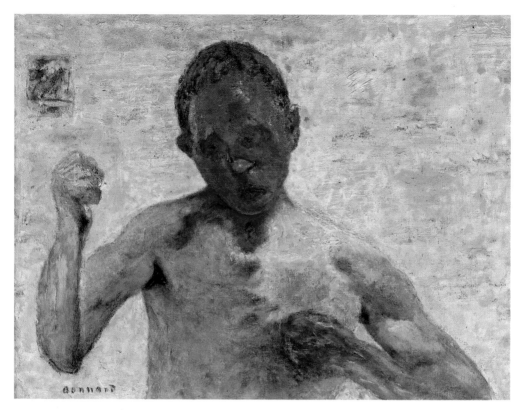

139 *The Boxer*, 1931

them, the astonishing hot darkness of the head. As our eyes adapt, we make out all the colours that are stored in shadow: the vermilion ear alongside the viridian bristle, the apple-green of the jowl, the blue eyebrow and moustache; and on the brow, burning, an impasted highlight of brightest cadmium yellow. Bonnard's emphasis on the close-up may be partly linked to his worsening short-sightedness, but above all it communicates an intimacy of visual engagement. Face to face with him, the sense is of our eye being forced to open wide, to take in extremes of colour and tone, contrasts of close and far — a simultaneity impossible to register with the mechanical eye of the camera, but very much a property of the human eye in its excited response to the world — when our eyes are, as they say, 'on stalks'.

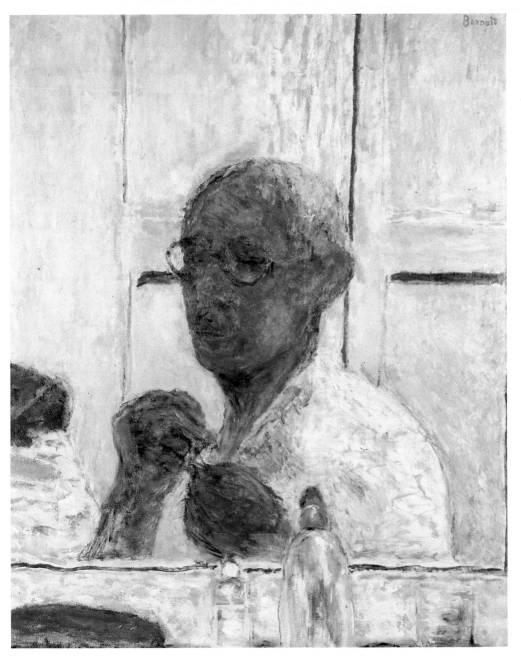

140 *Self-Portrait, c.* 1940

Photographs of Bonnard in his final years make him look strangely oriental and 'Japanesy' (sometimes a sage, sometimes the shabby penitent tax-official of Kurosawa's film *Ikiru*). His own self-portraits emphasize his growing baldness and thereby, nakedness. The head and shoulders self-portrait painted in 1943, shortly after Marthe's death, is painfully vulnerable. Bonnard is here painting a very short-sighted self who has peeled off his spectacles – an aspect almost repellent, like some blind creature surfacing from underground. It is unclear whether the striations at the top register actual flaws in the mirror, reflected light burning off it, or the margins of his – possibly damaged? – visual field.

His final self-portrait dates from some eighteen months before his death; the bathroom's green and white tiles are now painted so fluidly, we could be in an aquarium. The face of the 'Nabi très Japonard' has become, fifty years later, that of a Noh mask – the eyes, empty greenish-black slits, the darkest notes in the picture. At seventy-eight, Bonnard's touch achieves the intimacy of late Titian, where pigment and flesh and atmosphere are fused. And everywhere the brush has been supplemented by the artist's own hands, smearing and fingerprinting white and yellow blobs of an unmatched tenderness.

One last picture also demands to be included in this sequence of selves – the phantasmal close-up of *Le Cheval de cirque* (The Circus Horse). The picture first took shape in Deauville in 1936, but continued to develop for another decade. It remains in some areas very thinly painted, the pencil drawing still visible across much of the horse itself; the refractory elements must have been elsewhere – the stables, the figure, the orange strip. It is of course in the great white head, in its stooped blind inward gaze, its enormously sensitive and resigned visage, that we recognize the image as a self-portrait. But the clown-like trainer who is in charge of the huge animal might also be seen as a second self, his stiffly held hand and stick unmistakably resembling the painter's palette and brush. Bonnard is close here to a child-vision, and also to the comic-melancholy of other contemporary treatments of the circus theme: Beckmann, Jack Yeats, Chagall and Rouault. (I also think of Yeats's late poem, 'The Circus Animals' Desertion', with its eventual return to the self as 'the place where all the ladders start'.) Bonnard's image is neither romantic nor sentimental. Jean Clair has identified *The Circus Horse* with the mythical psychopomp, the horse who at death comes to convey the soul into the other world. Certainly this bleached form disappearing inwards seems a funereal apparition, the dark pencilled sockets in the white surface unmistakably skull-like. It is Bonnard's most uncanny and visionary invention.

174

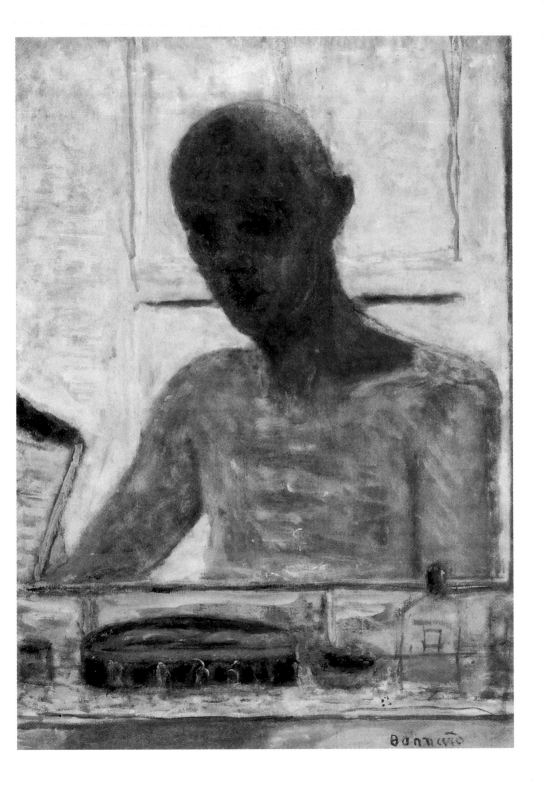

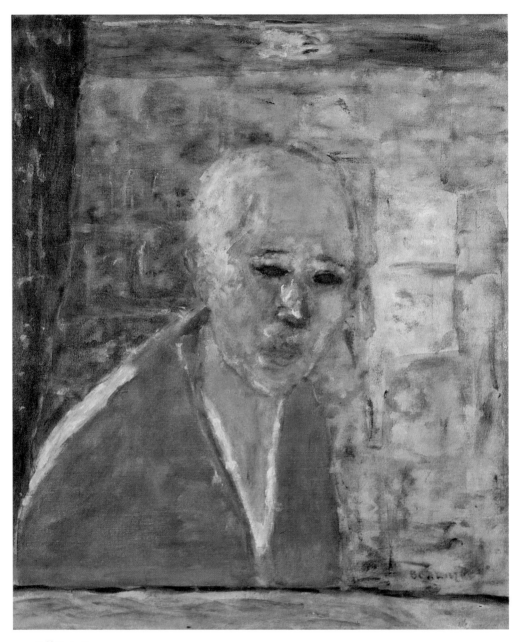

142 *Self-Portrait*, 1945

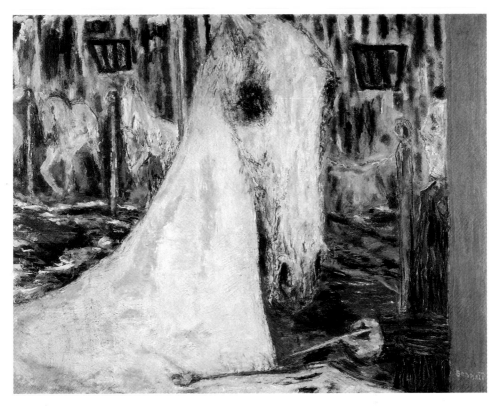

143 *The Circus Horse*, 1936–46

BONNARD AS 'SELBST-KUNST'

Paul Westheim and other German critics of the 1920s devised a category they called *Selbst-Kunst* (Self-Art), initially coined for painters such as Corinth, Beckmann, Munch and Kirchner, whose art often hinged on their projection of the self as a dramatized persona. According to Hans Belting, writing in the 1980s, *Selbst-Kunst* is 'rooted in the split between person and the world'; but

> critics have tended to shy away from this theme, for fear of afflicting visual art with the stigma of the literary... Art criticism thus lacks the categories to do justice to the 'authorial' dimension of visual art. The author of a text is allowed to tell of himself. The painter is supposed to restrict himself to depicting the world.

177

But as soon as we isolate this vein, we realize how pervasive it has been. In 1995, to mark the centenary of the Venice Biennale, an enormous exhibition, *Identity and Alterity*, was mounted by Jean Clair; included among perhaps a hundred self-portraits was Bonnard's *The Boxer*. In his introductory essay, Clair asked: 'What if the twentieth century had been, more than any other, the century of the self-portrait, not of abstraction?'

Selbst-Kunst could indeed be extended to a wide range of twentieth-century painters (including, for example, Stanley Spencer, Marc Chagall, and more recently Philip Guston in America and Bhupen Khakhar in India). Implicit in the best work of all these artists is not a mere celebration of the individual, of autobiographical anecdote, but something more timely, a radical interrogation of the self. Bonnard's sense of himself as a spectator is more searching, more unstable, than the bourgeois self would allow for. What he affirms is, precisely, a discontinuous self, a subjectivity to be rediscovered only in exceptional moments.

In the bathroom pictures especially, Bonnard's empathy for Marthe creates ambiguities of identity. His mode of seeing might be characterized not as that of the hunter – acute, focused – but of the hunted: wide and peripheral, fugitive and vulnerable. And the space that results registers the experience of weakness. Perhaps this is the special potentiality of Bonnard's art – to speak *for* the weak. As has often been recognized, there is in his use of space, in his lurking peripheral presences, a dimension of fear. (One of the few other twentieth-century painters to employ peripheral vision, E. L. Kirchner, described his own work as 'the life-story of a paranoid'.) But here one might ask: is Bonnard telling of his own fear and weakness, or is he entering into Marthe's? His seeing embodies an attitude towards the world less willed and concentrated than in any previous Western art. His vision is not about 'capturing' or 'imprisoning' the object of his gaze; the absence of visual aggression is especially striking in the late bathroom nudes. Whether we call it 'diffuse' or (too loaded a term) 'feminizing', the result is a seeing that attempts to lose the self in the other – in the still-life, the landscape, or in Marthe – by an act of submission.

The tragic dimension in Bonnard's art emerges from the inevitable failure of such an attempt. That failure had always been part of the subject-matter of Romanticism; Caspar David Friedrich, for example, could only achieve his landscape-vision by inserting a *Rückfigur* – a figure seen from the back, embodying both yearning and solitariness. Bonnard also is forced to observe himself, as a consciousness which is inescapable and almost imprisoning; as that which *surrounds* his vision of the world. (We see the world through two apertures in a bony structure.) When he

employs curved space, this space must wrap itself around some core, must proceed from some central consciousness. The disadvantage of wide-angle or 'fish-eye' seeing in painting is that it will tend to present unstable forms, more or less comical in their distortion; and thus to be destructive of dignity, gravitas, and monumentality. In consequence, Bonnard's representation of Marthe seldom takes on the sculptural grandeur of the classical nude (or even of his sometime master, Renoir).

More generally, this kind of seeing entails a loss of objectivity and materiality; all forms risk being swallowed up into the artist's subjective emotion. Formal clarity is threatened by the wide angle. As early as the fifteenth century, Piero della Francesca in his *De Prospettiva* wrote eloquently of trying to peer out of the very limits of the ninety-degree visual field. 'The eye will no longer distinguish men from animals, and everything will be reduced to flecks.' This passage surely reads very suggestively in relation to Bonnard, who wanted 'to show what one sees on first entering a room...one sees everything and at the same time nothing'. What Bonnard wants (and Piero, his opposite, abhors) is the collapse of distinction – between the different classes of objects, as between those objects and the self. They must all be made one.

The paradox is that his closeness to sense-data, to perceptual truth, results in the extreme subjectivity of his later work. It is through being based in the facts of vision, that his art becomes 'visionary'. Yet it ends by opening, rather than closing the world. Through the subjectivity of Bonnard's wide-open space we are shocked out of the narrowness of our normal seeing, overwhelmed anew by the power and beauty of the visible.

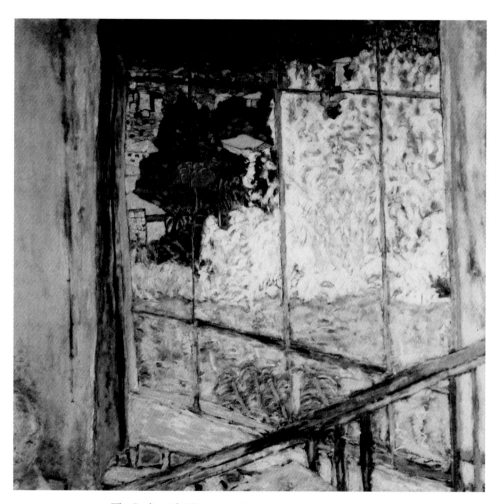

144 *The Studio with Mimosa,* 1938–46

Late Gold

Most visitors to the studio at 'Le Bosquet' were surprised by its con-
stricted and awkward split-level space. But Bonnard always preferred an 145
improvised work-room: 'I don't like elaborate set-ups when I'm painting
– that intimidates me'. He pinned his canvases to a single high wall,
painting in the full light of the big window, but if he wanted to step back
more than a few feet, he had to climb the stairs to the mezzanine, and
look down over the flimsy wooden rail. Usually he kept his paints and
palette downstairs; the upper area he seems to have reserved for his
gouaches and graphic work, and here also was that wall of postcards and
inspirational images (see illustration 5) with various oils and other medi-
ums in bottles on the ledge beneath.

Between 1936 and 1947, Bonnard's working pattern was to keep a
great many pictures in progress at any one time. Some would be set aside
for months or even years, only to be taken up again and radically altered
in the light of some new painterly discovery.

L'Atelier au mimosa (The Studio with Mimosa) was begun in 1938, but
continued to develop throughout the war years. It celebrates the annual
flowering of the tree outside his studio window, usually in February, and
thus one of the earliest signs of the approaching spring. Like so many of
his compositions, it exemplifies his saying, that 'to begin a picture, there
must be an empty space in the centre' – except that here, the 'empty
space' becomes an astonishing billowing field of yellow, held within the
square four-foot canvas. Jean Clair writes of the mimosa as an 'explo-
sion...like a kind of solar flare'. To keep the yellow in equilibrium, the
central struts of the white foreground railing are forced to turn a deep
cadmium red; red verticals run either side of the window; the plane of
the white wall is transposed to a fleshy pink; and four 'red hot pokers'
slant upwards almost like staples at the lower edge. Yet this window is so
filled with yellow that it still presses forward, and against its force the
phantasmal woman in the left corner hardly registers.

Yellow takes on a dominant and symbolic value in the later work. As
Bonnard looked back at his Parisian and Normandy pictures, he recoiled
from their greyness; he had moved from shade into light. In the last year

of his life, when a dealer commented doubtfully of a picture by Signac, 'There is a lot of yellow in it', Bonnard replied, 'You can't have too much'. Yellow appears in all its variety, from the mimosa's lemon cadmium, through ochre, to a deep Indian yellow, often set against white. For Bonnard, as for Van Gogh, yellow is felt as the true Primary – the colour of the sun, of pollen, of life itself. But in the late work it can also carry a more complex invocation – of the golden light of anarchism; of a yearning for a lost state of well-being, as well as its rediscovery in the sudden illumination of visionary consciousness. Throughout these final years in the Midi, the latent process is his dissolving the image into gold – the Golden Age being thereby restored, or imaginatively affirmed.

His late work is often other-worldly in mood. In *La Terrasse ensoleillée* (The Sunlit Terrace) we are placed high up, close to the yellow arch, looking across a formal garden rendered in deepest rose-pink, and bordered by a forest – a long band of broken pale blue, scarcely differentiated

147

145 Bonnard's studio at Le Cannet. Photograph by Sargy Mann and Tom Espley, 1983

146 *The Studio*, 1932

from the sky. (The site has been identified as a 1930s villa, built by friends of Bonnard near Vaucresson, and since demolished.) The extreme horizontality of format – just over two feet high, but nearly eight feet long – is unique in his work. It makes for a very artificial construction, rising from the left to the brick cube at the far end, its radiant pink-and-yellow wall broken by a square window; we see into the dark interior, past the woman seated in a deckchair, and out again through the open loggia to the distant trees. In the foreground, the greyish-blue object might equally be a garment, or the profile of a dog.

From the 1930s onwards, Bonnard pushes the formal structure of each painting to a new abstractness. *La Table devant la fenêtre* (The Table in 149 Front of the Window) could serve as title for several earlier pictures, but this canvas of 1934–35 (set in a villa rented at Bénouville-sur-Mer in Normandy) has the intensity of a final restatement. His starting-point was perhaps the observed play of light and reflection in a bright sunny room. A cloth (its thin red stripes rendered vertical on the right, divergent on the left) has been laid over a shiny table, whose upper edge remains uncovered, to reflect blue sky and orange walls, while the tablemat also presents a reflective surface. Behind, to either side of the window, the curtains are impasted with white, but the central cross-shaped area jumps suddenly to a blackness of a wonderful intensity and resonance. Along the top edge, gold striations fret the image. And as the table

147 *The Sunlit Terrace, c.* 1939

curves around to the right, it acquires a yellow aureole, which licks also around the decanter and fruit-bowl, like some Pentecostal flame. The barely indicated figure is swallowed by the deep orange wall; Bonnard's subject here is not Marthe, but some more impersonal moment of visionary perception.

148 *Coin de table* (Corner of a Table) from the same years is another extreme work. Mountainous baskets of piled fruits rise up towards us, casting yellow shadows on the white cloth. On the left, however, space falls violently away, across a wide diagonal band of flat red towards the far edge, and as if miles distant, a tiny chair set almost on its side, establishing our weird angle of vision. In all these works, his art seems to become more detached from immediate circumstance. As he explained to Hedy Hahnloser,

> when one is young, one becomes enthusiastic about a place, a motif, whatever it is that one encounters. It's that sense of the marvellous that

makes one want to paint. Later one works in a different way, guided by
the need to express a feeling, so one chooses a point of departure more
in rapport with one's own capacities.

In similar vein, he had written in 1929: 'Rhetoric in the realization of the
work: calling up one's mental reserves of beautiful shapes and colours, the
outcome of personal observation, and of looking at the masters, conjured
up before one's eyes as fast as the brush makes its touches.' And again, in
1936: 'A group of coherent relationships produces something true. The
choice of that group is a matter of convenience. One can swim in choco-
late or in blue sky.'

Bonnard began to make his *Notes* from 1927 onwards, and they assert
again and again the autonomy of the picture. He is now working from a
world largely self-created; the withdrawal from social obligations
imposed by Marthe, and even the apparent inconvenience of painting for
months on end in hotel rooms, may have suited his deepest needs. In

148 *Corner of a Table, c.* 1935

December 1935, he noted: 'The main subject is the surface, which has its colour, its laws, over and above those of the objects.' Earlier in the same year he had written to Matisse, 'as soon as the colours achieve an illusion, one no longer judges them, and the stupidities begin'. In February 1939, the pocket diary reads: 'They always talk of surrendering to nature. There is also such a thing as surrendering to the picture.' In the war years he felt linked to Picasso, pinning a reproduction of a recent picture to his studio wall; he explained to the publisher Tériade in 1942, 'I approved of collage when they started taking bits and pieces of the outside world and incorporating them into their pictures... They remind us of the artificiality of painting.' And in 1946, in one of the last notes he made: 'It's not a matter of painting life. It's a matter of giving life to paint.'

149 *The Table in Front of the Window*, 1934–35

A drawing of Trouville dating from 1936 conveys the liveliness of the busy scene. But by the time the canvas was under way, Bonnard was confined to Le Cannet, the composition reinterpreted, allegorized and distanced. The blue-and-red striped foreground was perhaps already implicit in the drawing; but the pencilled scribble became in the painting a host of clustered touches – gold, black, and white. The forms have everywhere been simplified – one might say, infantilized – so that stick men are scarcely differentiated from bollards. Bonnard remained interested in the art made by children, and by 'naïve' or Sunday painters, as also in the cheap luridly tinted chromos of seaside views; something of all these fed into the work of his final decade, which became in every sense a kind of second childhood. *Le Port de Trouville* (The Port of Trouville) may have come to embody a place, and a state of mind, now lost to him. The frail yacht glides out of harbour, up along a white sea-road, into a white mist – a Cimmerian nothingness. On the shore, the little figures scurry about, but all our yearning reaches beyond and above, into the celestial dappling of silver and gold. The image should be seen alongside several other late pictures, where the primal yellow is combined with white in an all-over patterning, all-dissolving, and in which the *millefleurs* of the Musée Cluny tapestries appear again in a new paradisal flowering.

In Le Cannet, more of his energies went into landscape than ever before. Like most great landscapes, they tend towards abstraction, and are hard to find words for. In 1932, Bonnard had made a note that reads almost as a catechism: 'Represent Nature when it is beautiful. Everything has its moment of beauty. Beauty is the satisfaction of sight. Sight is satisfied by simplicity and order. Simplicity and order are produced by the legible divisions of surfaces, the groupings of sympathetic colours, etc.' Many of these later landscapes are centred on a path. *Garden with a Small Bridge* (1937) has a collage-like surface, patched together with cool broken greens and yellows and blacks, the flickering fluid underdrawing still mostly visible. We do not at first make out the wealth of figures in the busy terrain; the blue woman on the path, the bending man across the stream, the mother with child in arms, the tiny almost dancing children at the lower edge. Probably this was the picture whose exceptionally rapid progress was witnessed by Félix Fénéon (see p. 124) and it also served as the basis for the Palais Chaillot mural.

152 But when he returns to a similar theme in *Chemin montant* (Uphill Path), some time into the war, his treatment is less linear, the brush more independent in its chancy squiggles and dashes; drawings of the same

150 *The Port of Trouville*, 1938–45

151 *Exit from Trouville Harbour*, 1936

years can be almost frenzied in their wild markings. Here, the colour is also more emotionally charged, the pink road becoming orange as it rises up towards the single greenish-white cloud, set in the purple sky, and to which the dark figure on the path seems to be journeying. Bonnard's sense of the landscape is close to that of the early Chinese poet-painters; as Chu Hsi wrote in the eleventh century, 'In the great pattern of Heaven and Earth there is nothing isolated, and everything must have its opposite; and this is spontaneously so, not the result of any purposive arrangement. Pondering often on this at night, I could not help experiencing great joy.'

THE BATH 1936–46

Bonnard's work on his three large *Baignoires* spans almost the whole of his last decade. Rarely shown together, they are arguably his culminating achievement – a distillation and also, especially in the final version now in Pittsburgh, a vessel or container into which a great many separate and contrary feelings, the experiences of a lifetime, could be poured. The nearest comparison might be to Braque's late *Atelier* pictures – their space similarly buckled and elided into near-impenetrability – which explore the same difficult or secret processes of metamorphosis, by which a room presents a kind of credo. When Bonnard writes to Matisse at the end of 1940, 'I dream of the quest for the absolute' (a reference to Balzac's *La Recherche de l'absolu*), he is almost certainly casting himself in the key story in the volume, 'Le Chef d'œuvre inconnu' (The Unknown Masterpiece) – as another elderly Frenhofer searching for a new, perhaps impossible, language of painterly representation.

The 1925 *Bath* had been very much a portrait of Marthe. By 1936, when Bonnard embarked on the new version, she was almost seventy, and yet the figure floating here is ageless. Perhaps the true theme of all these pictures is not Marthe and her long days in the water so much as the suspension of physicality and of time, and the dissolving of all into reflection. The *Baignoires* (paintings made of her in the bath) provide a riposte in an unexpected way to Monet's *Waterlilies*, and are the final fulfilment of the 'floating world'.

In all three of these late *Baignoires*, tiles and bath and body taper upwards to the left edge, suggesting Bonnard's standpoint directly above the bath, close to Marthe's head. But this spatial thrust is in conflict with a contrary impulse, to recreate the bath as an oval enclosure – as womb or microcosm or sarcophagus – in which the woman is held as a kind of emblem entirely independent of the artist's presence. The image has

152 *Uphill Path*, 1940

sometimes been interpreted as her reflection in a mirrored ceiling. Marthe took her baths in full sunlight, in the middle of the day. In a remarkable photograph, the painter Sargy Mann has reconstructed the situation, showing how, at a certain moment in the afternoon, the sun floods in not only from the French windows to the right, but from another window parallel to the bath, dazzlingly reflected in tiles and floor; so that the triangle of white in the first version, or the pink in which the dog sits in the final canvas, may be not a bath mat, but a patch of sunlight.

154, 155 The first version (1936) is the calmest and most integrated, despite a kind of tension where Bonnard has at a late stage stretched the bath a few inches to the left. Successive vertical bands − yellow, blue, white, gold, violet − surround the dark water with harmonious chords; the deep gold, nearest the head, moves onto her body and is reflected in the floor. Sharp notes of red and black below the bath do not break the overall serenity, and golden light is felt as a benison, a metaphysical force; the myth of Danae visited by Zeus in a shower of gold again comes to mind. As Bonnard told a young painter, 'Our god is light!'

158 156 A few months later, probably in early 1937, he once more took up the theme, this time in a squarer format. In the preliminary drawing reproduced here, the roundedness and depth of the tub are emphasized, and the figure rendered more doll-like within it. A famous photograph shows the uncompleted picture pinned to the flowered wallpaper of a Deauville hotel room. 'Never again shall I dare to tackle so difficult a motif', Bonnard declared in an interview. 'Although I have been working for six months, I still can't manage to get what I'm after, and I foresee several

157 months work ahead.' Only by various desperate remedies − the sudden deep orange rim of the tub, the unidentified bright yellow object on the floor (perhaps a scent-bottle?) and what appears to have been a final slashing in of white, almost like a burnishing − could the image be resolved.

Its greyer, more subdued pitch may partly reflect the Normandy light. In the late 1930s Bonnard still divided his loyalties between North and South. He wrote to Matisse from Deauville, 'I miss the light of the Midi here a little, even though there are sometimes very beautifully nuanced

159, 160 skies'. But by the time the third version was begun, probably in 1941, he was two years into his war-time confinement at Le Cannet, and nuance had yielded to an almost violent intensity of pure colour. At four by five feet this is the largest, and by far the most extreme version; more enveloping, and at the same time more disconcerting than any other Bonnard picture. Standing before it, we are invited to lose ourselves in

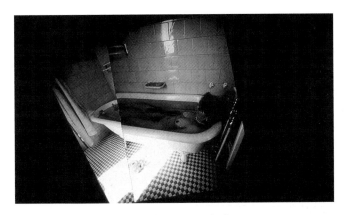

153 Bathroom at Le Cannet (reconstruction).
Photograph by Sargy Mann and Tom Espley, 1983

these fugitive streaks and smearings, these inexplicable shifts of light and hue that seem to stand as metaphor for the mind's motion in reverie. Most amazing of all are the areas where the bath narrows towards the right, then seemingly exhales and expands, buckling and merging molten with the vibrating floor; the paint here crusty with layer upon layer, and the drawn edges of bath and figure just barely defined by a brush, or a fingertip, dipped in crimson, dragged loosely across.

A pale, very ordinary tiled bathroom has over many years been utterly transformed, until it wraps the bather in a kind of crazy quilt. Bonnard has found it necessary to push further beyond naturalism than ever before. The final *Bath* is the ultimate stage in a long journey, evident in his pocket diary notes, by which Bonnard claimed pictorial liberty, in a dialectic of 'lies' and 'truth'. In 1934 he was reminding himself of what was already a doctrine in his Nabi beginnings: 'Untruth is cutting out a piece of nature and copying it.' The following year: 'In painting, too, truth is next to falsehood.' And ten years later: 'There is a formula which fits painting perfectly: many little lies to create one great truth.' The painter and writer Patrick Heron has defined an 'underlying abstract rhythm' in Bonnard's work. He asks us to 'think of a piece of large-scale fish-net drawn over the surface of the canvas; it is through an imaginary structure of loose connected squares – sometimes pulled into oblongs, and sometimes into diamond shapes – that Bonnard seems to look at his subject'. The lozenges of pure colour in the final version of *The Bath* are at the very limit of representation.

193

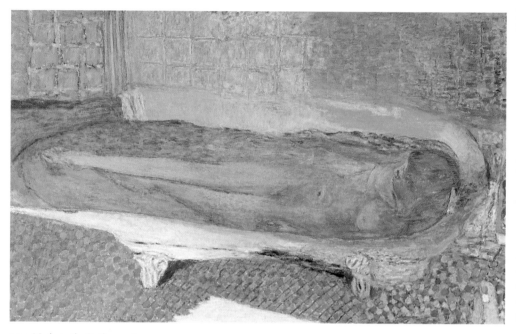

154 *Nude in the Bath*, 1936

155 *Nude in the Bath* (detail), 1936

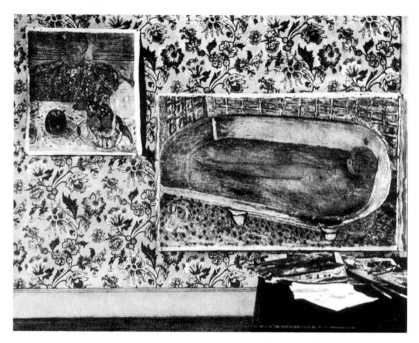

156 Wall of Bonnard's room at Deauville, 1937. Photograph by Rogi André

At the centre of all this dazzle lies the bather herself. The picture is now usually dated 1941–46; in other words, it was completed some four years after Marthe's death. We seem to be witnessing a visionary transfiguration, as though the room were some crystalline chamber or mechanism by which the dead woman is dissolved into light. She is, in John Berger's words, 'potentially everywhere, except specifically here. She is lost in the near'. Marthe died on 26 January 1942, aged seventy-three. Bonnard wrote to Matisse:

> After a month of illness, the lung being affected as well as the digestive tract, my poor Marthe has died of a cardiac arrest. Six days ago we buried her in Le Cannet. You can imagine my grief and my solitude, full of bitterness and worry about the life I may be leading from now on.

Marthe's bedroom had been the only part of the house he had never drawn or painted. Now he locked the door, and never entered it again.

196

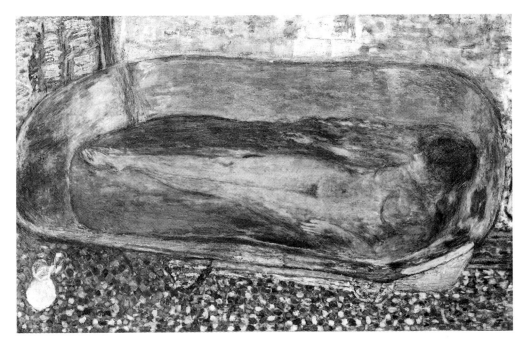

157 *The Bath*, 1937

158 Drawing for *The Bath*, 1937

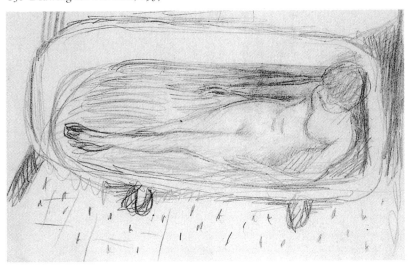

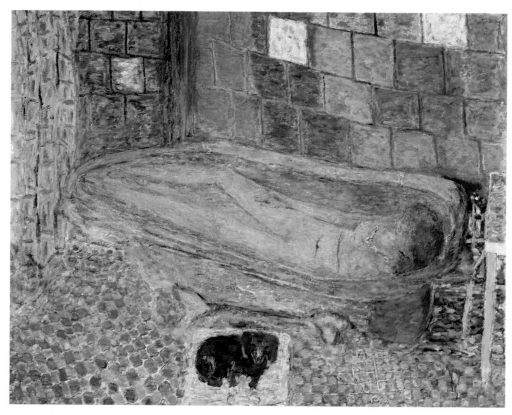

159 *Nude in the Bath, with Dog,* 1941–46

160 *Nude in the Bath, with Dog* (detail), 1941–46

The war had immediately hit Bonnard hard. He wrote to Charles Terrasse at the end of 1939, 'Nature is the only consolation at this time'. A few months later he learnt of Vuillard's solitary death on the road north from Paris, fleeing the advancing German army, lost in the confusion of the débâcle. His Jewish friends were soon being persecuted, and Bernheim-Jeune shut down; yet Thadée Natanson stayed on in occupied Paris, and was observed with his gentile wife, arm in arm, 'walking slowly, proudly... a tall old gentleman stamped with a yellow star'. In 1944, learning of the destruction of his beloved Normandy, where 'each village name is a memory', Bonnard writes: 'One arrives at an impasse of despair'. We glimpse his own day-to-day life vividly in his correspondence with Matisse. Earlier Bonnard had driven frequently down into Cannes, but he writes in September 1940: 'For some time I've been virtually a prisoner of my mountain, with no use of a car, of course.' In 1941: 'Shortages are beginning to be felt around Le Cannet: a dozen days with neither meat nor cheese... Naturally work has been set back by this. It no longer matters about painting, but about eating.' He and Marthe had already become 'three-quarters vegetarian'; now they relied partly on food parcels sent by friends and relatives.

His political standpoint was unclear. Some of his closest friends had moved left, Fénéon becoming first a syndicalist, then a supporter of the French Communist Party; after retiring from Bernheim's in 1924, he intended to leave his superb art collection to the Soviet Union. But Bonnard is said to have become a 'nationalist', and his work has been seen as exemplifying the aesthetic propounded by Louis Hautecoeur, the bureaucrat in charge of the arts under Vichy: 'French painting has always manifested its taste for moderation, for harmony, and for nature.' Bonnard was invited to make a portrait of Marshal Pétain, and probably would have done so had an administrative hitch not intervened. It is a shock to find him, exasperated by the Allies' bombing of the Côte d'Azur, writing in 1942 to Matisse: 'The war is increasingly reaching dimensions that might mean years, and during all this time we are to be trampled under. And the British will never be punished...'

Earlier in 1942, he'd been asked to make an altarpiece for the church of Assy in the Savoy Alps. It was characteristic of the project's director, Father Couturier, to commission non-believing artists alongside those who were committed Christians; among the other participants would be the Marxist Léger, as well as Rouault and Lurçat. The altar was dedicated to Saint François de Sales, a sixteenth-century Savoyard counter-

Reformation bishop – a reconverter of Calvinists, but also the author of the famous *Introduction to the Devout Life*, whose rational everyday spirituality may have appealed to Bonnard. Photographs show him at work in his studio, perched on a step-ladder, drawing in charcoal on a piece of canvas cut to fill an arch more than seven feet high. In the completed picture, the dark half-figure of the saint looks out at us, surrounded by little grey supplicants, and even tinier children below, their hands raised in prayer. This haloed, superhuman figure, set against the townscape of Annecy and its lake (rendered so as to resemble the view from 'Le Bosquet', with the Mediterranean beyond) appears archaic and hieratic; as Bonnard himself commented to Thadée Natanson, 'It's an *Image d'Epinal*' – that is, a naïve popular print. Its colour is dominated by the bishop's pale magenta cape, echoed in the lake, and set off against accents of blue and gold; the dove at the apex has a wing of each colour. Less vapid than the earlier bucolic decorations, it is also more responsive in its shimmering surface; thus, in a crucial late adjustment, both lower corners are pulled inwards. 161

It was Bonnard's one-time Nabi comrade, Father Verkade, who recognized in the saint's gentle bearded visage a memorial to Vuillard, whose death continued to haunt Bonnard. His solitude was eased by the new intensity of his longstanding friendship with Matisse, who lived in Nice, not far away. As Bonnard wrote early in 1940, 'I very much need to see another kind of work than my own', and their genuine dialogue as artists seems to have hinged on their differences – the fluidity of Bonnard, the flatness of Matisse. In the middle of the war, Maillol sent over his favourite model (the statuesque Dina Vierny, who had first posed for Bonnard in 1939) as a kind of consolatory presence after Marthe's death. In Vierny's own account, 'Posing for him was a different experience than for other artists. He didn't want me to stay still – he needed movement; he asked me to "live" in front of him, trying to forget he was there. He wanted at the same time life and absence.' In the resulting powerful *contre-jour* nude, completed at last in his final months, we see exactly that contradiction: the fleshiness of her massive torso, her golden breasts recalling late Renoir – yet the picture as a whole dematerialized, dissolved into 'the great pattern'.

'TO START ALL OVER AGAIN'

By the time Bonnard began *Paysage au toit rouge* (Landscape with Red Roof), the war was over, and there was a mood everywhere of a new beginning. The orange-red of the foreground and the green area along 165

161 *Saint François de Sales*, 1942–45

the right edge are both pitched to an astonishing intensity, unparalleled even in his own work, and almost impossible to experience in reproduction. These two areas of flat colour read as contrasted curtains being drawn back, to reveal between them a blossoming world – white and yellow jewels set in a bluish darkness. The mark is now everywhere expressive, in direction, in thickness, as though the brush were totally an extension of mind and spirit. To the much younger painter Bazaine he

confided, 'I'm only just beginning to understand what it is to paint. One ought to start all over again…'

The tentativeness of Bonnard's touch in his final years imparts a kind of quivering, true to experience; it seems to acknowledge doubt (self-doubt, as well as perceptual uncertainty). Vulnerability and diffidence become positive values, and we are made to experience his 'weakness' as a very great strength. The blur is more pronounced, and may sometimes indicate failing sight, but in the dissolved world of Bonnard's old age there is also a wonderful merging, a loss of willed structure, an undifferentiated tenderness. In this final imagery of blossoming plants and watery selves may be recognized something of a 'Green', or Aquarian, prophecy. Yet in the world that emerged in Paris after the war, that dematerialization was particularly repellent – to Picasso, as to the *Marxisants* of Existentialism. Bonnard had no illusions about his standing among younger French artists: 'They don't much like me. I understand that. That's what happens to each generation.'

He spent a week in Paris in July 1945, his first visit in almost six years, and saw such surviving friends as Misia and Thadée Natanson. Fénéon, Roussel, Josse Bernheim, Denis were all dead. A year later, he returned for a month, staying some nights at the Hotel Terminus beside the Gare St Lazare, a haunt of commercial travellers. The pencil, charcoal and wash

162 *Dark Nude*, 1942

drawing of *Place du Havre* was begun from a high balcony, with people appearing 'no bigger than insects':

> What a spectacle to see this world of workers escaping from the station like bees from a hive... For an elderly man like myself these goings and comings become touching, they assume a certain grandeur... I can imagine that they are carrying home to the cells of their honeycombs the spoils of their day. Brave little people, I love them with all my heart.

The almost infantile, but marvellously candid and tremulous pencil line of *Place du Havre* is evident again in the underdrawing of *Le Bœuf et l'enfant* (Child and Bull), especially in the huge but fragile beast face turned towards us. The pathos of these scribbled eyes and nostrils recalls the blind sockets of *The Circus Horse*, while the body is rendered as an expanse of flattened pink, extending even into the stylized landscape all around. As so often in Bonnard, we are made to enter sympathetically into the experience of the animal, as in very few Western painters; the little boy at the fence with downcast eyes, and the bending peasant behind,

167

163 Landscape drawing, *c.* 1943–45

BURTON

164 *Place du Havre*, 1946

are much less vivid. One of his last large-scale pictures, it was exhibited in Paris at the Salon d'Automne in October 1946, which Bonnard attended. Later that month, staying in Fontainebleau (where his nephew Charles was a curator at the palace) he completed *The Studio with Mimosa*, as well as *The Circus Horse*. It was on the wall behind him as the family lunched; when the meal was over, he asked for a step-ladder, and 'applied some touches of dark blue and black at the top of the picture'.

At Le Cannet that spring he had been moved, not for the first time, to see the small almond tree under his bedroom window burst into blossom again. But now its early flowering signified the end not only of winter,

165 *Landscape with Red Roof*, 1945–46

but of a terrible and almost annihilating era of destruction. The little picture he embarked on then has come to seem an emblem, appearing as Bonnard's final 'Talisman' to contemporary painting, reminding us how much can be done with how little – its blue and white held with such luminous intensity, its sense of nature nearer to Chinese than to French 168 tradition. In Brassaï's marvellous tragicomic photograph, we see him in hat and slippers at work on it – the canvas still unstretched, tacked low on the wall – bent almost double as he reaches down in a gesture rather as though greeting a small child, or feeding a dog. All around are other

166 *The Almond Tree in Flower*, 1946–47

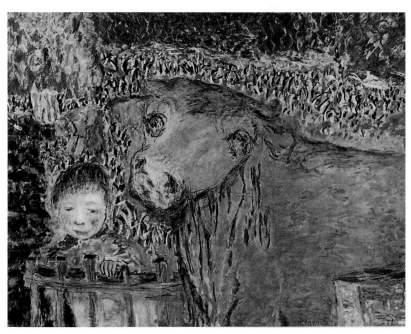

167 *Child and Bull*, 1946

pictures also nearing completion (including the *Landscape with Red Roof*). *L'Amandier en fleur* (The Almond Tree in Flower) was signed, and photographed for a magazine reproduction, which duly appeared. But in January 1947, when Bonnard was already bed-ridden and too weak to paint, he told his nephew Charles to make some alterations. "'The green on the patch of ground to the left is wrong. What it needs is yellow..." He asked me to help him paint the bit of ground yellow, that is, gold. A few days later, Bonnard was dead.'

168 Bonnard in his studio at Le Cannet painting *The Almond Tree in Flower*, 1946. Photograph by Brassaï

Postscript

The year Bonnard died, *Cahiers d'Art* – at that time the leading art maga-zine in the world – published an editorial headed: 'Pierre Bonnard: Is He a Great Painter?' It concluded, 'How can we explain the reputation of Bonnard's work? It is evident that this reverence is shared only by people who know nothing about the great difficulties of art and cling above all to what is facile and agreeable.' Matisse scrawled over his own copy, which survives: 'Yes! I certify that Pierre Bonnard *is* a great painter, for today and for the future. [signed] Henri Matisse'. Pierre Matisse later recalled that he had rarely seen his father so angry.

Yet the article reflected the prevailing estimate of Bonnard's achieve-ment until well into the 1960s. True, its author, Christian Zervos, was something of a mouthpiece for Picasso, and Bonnard was (according to John Richardson) Picasso's 'pet aversion', the butt of such gibes as 'that's where I caught my fear of melting in the bath like a piece of soap'. Françoise Gilot has him ranting on for two pages:

> Don't talk to me about Bonnard. That's not painting, what he does. He never goes beyond his own sensibility. He doesn't know how to choose. When Bonnard paints a sky, perhaps he first paints it blue, more or less the way it looks. Then he looks a little longer and sees some mauve in it, so he adds a touch or two of mauve... The result is a pot-pourri of indecision... Painting can't be done that way. Painting isn't a question of sensibility: it's a question of seizing the power, taking over from nature, not expecting her to supply you with information and good advice...

Some of this attack can be discounted as simply a misunderstanding of Bonnard's procedures and intentions – it is clearly assumed that he paints from life. But more fundamentally, Picasso opposes the tentative and non-aggressive character of Bonnard's art. He is 'a piddler': 'you never once get the big clash of the cymbals'. Picasso's final criticism – 'He's not really a modern painter' – is the most devastating of all, and it identifies

211

169 Bonnard in his studio at Le Cannet, 1946. Photograph by Gisèle Freund

what would be the central problem in assessing Bonnard's achievement.

His death so soon after the war had come at the worst possible moment for his reputation. Europe was casting about to rebuild itself; this cult of little domestic epiphanies appeared almost laughably irrelevant and inconsequential. And there had begun meanwhile that cultural civil war between Abstraction and Figuration, which would dominate painting for the next three decades. Whereas Picasso or Matisse could be appropriated as stepping-stones to abstraction, Bonnard seemed more tied to the specifics of the world he depicted; a world, however, entirely lacking the moralizing overtones that might have endeared him to the post-war fanatics of figuration. Never a favourite among American collectors, his place, as the modernist canon began to be institutionalized in New York, was at best marginal.

Of course, there were always contrary voices. David Sylvester recalls 'in 1954 saying to Balthus that I couldn't make up my mind whether the greatest artist of this century was Matisse or Bonnard. He replied that if I didn't think it was Bonnard, we had nothing further to say to one another.' The painter and writer Patrick Heron (usually considered an apologist for English abstraction) began in the month after Bonnard's death the impassioned essay quoted in the last chapter, arguing that he was not 'the final ambassador of an anachronism', but a great contemporary whose art could mediate between the two false positions of the day – between an over-pure abstraction, and an over-programmatic figuration. And yet, as Heron admitted, there remained a general suspicion 'that Bonnard was "not quite modern", and therefore not in the first flight'. Even when I arrived at art school in the early 1960s, that view still prevailed; he remained the 'soft option' among the possible stylistic exemplars open to us.

The 1966 London retrospective at the Royal Academy, the largest Bonnard show ever mounted, marked a major shift. Included within it were several previously little-known pictures – some of the most intense and personal of the late Marthe images, as well as some key self-portraits – which ever since Bonnard's death had been shut away due to a long lawsuit. (When Marthe died intestate in the middle of the war, Bonnard forged her will, assuming that she had no heirs and wanting to avoid complications; but after his own death, four previously unknown nieces came forward to claim their share from the Terrasse family, and for the next eighteen years all the unsold work lay under legal sequestration.) With this new focus on Marthe and the later work, Bonnard began to be reassessed. John Berger, reviewing the London show, marvelled at the sudden rise in his critical standing. 'Some now claim that he is the

greatest painter of this century. Twenty years ago he was considered a minor master.'

In parallel, though much more slowly, new facts began to leak out about Bonnard's life with Marthe. It is astonishing to read today, in Charles Terrasse's would-be eulogistic introduction to the 1948 retrospective at the Museum of Modern Art, New York, 'One will find in his work neither sadness nor suffering, only an occasional trace of melancholy, and then only as an accompaniment to feminine grace.' As late as 1966, when Denys Sutton introduced the London retrospective, he could blandly declare: 'No legend could be prised out of his life story'. But already the 'legends', of Marthe, of her mental illness, and of the suicide of Renée Monchaty, were altering the general perception of Bonnard. For Berger, the late nudes were the sole redeeming component in an oeuvre otherwise 'intimate, contemplative, privileged'; it was the 'tragedy' of his relationship with Marthe that 'ensured his survival as a painter'.

But how was this new, darker and more psychologically complex Bonnard to be placed? One way to construct twentieth-century art had been as a succession of avant-garde movements, with Bonnard slotted in early, as a Nabi or an Intimist – leaving him stranded in the Belle Epoque at the age of thirty-eight. This could hardly be reconciled with the general consensus, that his best works (even if painted in a style sixty or seventy years 'out of date') were completed after 1920. For the generation of painters who grew up in the 1960s and 1970s, Bonnard now appeared as one of several previously peripheral artists, whose reassessment shook the whole edifice of contemporary art. Modernity had been defined by its severity, its arduous purity, its 'truthfulness' – its abjuring of illusion. The cult of flatness, as propounded in the writings of Clement Greenberg, was central to late-modernist criticism, along with the suppression of subjectivity. But by the late 1970s, Bonnard's retrieval of space and self, seemed full of promise for the renewal and continuity of painterly language, while his freedom from any obvious stylistic ideology became another factor in making him such a timely rediscovery. This was how the revisionist curator Jean Clair presented Bonnard in Paris in 1984, for a neo-Expressionist generation. And despite the subsequent debasement of subjectivity evident in so much painting of the 1980s, I think that promise has continued to hold.

Bibliographical Note

The best general monograph on Bonnard currently available in English is by Nicholas Watkins (London 1994). It incorporates a comprehensive bibliography, alphabetically listed. The catalogue raisonné of Bonnard's paintings was published in four volumes (Paris 1965–74) by Jean and Henri Dauberville, but much of their dating is now contested, and a revised edition is long overdue. A high proportion of the monographs on Bonnard in French have been by members of the Terrasse family, the artist's heirs. Charles Terrasse's *Bonnard* (Paris 1927), written under his uncle's supervision (see Chapter Four), is a key text. Antoine Terrasse's *Bonnard* first appeared in 1967, and was republished in a larger format in 1988 (Gallimard, NRF, Paris) with many spectacular plates. Michel Terrasse's *Bonnard – du dessin au peinture* (Paris 1996) is another splendid picture-book, and helps to place drawings and paintings in relation to one another.

Bonnard Drawings by Sargy Mann (London 1991) is the most extensive selection of drawings so far published. F. Bouvet, *Bonnard, Complete Graphic Works* (London 1981) and A. Terrasse, *Pierre Bonnard, Illustrator* (London 1989) are useful compendiums. For vivid colour reproductions, the Museum of Modern Art's *Bonnard and his Environment* (New York 1964) remains unrivalled. The catalogue of the Centre Pompidou's Bonnard retrospective has a particularly acute selection; *Bonnard: The Late Paintings* (Washington and Dallas 1984) is nearly identical. Both volumes incorporate Jean Clair's superb interpretative essay, 'The Adventures of the Optic Nerve', as well as Bonnard's 'Notes of a Painter', and a fine selection of his diary drawings.

Introduction
For Bonnard's life, see especially *Le Bonnard que je propose 1867–1947*, by the artist's friend Thadée Natanson (Geneva 1951). A very informative and detailed chronology of the artist's life was prepared by Belinda Thomson for *Bonnard at Le Bosquet* (London 1994). Annette Vaillant's *Bonnard* (Neuchatel 1965; English edition London 1966) is as much memoir as monograph. Patrick Heron's essay on Bonnard is reprinted in *The Changing Forms of Art* (London 1955). Julian Bell's introduction to *Bonnard* (London 1994) is an exceptionally well focused brief account.

Chapter One
The catalogue of the Grand Palais's *Les Nabis* (Paris 1993) is the best general work. I recommend Richard O. Sonn's *Anarchism and Cultural Politics in Fin de Siècle France* (University of Nebraska Press 1989). For other tangential perspectives, see *Félix Fénéon* by Joan Ungersma Halperin (New Haven 1988). Hahnloser's account appeared in *The Times*, London, 15 February 1966.

Chapter Two
Several recent books and exhibitions have deepened our knowledge of intimist circles: the Lyons–Nantes–Barcelona *Vuillard* (catalogue published by Flammarion, Paris 1990); *Félix Vallotton* (New Haven 1991); and Gloria Groom's *Edouard Vuillard, Painter-Decorator: Patrons and Projects 1892–1912* (New Haven 1993) which incorporates much material on Bonnard's *mythologies*. *La Revue Blanche* (New York 1983) is an attractive brief survey. For Mallarmé and painting, see James Kearns, *Symbolist Landscapes* (MHRA, vol. 27, 1989). For the Jarry drawings, see *Tout Ubu* (Livres de

Poche, Paris 1962). *Pierre Bonnard: The Graphic Art* (New York 1990) is the best text on the early prints. Nicholas Watkins (*op. cit.*) has a detailed account of the *Parallèlement* lithographs.

Chapter Three
Albert Aurier's essay 'Symbolism in Painting' is republished in *The Post-Impressionists*, ed. Martha Kapos (London 1993). Count Harry Kessler's diaries are about to appear in English. The illustrations to Mirbeau's *La 628-E8* have been republished as *Bonnard: Sketches of a Journey* (London 1989). *Pierre Bonnard: Photographs and Paintings* by F. Heilbrun and P. Néago (Aperture 1988) reproduces all his known photographs. Henri Bergson's *Matter and Memory* was first published in English in 1911.

Chapter Four
The best text on Bonnard's drawings is Sargy Mann's (*op. cit.*). Charles Terrasse's 1927 monograph (*op. cit.*) is a source throughout this section, while John Rewald's *Bonnard* (New York 1948) also supplies several quotations. For the postwar *Return to Order* see *On Classic Ground* (Tate Gallery, London 1988). Bonnard's affair with Renée Monchaty was first discussed in print in 1966; Sacha Newman promised a full account in 1990, but this has not been forthcoming. Pierre Schneider's superb monograph on Matisse (London 1984) contains much interesting thought on swift drawing.

Chapter Five
Annette Vaillant (*op. cit.*) is a rich source on Marthe. I owe much to conversations with Nicholas Watkins, and with Sarah Whitfield, whose research appears in the Tate Gallery's *Bonnard* (1998). The catalogue includes an essay by John Elderfield in which he applies a perceptual and more or less mechanistic terminology to Bonnard's work. Gabriel Josipovici's novel *Contre-Jour: a Triptych After Pierre Bonnard* (Manchester 1986) has recently been reissued. *Bonnard at Le Cannet* by Michel Terrasse (London 1988) and Belinda Thomson and Sargy Mann's *Bonnard at Le Bosquet* (*op. cit.*) help to establish the topography of his later pictures. John Berger's essay is included in *The Moment of Cubism* (London 1969). David Sylvester's broadcast on *The Table* was reprinted in *About Modern Art* (London 1996).

Chapter Six
Throughout this section, Jean Clair's 1984 essay 'The Adventures of the Optic Nerve' (*op. cit.*) and James Elkins's *The Poetics of Perspective* (Cornell 1995) have been constant reference points. Twentieth-century painters' treatment of the self is discussed in Chapter Six of Hans Belting's *Max Beckmann* (Munich 1984; New York 1989) and by Jean Clair in *Identity and Alterity* (Venice 1995).

Chapter Seven
Bonnard at Le Cannet (*op. cit.*) reproduces many photographs of the artist at work by Henri Cartier-Bresson. For the Matisse/Bonnard correspondence, see *Letters Between Friends* (New York 1991). Among several recent accounts of wartime cultural politics, see Michèle Cone, *Artists Under Vichy* (Princeton 1992).

Postscript
For Christian Zervos's article, see *Cahiers d'Art 22*, 1947. *Vivre avec Picasso* (published in English as *Life with Picasso*, 1965) by Françoise Gilot and Carlton Lake has several passages on Bonnard.

List of Illustrations

All works are by Pierre Bonnard unless otherwise stated. Measurements are given in centimetres and inches, height before width.

All works by Pierre Bonnard © ADAGP, Paris and DACS, London 1998

1 Pages from Bonnard's pocket diary, 1934. © Cliché Bibliothèque Nationale, Paris

2 Pages from Bonnard's pocket diary, 1931. © Cliché Bibliothèque Nationale, Paris

3 Page from Bonnard's pocket diary, 1944. © Cliché Bibliothèque Nationale, Paris

4 Bonnard *c.* 1892. Photo Alfred Natanson. Private collection

5 Paul Gauguin, *The Vision After the Sermon*, 1888. Oil on canvas 73 × 92 (28¾ × 36¼). National Gallery of Scotland, Edinburgh

6 Bonnard's studio wall at Le Cannet, *c.* 1946. Photo X.-D. R.

7 Poster for France-Champagne, 1889 (published 1891). Colour lithograph 78 × 50 (30¾ × 19⅝)

8 *The Game of Croquet*, 1892. Oil on canvas 130 × 162.5 (51⅛ × 64). Musée d'Orsay, Paris

9 *On the Parade Ground*, 1890. Oil on canvas 23 × 31 (9 × 12¼). Private collection. Photo Artephot, Paris

10 *House with Tower (near Le Grand-Lemps)*, 1888. Oil on canvas 19 × 29 (7½ × 11⅜). Private collection

11 Maurice Denis, *Patches of Sunlight on the Terrace*, 1890. Oil on cardboard 24 × 20.5 (9½ × 8⅛). Musée d'Orsay, Paris. © Photo RMN. © ADAGP, Paris and DACS, London 1998

12 Kitagawa Utamaro, *Sankatsu and Hanhichi with their Baby*, *c.* 1790. Colour woodcut 62.2 × 14.9 (24½ × 5⅞). The Metropolitan Museum of Art, New York. Rogers Fund, 1919

13 *Family Scene*, 1892. Colour lithograph 21 × 26 (8¼ × 10¼)

14 *Nannies Out for a Walk, Frieze of Carriages*, 1894. Four-panel folding screen. Distemper on canvas with carved wood frame, each panel 147 × 45 (57⅞ × 17¾). Private collection

15 *Nannies Out for a Walk, Frieze of Carriages*, 1899 (detail). Colour lithograph, each panel 114.3 × 47.6 (45 × 18¾)

16 *Two Dogs Playing*, 1891. Oil on canvas 36.3 × 39.5 (14¼ × 15½). Southampton City Art Gallery

17 Paul Signac, *In the Time of Harmony*, 1894. Oil on canvas 300 × 400 (118⅛ × 157½). Mairie de Montreuil. © ADAGP, Paris and DACS, London 1998

18 Poster for *La Revue blanche*, 1894. Colour lithograph 80 × 63 (31½ × 24¾)

19 *The Passer-By*, 1894. Oil on wood 36 × 25 (14⅛ × 9⅞). Private collection

20 *The Omnibus*, 1895. Oil on canvas 59 × 41 (23¼ × 16⅛). Galerie Vercel, Paris

21 *Child Eating Cherries*, 1895. Oil on board 53 × 52 (20⅞ × 20½). National Gallery of Ireland, Dublin

22 Edouard Vuillard, *Misia and Cipa Godebski*, *c.* 1897. Oil on cardboard 63.5 × 56 (25 × 22). Kunsthalle, Karlsruhe. © ADAGP, Paris and DACS, London 1998

23 Félix Vallotton, *Dinner*, 1899. Oil on canvas 57 × 89.5 (22½ × 35¼). Musée d'Orsay, Paris. © Photo RMN

24 *Thadée Natanson*, 1897. Oil on canvas 42 × 41 (16½ × 16⅛). Private collection

25 *Child in Lamplight*, 1897. Colour lithograph 33 × 45.5 (13 × 18)

26 *Breakfast by Lamplight*, 1898. Oil on board 24 × 33 (9½ × 13). Private collection. Photo courtesy Sotheby's, New York

27 *Misia's Breakfast*, 1896. Oil on canvas
32 × 41 (12⅝×16⅛). Private collection

28 *Calendar of Saints Days* from
L'Almanach illustré du Père Ubu by
Alfred Jarry, 1901. Colour lithographic
drawing 20 × 28.5 (7⅞×11¼)

29 *Ubu in Paris* from *Petit Almanach du
Père Ubu* by Alfred Jarry, 1899. Ink
drawing 9.5 × 10 (3¾×3⅞)

30 *Street at Evening in the Rain*, c. 1897
from *Quelques Aspects de la Vie de
Paris*. Colour lithograph 25.7 × 35.5
(10⅛×14)

31 *The Organ Grinder*, 1895. Oil on
panel 41 × 26 (16⅛×10¼). Collection
William Kelly Simpson, New York

32 Drawing from *La Vie du Peintre*,
c. 1910. Pencil, pen and wash on
paper. Private collection

33 *The Fourteenth of July*, 1896. Oil
on canvas laid on panel 58 × 68
(22⅞×26¾). Private collection

34 *Place Blanche*, 1902. Oil on paper
laid on canvas 60 × 79.5 (23⅝×31¼).
Private collection

35 *Place Pigalle*, 1900. Oil on panel
13 × 23 (5⅛×9). Private collection

36 *Street Corner Seen from Above*, c. 1897
from *Quelques Aspects de la Vie de Paris*.
Colour lithograph 36 × 21 (14⅛×8¼).

37 *The Boulevards*, 1900. Colour
lithograph 26 × 33 (10¼×13).

38 *Street Corner*, c. 1897. Colour
lithograph 27 × 35.5 (10⅝×14).

39 Edvard Munch, *Ashes*, 1894. Oil
on canvas 120.5 × 141 (47½×55½).
Nasjonalgalleriet, Oslo. © The Munch
Museum/The Munch-Ellingsen
Group/DACS 1998

40 *Man and Woman*, 1900. Oil on
canvas 115 × 72.5 (45¼×28½). Musée
d'Orsay, Paris

41 Edouard Vuillard, *Married Life*, 1900.
Oil on cardboard 20 × 22 (7⅞×8⅝).
Private collection. © ADAGP, Paris
and DACS, London 1998

42 Illustration from *Marie* by Peter

Nansen, 1897. Process print, page size
18.5 × 11.6 (7¼×4½).

43 *Marthe on a Divan*, c. 1900. Oil on
cardboard 44 × 41 (17⅜×16⅛). Musée
National d'Art Moderne, Centre
Georges Pompidou, Paris

44 *The Indolent Woman*, 1899. Oil on
canvas 96 × 106 (37¾×41¾). Musée
d'Orsay, Paris. © Photo RMN/
R. G. Ojeda

45 Illustration from *Parallèlement* by
Paul Verlaine, 1900. Lithograph,
page size 30.5 × 25 (12 × 9⅞)

46 Illustration from *Daphnis and Chloe*
by Longus, 1902. Lithograph, page size
30.2 × 25 (11⅞×9⅞)

47 *Pan and the Nymphs*, 1899.
Oil on panel 32 × 22.5 (12⅝×8⅞).
Private collection

48 Bonnard c. 1909, photographer
unknown. Private collection

49 *Boating on the Seine, the Bridge at
Chatou*, 1896. Oil on panel 32 × 59.5
(12⅝×23½). Private collection

50 Bonnard's studio, c. 1905. Photo
Edouard Vuillard. Private collection.
© ADAGP, Paris and DACS,
London 1998

51 Auguste Renoir, *Moulin de la Galette*,
1876. Oil on canvas 131 × 175 (51⅜×
68⅞). Musée d'Orsay, Paris

52 *The Bourgeois Afternoon*, 1900. Oil on
canvas 139 × 212 (54¾×83½). Musée
d'Orsay, Paris

53 *Le Jardin de Paris*, c. 1900. Oil on
canvas 119 × 192 (46⅞×75⅝).
Private collection

54 *Vollard's Dinner*, c. 1907. Oil
on canvas 73 × 104 (28¾×41).
Private collection

55 *Portrait of Vollard*, 1924.
Etching 35.5 × 24 (14 × 9½).

56 *In the Boat*, 1910. Oil on canvas
278 × 301 (109½×118½). Musée
d'Orsay, Paris

57 *Pleasure*, 1906. Oil on canvas 251.5 ×
464.7 (99 × 183). The J. Paul Getty

Museum, Los Angeles, California

58 *Portrait of the Bernheim-Jeune Brothers*, *c.* 1920. Oil on canvas 165.5 × 155.5 (65⅛×61¼). Musée d'Orsay, Paris

59 Illustration from *La 628-E8* by Octave Mirbeau, 1908 (detail). Ink drawing 24 × 19 (9½×7½).

60 Bonnard, Marthe and Suzanne Bernheim de Villiers, *c.* 1913, photographer unknown. Private collection

61–62 *The Box*, 1908. Oil on canvas 91 × 120 (35⅞×47¼). Musée d'Orsay, Paris. © Photo RMN/Jean

63 *Place Clichy or the Green Tram*, 1906. Oil on canvas 121 × 150 (47⅝×59). Private collection

64 *Regatta*, 1913. Oil on canvas 73 × 100.3 (28¾×39½). Carnegie Museum of Art, Pittsburgh. Acquired through the generosity of the Sarah Mellon Scaife family, 63.12.1

65 *The Train and the Barges*, 1909. Oil on canvas 77 × 108 (30¼×42½). The Hermitage, St Petersburg. Photo AKG, London

66 *The Lane at Vernonnet*, 1912–14. Oil on canvas 74.3 × 62.8 (29¼×24¾). Scottish National Gallery of Modern Art, Edinburgh

67 *La Place Clichy*, 1912. Oil on canvas 139 × 205 (54¾×80¼). Musée des Beaux-Arts et d'Archéologie de Besançon

68 *Café 'Au Petit Poucet'*, 1928. Oil on canvas 139 × 206 (54¾×81⅛). Musée des Beaux-Arts et d'Archéologie de Besançon

69 *Dressing Table and Mirror*, 1913. Oil on canvas 125 × 110 (49¼×43¼). The Museum of Fine Arts, Houston. John A. and Audrey Jones Beck Collection

70 *The Mantlepiece*, 1916. Oil on canvas 81 × 111 (31⅞×43¾). Private collection. Photo Artephot, Paris

71 *Coffee*, 1915. Oil on canvas 73 × 106.4 (28¾×41⅞). Photo © Tate Gallery, London

72–73 *Dining Room in the Country*, 1913. Oil on canvas 164.5 × 205.7 (64¾×81). The Minneapolis Institute of Arts. The John R. Van Derlip Fund

74 *Trees and House*, *c.* 1916. Pencil on paper 12 × 15.8 (4¾×6¼). Private collection. Photo courtesy Neffe-Degandt Gallery, London

75 *The Factory*, *c.* 1916. Oil on canvas 243 × 340 (95⅝×133⅞). Private collection

76 Drawing for *The Factory*, *c.* 1916. Pencil on paper 13.6 × 21.2 (5⅜×8⅜). Private collection. Photo courtesy Neffe-Degandt Gallery, London

77 *The Bay of Saint-Tropez*, *c.* 1935. Pencil on paper 15.6 × 11.7 (6⅛×4⅝). Private collection. Photo courtesy Neffe-Degandt Gallery, London

78 Claude Monet in his studio with *Morning* for the Orangerie, Paris, *c.* 1924–25. Photo Document Archives Durand-Ruel, Paris

79 *Early Spring in the Village*, 1912. Oil on canvas 202 × 254 (79½×100). Pushkin Museum, Moscow. Photo Scala

80 *Summer*, 1917. Oil on canvas 260 × 340 (102⅜×133⅞). © Photo Galerie Maeght, Paris

81 *The Modern City*, 1916–20. Oil on canvas 130 × 160 (51⅛×63). The National Museum of Western Art, Tokyo

82 *The Abduction of Europa*, 1919. Oil on canvas 117.5 × 153 (46¼×60¼). The Toledo Museum of Art, Toledo, Ohio. Purchased with funds from the Libbey Endowment. Gift of Edward Drummond Libbey

83 *The Armistice*, 1918. Oil on canvas 60 × 84 (23⅝×33⅛). Private collection

84 Bonnard and Marthe at Vernonnet, *c.* 1920, photographer unknown. Private collection

85 Drawing for *The Bowl of Milk*, 1919.

Pencil on paper 12.3 × 18.1 (4⅞×7⅛).
Photo © Tate Gallery, London
86 *Renée Monchaty*, 1921. Pencil on
paper. Private collection
87 *Young Women in the Garden*, 1921–23
(reworked 1945–47). Oil on canvas
60.5 × 77 (23⅞×30¼). Private
collection
88 *Decoration at Vernon*, 1920–39.
Oil on canvas 147 × 192 (57⅞×75⅜).
The Metropolitan Museum of Art,
New York. Gift of Mrs Frank Jay
Gould, 1968
89 *Piazza del Popolo*, 1922. Oil
on canvas 79.5 × 96.5 (31⅜×38).
Private collection. Photo courtesy
Sotheby's, New York
90 *The Terrace at Vernon*, 1928. Oil
on canvas 242.5 × 309 (95½×121⅝).
Kunstsammlung Nordrhein-Westfalen,
Düsseldorf
91–92 *The Bowl of Milk*, 1919. Oil on
canvas 116.2 × 121 (45¾×47⅝). Photo
© Tate Gallery, London
93 Bonnard and his Ford, 1923. Photo
Jacques Salomon. Private collection
94 *The Sailing Excursion*, 1924–25.
Oil on canvas 98 × 103 (38⅝×40½).
Private collection
95 *Signac and His Friends Sailing*,
1914–24. Oil on canvas 124.5 × 139
(49 × 54¾). Kunsthaus, Zurich
96 *Fishing Boat at Deauville*, c. 1935.
Black chalk on paper 12.4 × 16.5 (4⅞×
6½). Private collection. Photo courtesy
Neffe-Degandt Gallery, London
97 *Beach at Low Tide, Arcachon*, c. 1930.
Pencil on paper 20.3 × 15.9 (8 × 6¼).
Private collection. Photo courtesy
Neffe-Degandt Gallery, London
98 *Conversation in the Park*, c. 1922.
Oil on canvas 90 × 71 (35⅜×28).
Private collection
99 *The Bay of Cannes*, c. 1938.
Pencil on paper 17.8 × 23.7 (7 × 9⅜).
Private collection. Photo courtesy
Neffe-Degandt Gallery, London

100 *The Window*, 1925. Oil on canvas
108.6 × 88.6 (42¾×34⅞). Photo ©
Tate Gallery, London
101 *Portrait of Marthe*, 1925. Oil on
canvas 78 × 50 (30¾×19⅝). Private
collection
102 *The Bath*, 1925. Oil on canvas
86 × 120.6 (33⅞×47½). Photo © Tate
Gallery, London
103 *Interior of the Small Sitting Room at
Night*, c. 1940. Pencil on paper 16 × 13
(6¼×5⅛). Private collection
104 *The Radiator*, c. 1941. Gouache,
watercolour and pencil on paper
65 × 50 (25⅝×19⅝). The Arkansas
Arts Center Foundation Collection.
The Fred Allsopp Memorial
Acquisition Fund, 1983
105 *The French Window*, 1929. Oil
on canvas 86 × 112 (33⅞×44⅛).
Private collection
106 *White Interior*, 1932. Oil on
canvas 109 × 162 (42⅞×63¾).
Musée de Grenoble
107 *The Coffee Grinder*, 1930.
Oil on canvas 48 × 57 (18⅞×22½).
Kunstmuseum, Winterthur
108 *Still-Life with Bouquet*, 1930.
Oil on canvas 60 × 130.5 (23⅝×51⅜).
Kunstmuseum, Basel
109 *The Table*, 1925. Oil on canvas
102.9 × 74.3 (40½×29¼). Photo ©
Tate Gallery, London
110 *Breakfast Room*, c. 1930–31. Oil
on canvas 159.6 × 113.8 (62⅞×44⅞).
The Museum of Modern Art,
New York. Given anonymously.
Photograph © 1997 The Museum
of Modern Art, New York
111 *La Toilette* (also known as *Nude in
the Bathroom*), 1932. Oil on canvas
121 × 118.1 (47⅝×46½). The Museum
of Modern Art, New York. Florence
May Schoenborn Bequest. Photograph
© 1997 The Museum of Modern Art,
New York
112 *Nude in the Bathroom*, 1931. Oil on

canvas 120 × 110 (47¼ × 43¼). Musée National d'Art Moderne, Centre Georges Pompidou, Paris

113 *Marthe with Dog*, 1941. Oil on canvas 120 × 50 (47¼ × 19⅝). Private collection

114 Drawing from Bonnard's pocket diary, 1939. © Cliché Bibliothèque Nationale, Paris

115 *Interior at Le Cannet*, c. 1939. Oil on canvas 125 × 125 (49¼ × 49¼). Yale University Art Gallery. The Katharine Ordway Collection

116 *Nude in Front of the Mirror*, 1933. Oil on canvas 153.5 × 104 (60½ × 41). Galleria Internazionale d'Arte Moderna, Venice

117 *Large Yellow Nude*, 1938–40. Oil on canvas 171 × 110 (67⅜ × 43¼). Private collection

118 *Nude in Front of a Mirror*, c. 1936. Pencil and watercolour on paper 17.2 × 13.6 (6¾ × 5⅜). Private collection. Photo courtesy Neffe-Degandt Gallery, London

119 *Nude in Front of a Mirror*, c. 1933. Pencil on paper. Private collection

120 *Self-Portrait at Le Cannet*, c. 1939–42. Pencil on paper 18.5 × 11.5 (7¼ × 4½). Private collection, Paris

121 *Landscape at Le Cannet*, c. 1928. Oil on canvas 123 × 275 (48⅜ × 108¼). © Galerie Maeght, Paris

122 *Descent to Le Cannet*, 1943. Oil on canvas 63 × 72 (24¾ × 28¼). The Metropolitan Museum of Art, New York. Robert Lehman Collection, 1975

123 *Garden with Small Bridge*, 1937. Oil on canvas 99 × 124 (39 × 48⅞). Santa Barbara Museum of Art. Bequest of Wright S. Ludington

124 *The Pink Road*, 1934. Oil on canvas 59 × 61 (23¼ × 24). Musée de l'Annonciade, Saint-Tropez

125 *Normandy Landscape*, 1926–30. Oil on canvas 62.6 × 81.3 (24⅝ × 32).

Smith College Museum of Art, Northampton, Massachusetts. Purchased Drayton Hillyer Fund, 1937

126 *Autumn Landscape*, 1932. Oil on board glued to canvas 46 × 65 (18⅛ × 25⅝). Reuters Collection

127 *Nude in the Tub*, 1908. Gelatin print 8.5 × 6 (3⅜ × 2⅜). Musée d'Orsay, Paris

128 *Large Blue Nude*, 1924. Oil on canvas 101 × 73 (39¾ × 28¾). Private collection

129 *Large Nude in Bath*, 1924. Oil on canvas 113 × 82 (44½ × 32¼). Private collection

130 *Nude with Bonnard's Leg*, 1919. Pen, ink and pencil on paper 22 × 9 (8⅝ × 3½). Private collection. Photo courtesy Neffe-Degandt Gallery, London

131 *Nude, Back View with Self-Portrait*, 1930. Pencil on paper 60 × 45.7 (23⅜ × 18). Private collection

132 Drawing for *Getting Out of the Bath*, c. 1926. Pencil on paper 13 × 18.5 (5⅛ × 7¼). Private collection

133 *Getting Out of the Bath*, 1926–30. Oil on canvas 129 × 123 (50¾ × 48⅜). Private collection

134 Edgar Degas, *Woman at her Bath*, c. 1895. Oil on canvas 72.4 × 90.8 (28½ × 35¾). Art Gallery of Ontario, Toronto. Purchase Frank P. Wood Endowment

135 *The Green Slipper*, 1925. Oil on canvas 142 × 81 (55⅞ × 31⅞). The Art Institute of Chicago

136 *In the Bathroom*, c. 1940. Oil on canvas 92 × 61 (36¼ × 24). Collection Stephen Mazoh

137 *Bonnard with Marthe in the Bathroom*, 1938–41. Oil on canvas 103 × 64 (40½ × 25¼). Private collection. Photo Sotheby's Picture Library, London

138 *Self-Portrait*, 1930. Pencil, watercolour and gouache on paper 65 × 50 (25⅝ × 19⅝). Private collection

139 *The Boxer*, 1931. Oil on canvas 53.5 × 74 (21⅛ × 29⅛). Private collec-

tion. Photo Christie's Images, London
140 *Self-Portrait, c.* 1940. Oil on canvas
76.2 × 61 (30 × 24). Art Gallery of
New South Wales, Sydney
141 *Self-Portrait in the Bathroom Mirror,*
1943. Oil on canvas 73 × 51 (28¾ ×
20⅛). Musée National d'Art Moderne,
Centre Georges Pompidou, Paris
142 *Self-Portrait,* 1945. Oil on canvas
56 × 46 (22 × 18⅛). Collection
Fondation Bemberg, Toulouse
143 *The Circus Horse,* 1936–46.
Oil on canvas 94 × 118 (37 × 46½).
Private collection
144 *The Studio with Mimosa,* 1938–46.
Oil on canvas 125 × 125 (49¼ × 49¼).
Musée National d'Art Moderne,
Centre Georges Pompidou, Paris
145 Bonnard's studio at Le Cannet,
1983. Photo Sargy Mann and
Tom Espley
146 *The Studio,* 1932. Pencil on paper.
Private collection
147 *The Sunlit Terrace, c.* 1939. Oil on
canvas 71 × 236 (28 × 92⅞). Private
collection. Photo Sotheby's Picture
Library, London
148 *Corner of a Table, c.* 1935. Oil on
canvas 67 × 63.5 (26⅜ × 25). Musée
National d'Art Moderne, Centre
Georges Pompidou, Paris
149 *The Table in Front of the Window,*
1934–35. Oil on canvas 101.5 × 72.5
(40 × 28½). Private collection
150 *Exit from Trouville Harbour, c.* 1936.
Oil on canvas 77 × 103 (30¼ × 40½).
Musée National d'Art Moderne,
Centre Georges Pompidou, Paris
151 *The Port of Trouville,* 1938–45.
Pencil on paper 11.8 × 15.6 (4⅜ × 6⅛).
Private collection. Photo courtesy
Neffe-Degandt Gallery, London
152 *Uphill Path,* 1940. Oil on canvas
55 × 46 (21⅝ × 18⅛). Private collection
153 Bathroom at Le Cannet
(reconstruction), 1983. Photo Sargy
Mann and Tom Espley

154–155 *Nude in the Bath,* 1936. Oil on
canvas 93 × 147 (36⅝ × 57⅞). Musée du
Petit Palais, Paris
156 Wall of Bonnard's room at
Deauville, 1937. Photo Rogi André
157 *The Bath,* 1937. Oil on canvas
94 × 144 (37 × 56¾). Private collection.
Photo courtesy Galerie Beyeler, Basel
158 Drawing for *The Bath,* 1937. Pencil
on paper. Private collection
159–160 *Nude in Bath, with Dog,*
1941–46. Oil on canvas 73 × 100.3
(38¾ × 39½). Carnegie Museum of Art,
Pittsburgh. Acquired through the
generosity of the Sarah Mellon Scaife
family, 70.50
161 *Saint François de Sales,* 1942–45.
Oil on canvas 225 × 185 (88⅝ × 72⅞).
Church of Notre Dame, Assy, Haute-
Savoie. Photo © G. Dagli Orti, Paris
162 *Dark Nude,* 1942. Oil on canvas
81 × 65 (31⅞ × 25⅝). Private collection
163 Landscape drawing, c. 1943–45. Ink
and pencil on paper. Private collection
164 *Place du Havre,* 1946. Pencil,
charcoal and wash on paper 35 × 26.4
(13¾ × 10⅜). The Metropolitan
Museum of Art, New York.
Rogers Fund, 1949
165 *Landscape with Red Roof,* 1945–46.
Oil on canvas 64 × 57 (25¼ × 22½).
Private collection
166 *The Almond Tree in Flower,*
1946–47. Oil on canvas 55 × 37.5
(21⅝ × 14¾). Musée National d'Art
Moderne, Centre Georges Pompidou,
Paris
167 *Child and Bull,* 1946. Oil on
canvas 95 × 119 (37⅜ × 46⅞).
Private collection
168 Bonnard in his studio at Le Cannet
painting *The Almond Tree in Flower,*
1946. Photo Brassaï. Copyright ©
Gilberte Brassaï
169 Bonnard in his studio at Le
Cannet, 1946. Photo © Gisèle Freund

Acknowledgments

This book relies heavily on the knowledge of previous writers on Bonnard. Both Nicholas Watkins and Julian Bell generously read the entire text, and I have incorporated much of their comment. Sarah Whitfield, Sargy Mann and Christian Neffe have each been consistently illuminating in conversation; while Gabriel Josipovici (with whom a Bonnard dialogue reaches back many years) gave helpful advice at proof stage. To all these, as well as the authors cited in my bibliography, I am grateful.

A grant from the Leverhulme Foundation enabled me to travel and to see many of the pictures discussed here; an Honorary Research Fellowship from University College London allowed me to browse fruitfully in a well stocked library. I want to thank both these institutions, as well as the many British art schools – including the Slade and the Royal Academy – whose invitations to lecture on Bonnard over the years helped me to clarify my thoughts. Parts of my text incorporate ideas originally published in 1994 in *Modern Painters*. I want also to acknowledge a longstanding debt to the editor of *Common Knowledge*, Jeffrey Perl, who first invited me to write on Bonnard;

Chapter Six, 'A New Space for the Self', is a remnant of that aborted essay.

My responses to Bonnard have been nurtured over many years by the shared interest (or, in some cases, antagonism) of fellow artists. I want especially to thank Jeffery Camp, John Davies, Paul Gopal-Chowdhury, Peter de Francia, Josef Herman, Howard Hodgkin, Andrzej Jackowski, Merlin James, Bhupen Khakhar, Ken Kiff, R. B. Kitaj, Henry Kondracki, Richard Lannoy, Leonard McComb, Alexander Moffat and G. M. Sheikh. Among the many other friends who have helped in the most various ways I am particularly grateful to David Bindman, H. W. Fawkner, Ian Fleming-Williams, David Goodway, Geeta Kapur, Richard Kendall, David Fraser-Jenkins, Norbert Lynton, Richard Maxwell, Richard Morphet, Jed Perl, Louis Spitalnick, Jean-Pierre Tison and Katie Trumpener.

The most sustained comradeship has come from Judith Ravenscroft, who travelled so much of the road alongside me. I am deeply grateful for the commitment and editorial skills of my friend Louise de Bruïn, who took on the job of typing draft after draft with unflagging efficiency. Finally I want to thank all those at Thames and Hudson.

Index